I0235958

IMAGES
of America

MICHIGAN CITY
BEACH COMMUNITIES

SHERIDAN, LONG BEACH, DUNELAND, MICHIANA SHORES

Michigan City Indiana

Beach Playland of the Middle West

Michigan City Indiana

America's Cleanest, Finest Sand Beach

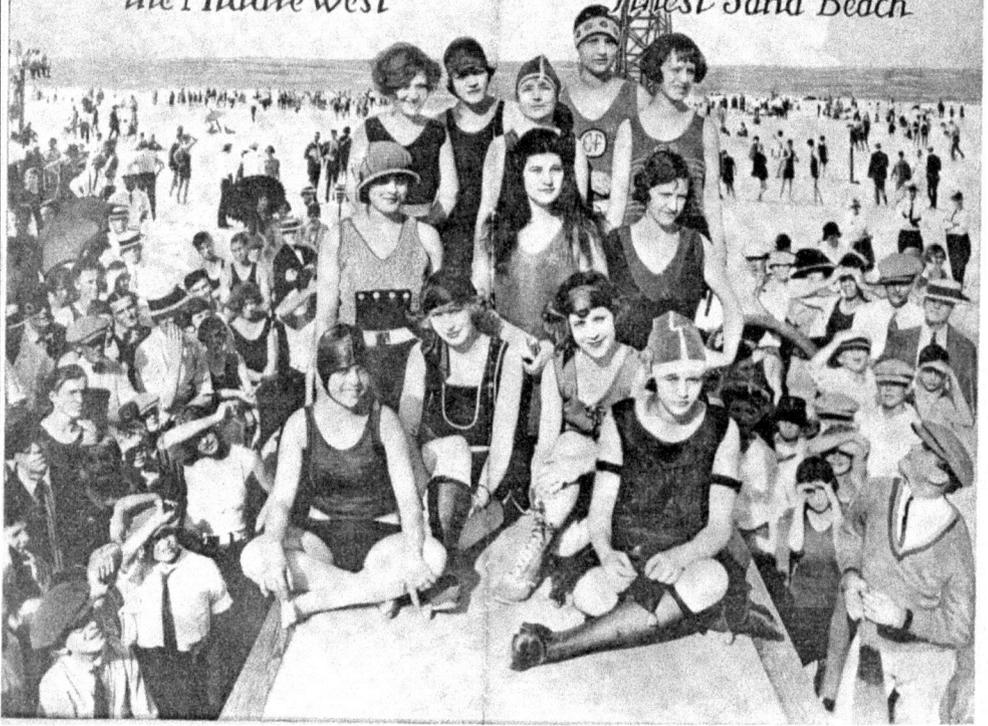

IMAGES
of America

MICHIGAN CITY
BEACH COMMUNITIES

SHERIDAN, LONG BEACH, DUNELAND, MICHIANA SHORES

Barbara Stodola

ARCADIA
PUBLISHING

Copyright © 2003 by Barbara Stodola
ISBN 978-1-5316-1473-7

Published by Arcadia Publishing
Charleston, South Carolina

Library of Congress Catalog Card Number: 2003102287

For all general information contact Arcadia Publishing at:
Telephone 843-853-2070
Fax 843-853-0044
E-mail sales@arcadiapublishing.com
For customer service and orders:
Toll-Free 1-888-313-2665

Visit us on the Internet at www.arcadiapublishing.com

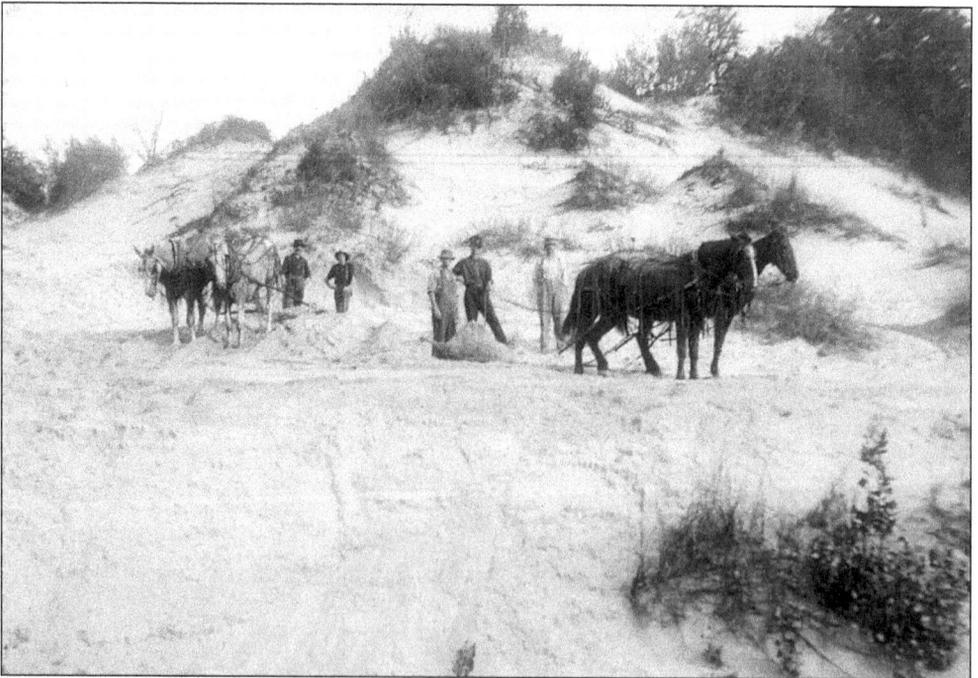

Sand scoops pulled by teams of horses were used in the early 20th century to clear paths through the dunes, and to excavate for building foundations. (MCPL)

CONTENTS

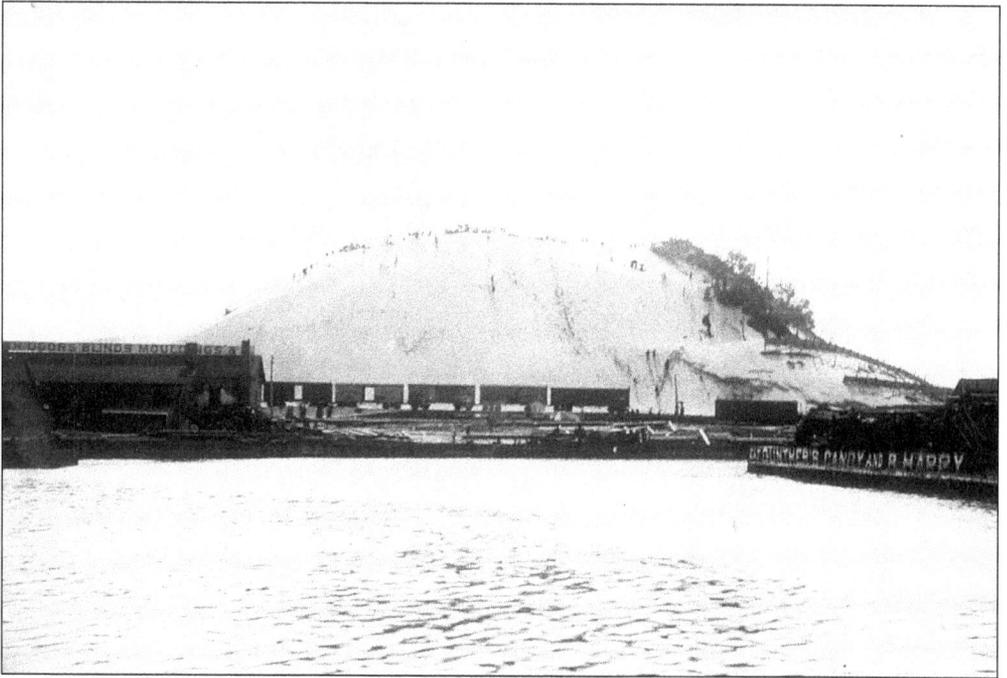

Hoosier Slide was a natural landmark and the scene of many significant events. Standing almost 200 feet tall, it was the largest dune on the Great Lakes. (MCPL)

ACKNOWLEDGMENTS

SPECIAL THANKS ARE DUE to Carter H. Manny Jr., a third-generation resident of Sheridan Beach, whose phenomenal memory and enthusiasm helped me to launch this project; to Michael Brennan, who holds the original documents from Long Beach Country Club, thus helping to keep the record straight; to Phyllis Waters, who bought Long Beach Realty from James Mathias, son of Clarence Mathias; to the Steve Glidden and Hoit Miller families of Duneland Beach, who shared their original photo albums; to Steve Millick, Michiana Shores town clerk and historian.

Many other individuals contributed their expertise and photos and, hoping that I can remember most of them, I wish to thank Thate Land Surveyors, Fred Miller and Sue Mathias Miller, Ted and Kim Reese, Jerry and Carol Solomon, John Vail, Max Barrick, Liv Markle, Peg Landsman, Dani Lane, Marsha Stonerook, June Hapke, John Newcomb, Jim Morrow, Dr. Charles Liddell, Robert and Marge Leiby, Sally Montgomery, Michael Fleming, Tom Montgomery, Patty Stodola, and most of all, Denise Holmes.

Numerous photos have come from public collections, with the assistance of staff members as follows: Jennifer McFerron, reference librarian at the Michigan City Public Library (MCPL); June Jacques, curator at the Old Lighthouse Museum (OLM); and Steve McShane, director of the Indiana University Northwest Archives (IUNA). Susan Vissing, director of the Old School Community Center in Long Beach, furnished copies of *The Billows*, which proved to be an invaluable resource. My own photos are identified as (BKS).

INTRODUCTION

BETWEEN MOUNT BALDY, on the west, and the Indiana-Michigan state line, a unique piece of land extends along Lake Michigan's southern shore for 6.6 miles. The first written description of this territory came from the pen of William H. Keating, the geologist who was sent on an expedition by President James Monroe in 1823. "The scenery changes here most suddenly," he wrote, "instead of the low level and uniformly green prairies, through which we had been travelling... we found ourselves transported, as it were, to the shores of an ocean . . . and a range of sand-hills, in some instances rising perhaps to upwards of one hundred feet."

Thirteen years later Harriet Martineau, a British lady traveling by stagecoach from Detroit to Chicago, stopped at the new settlement of Michigan City and wrote in her journal, "Such a city as this was surely never before seen . . . It is cut out of a forest . . . and the streets were littered with stumps. The situation is beautiful. The undulations of the ground, within and about it, and its being closed in by lake or forest on every side, render it unique." Miss Martineau and her companion, Mr. L___, climbed a sandy hill and beheld "that enormous body of tumultuous waters rolling in apparently upon the helpless forest—and everywhere else so majestic."

The town had grown up at the foot of a natural landmark—Hoosier Slide, largest of the sand dunes on the Great Lakes. Father Marquette was said to have camped at its base. Daniel Webster delivered an oration at the foot of Hoosier Slide on July 4, 1837. President McKinley spoke here on October 17, 1899, from the platform of his train. A 21-gun salute was fired from the top of Hoosier Slide, to celebrate the end of the Spanish-American war.

Hoosier Slide became the center of the social life, recreational life, and the folklore of the growing community. Weddings took place at its summit, none more remarkable than the wedding of Mr. and Mrs. Plasterer, a young farm couple from southern Indiana, whom the minister blessed with the following poem:

> To you who now stand side by side
> On this, the top of Hoosier Slide,
> I have pronounced you man and wife,
> As long as you both shall live this life,
> Now, Mr. and Mrs. Plasterer,
> Shun the ways which lead to disaster,
> And choose the path, which Christ has given,
> The path which leads from earth to Heaven.

The ceremony took place in the 1880s. By 1920, Hoosier Slide and its path to Heaven no longer existed. The rugged beauty of Lake Michigan's shore had been replaced by communities with quite a different character.

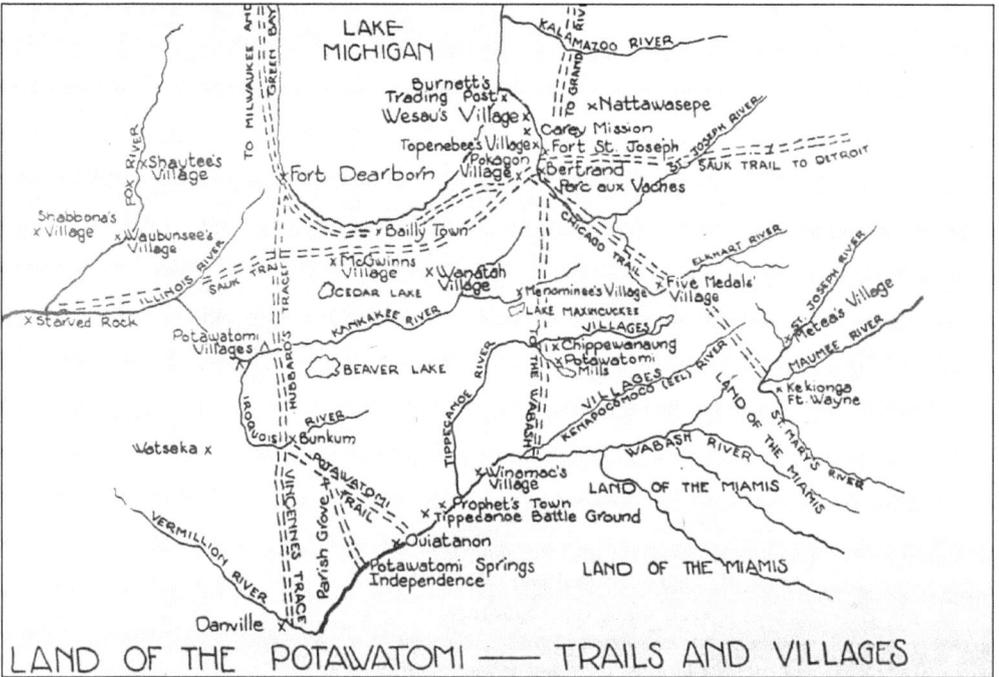

LAND OF THE POTAWATOMI — TRAILS AND VILLAGES

Indian settlements *c.* 1820 are indicated on this map of lower Lake Michigan. Fort Saint Joseph and Fort Wayne had been established in the 18th century. Fort Dearborn, site of the future city of Chicago, was founded in 1803. The only stopping point between forts was the home of fur trader Joseph Bailly, built after the War of 1812. (MCPL)

One

LAND OF THE
POTAWATOMI

DESPITE ITS UNIQUE BEAUTY, the southern shore of Lake Michigan was not conducive to settlement. The earliest Indians in the area were the Hurons (or Wyandots) who were pushed out by the Miami, who in turn were pushed out by the Potawatomi. Although the Potawatomi used the lands for hunting and fishing, there is no evidence that they ever maintained a village near the lake. Their campgrounds were further inland. However, the Indians were very familiar with the sand dunes, and used this rugged territory to hide from their enemies or seclude their families while out on the warpath. In the dunes, they also found medicinal plants and poisons to use on their arrowheads and blowguns.

The Potawatomi were among the Native Americans to whom Fr. Jacques Marquette brought the message of Christianity. His missionary work was taken up by Claude Allouez, who spoke of visiting the Indians "at the sand hills." On his final voyage, Father Marquette and his companion, Joliet, are believed to have camped at the foot of the giant dune later known as Hoosier slide. They then proceeded along the coast to the area of Marquette, Michigan, where Father Marquette died on May 27, 1675.

Even before the missionary expeditions, the French explorer LaSalle had begun his numerous forays into Indiana territory, with the intent of claiming the lands for King Louis XIV of France. LaSalle led the first European expedition to track the Mississippi River to the Gulf of Mexico, and in 1682 he claimed for France all the lands drained by the Mississippi and its tributaries. For the next 80 years, French voyageurs and *coureurs de bois* (wood-men) carried on a thriving fur trade with the Indians, exchanging beads, cloths, knives, and whiskey for the furs that were prized by fashionable Parisians.

The French and Indian Wars (1689–1763) were actually one long struggle between France and Britain for control of America. In 1763, France gave up the Indiana territory to Britain. The Indians, some of whom had fought on either side, were the biggest losers. The lands they had occupied for many generations were wanted for white men's settlements, and little by little the Indians were induced to turn over their lands to the federal government.

The Battle of Tippecanoe (1811) was a major turning point; the Indians, led by Tecumseh, were soundly defeated by the troops of Gen. William Henry Harrison. On October 16, 1826, the Potawatomi ceded land for a 100-foot-wide road from Lake Michigan to the Ohio River. The agreement was signed by 62 Indian chieftains, with their X-marks. In the Tippecanoe Treaty of 1832, the Potawatomi turned over their lands in Michigan and Indiana and began their westward move. Within five years, the migration was nearly completed. On September 4, 1838, the remaining Potawatomi—859 men, women, and children—were forced at bayonet point to march more than 600 miles to the Osage River Valley in Kansas, the reservation selected for them by the U.S. government. No more Indians were left on the southern shores of Lake Michigan.

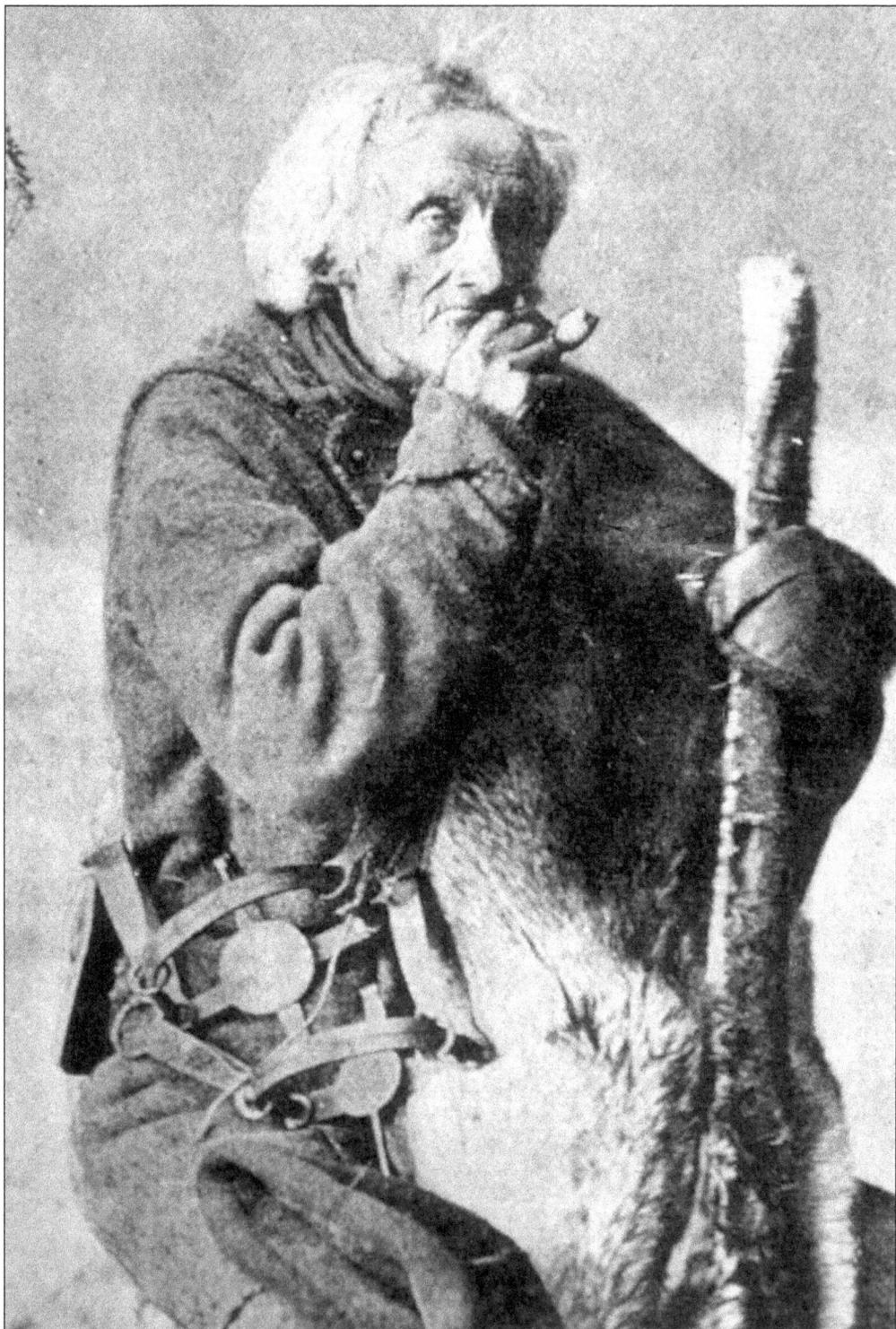

A Fur Trader is pictured in buckskins and furs and with the tools of his trade. Note the bear trap at his side. For 80 years, the French dominated the American fur trade. (MCPL)

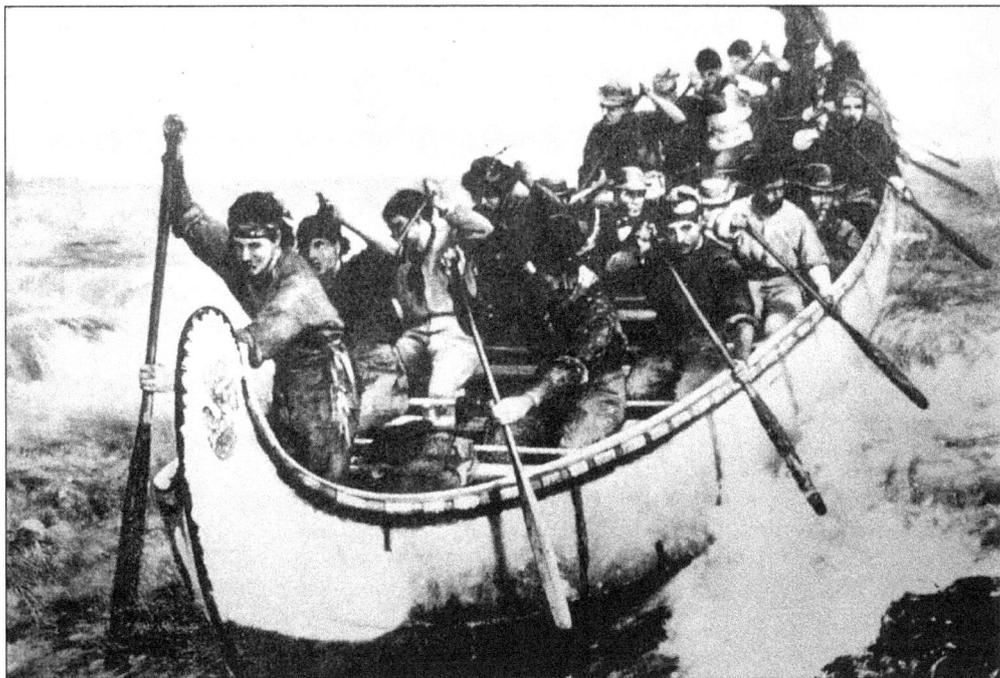

French voyageurs, with Indian guides, plied the Great Lakes in their birch-bark canoes. heading for the best hunting grounds. In 1809, the American Fur Company was founded by John Jacob Astor, and three years later the U.S. Congress prohibited foreigners from dealing in furs. (MCPL)

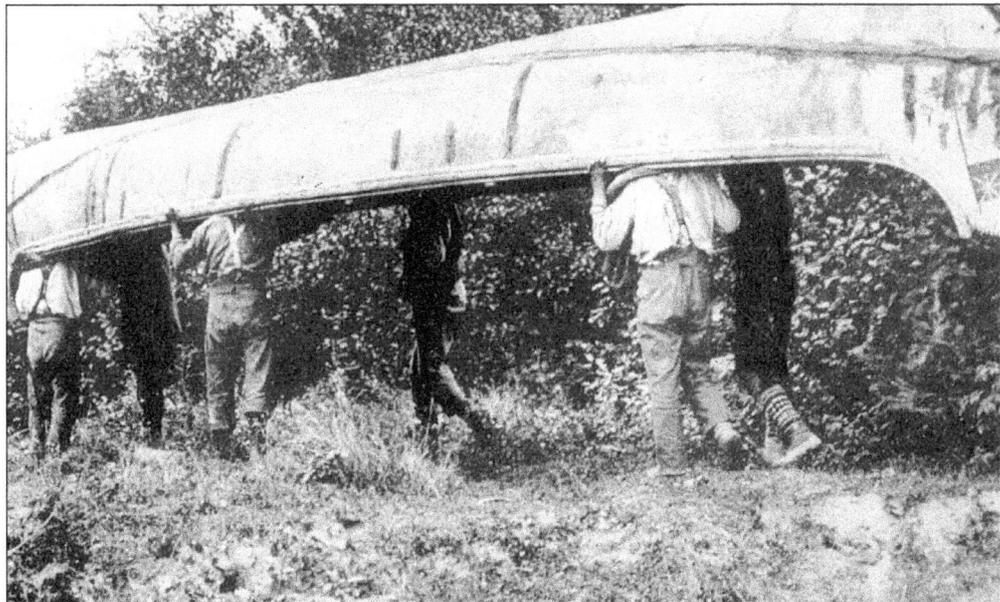

Portaging the canoe was the most difficult part of the journey. Convenience of portage locations was important to establishing major trading centers. Principal portage points in Indiana territory were from Lake Michigan to the Calumet River at Dune Park, and the St. Joseph-Kankakee portage near South Bend. (MCPL)

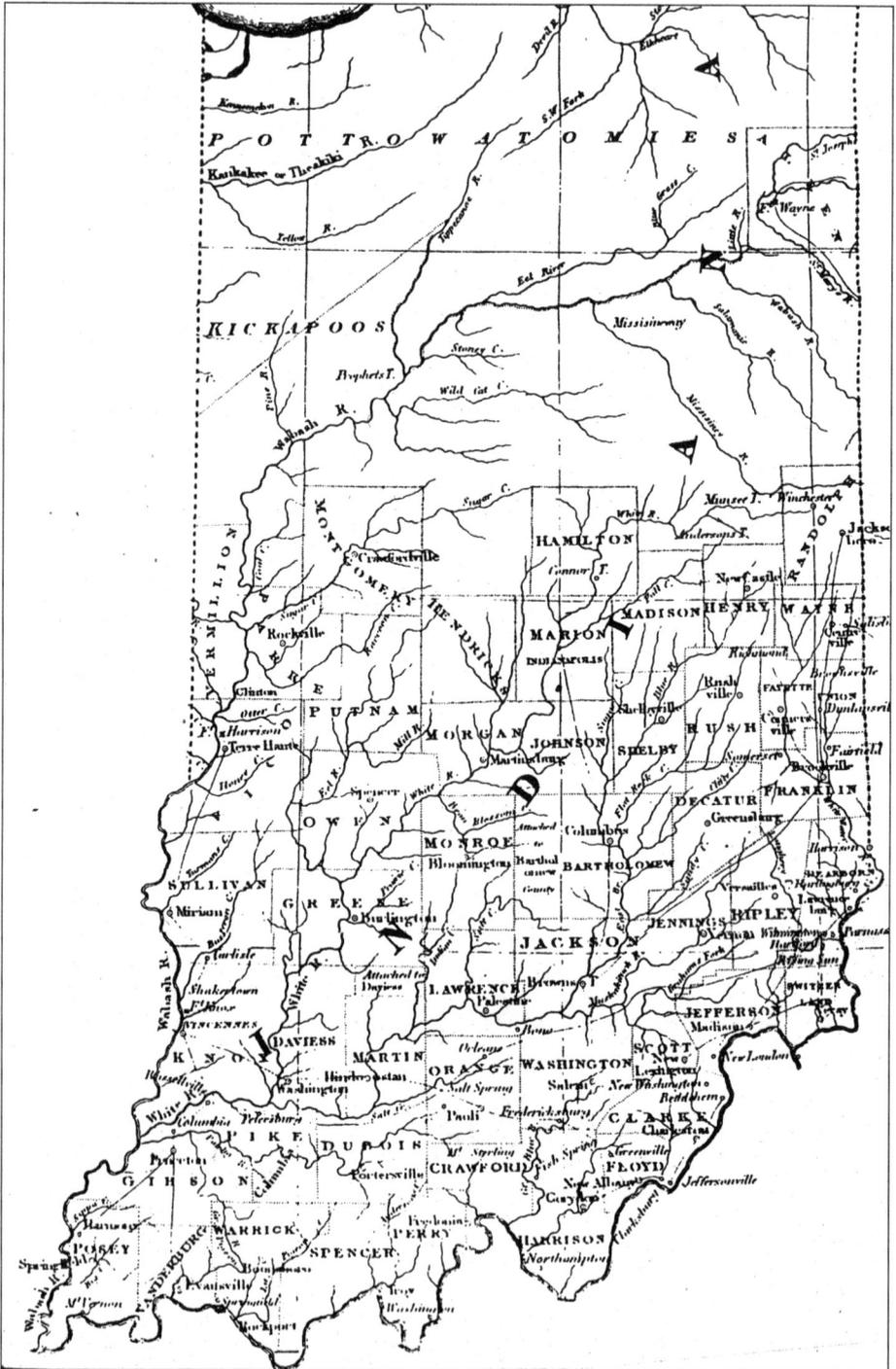

An 1824 map of Indiana shows 51 counties established since Indiana became a state on December 11, 1816. The northern part of the state was occupied by Indians, primarily Potawatomi, who ceded their lands to the federal government in a series of treaties between 1796 and 1832. (Courtesy of Thate Land Surveying.)

Indians dressed in buckskins await the arrival of the early American colonists, who cast an eager eye upon their hunting grounds. (MCPL)

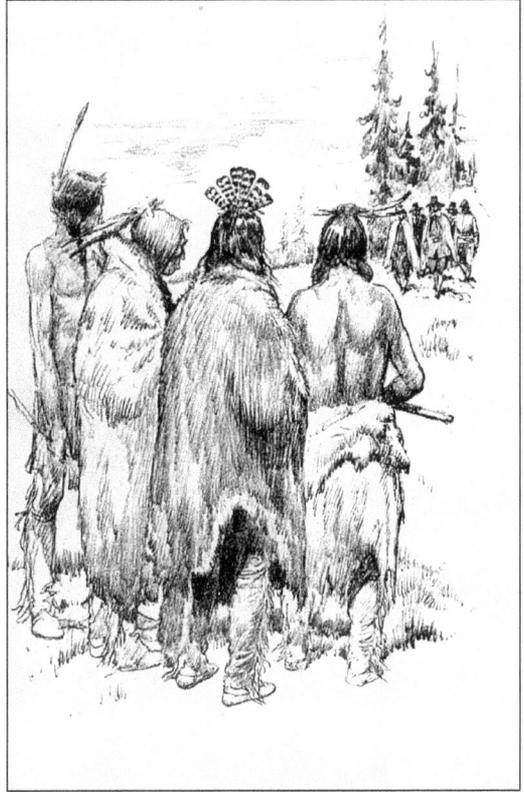

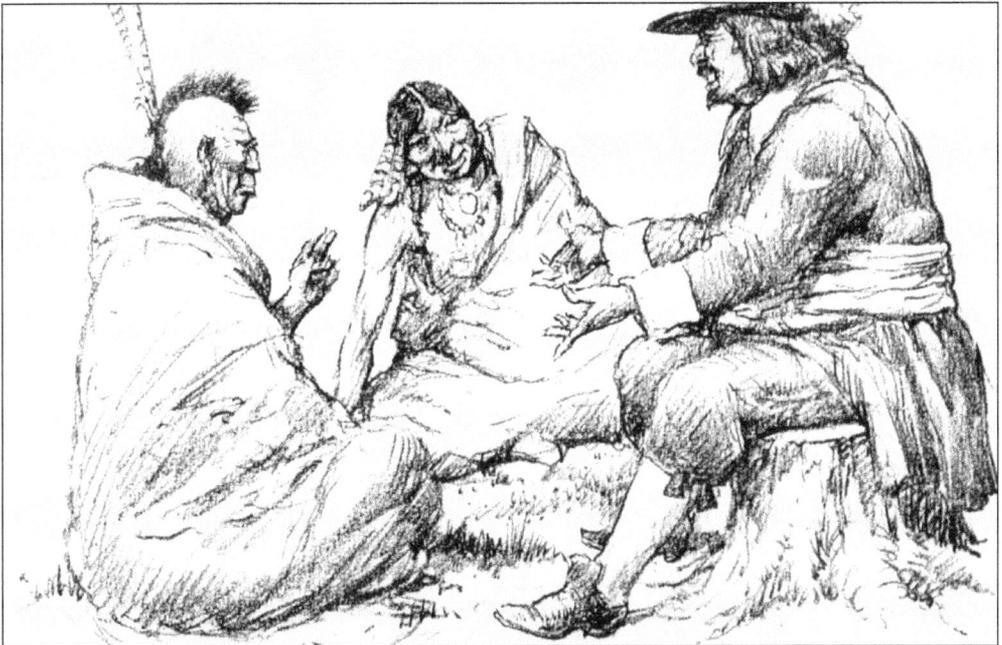

Negotiating for land left the Indians with strings of beads and the European settlers with control of the territory. By the end of 1838, no more Indians were left on the southern shores of Lake Michigan. (MCPL)

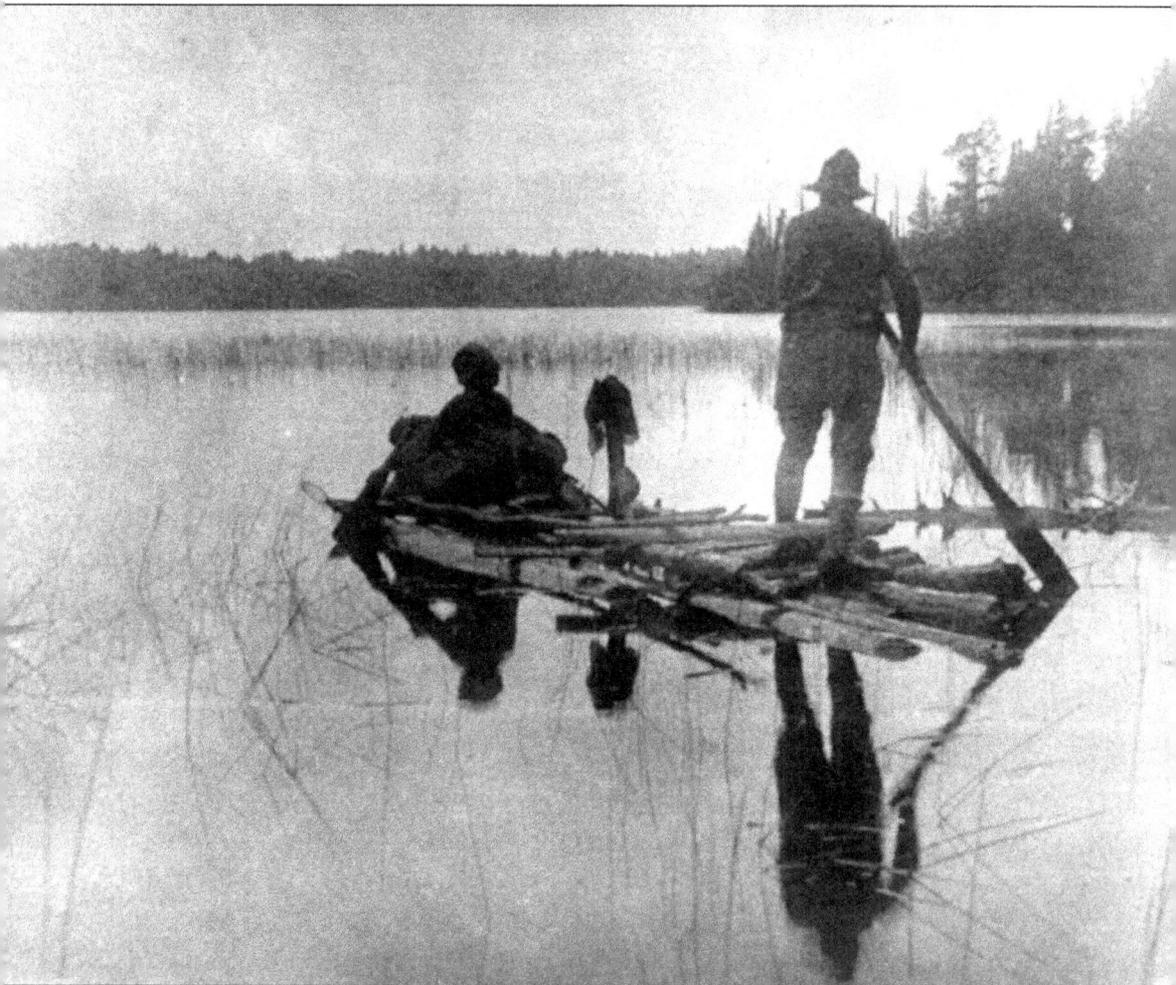

Travelers arriving at Michigan City found it a most unusual settlement, "cut out of the forest and curiously interspersed with little swamps." Transportation ranged from primitive rafts to the occasional stagecoach, headed from Detroit to Fort Dearborn. (IUNA)

Two

EARLY SETTLERS

DREAMS OF A MAJOR HARBOR attracted pioneers to travel west and settle on the land of promise near Lake Michigan. The initiative for harbor development was taken by lawmakers from southern Indiana, who wanted to reach new markets for their farm products. The first step was to build a road. In 1828, surveyors began laying out the Michigan Road, starting where Trail Creek emptied into Lake Michigan, and ending in front of the governor's mansion in Indianapolis.

The Michigan Road followed the ancient Indian trail known as the Yellow River Road—the "yellow rivers" being the St. Joseph, near present-day South Bend, and the Eel River at Logansport. The road was completed in 1832. By this time, the land at the mouth of Trail Creek had been purchased by Isaac C. Elston, a real estate speculator from Crawfordsville, Indiana, who platted his 160-acre parcel into the settlement which, in 1836, was incorporated as Michigan City. Elston bought the land for $1.25 an acre and sold the lots for $20 to $30.

In those first years, hopes ran high. On July 4, 1836, U.S. President Andrew Jackson signed a bill appropriating $20,000 for development of the harbor. For the celebration on the waterfront, a barrel of whiskey was rolled out and a nail driven in the side, with a tin cup hung on it. "Nobody failed to partake of the liquid," according to reports. "It was a general spree in which every last man lent a hand." In 1837, the famed orator Daniel Webster spoke in Michigan City and predicted the success of the community. In thanks, he was given a lot at the corner of Michigan and Spring Streets, which he later sold.

Despite the persistence of Indiana lawmakers, the federal government gave preferential treatment to the rival harbor at Chicago. Progress was also halted by the shifting, blowing sands, which continually blocked the Trail Creek channel. The sand problem also deterred construction of homes near the lake. The land bordering Lake Michigan came to be occupied by the shipping and lumber industries, which enjoyed considerable success.

In 1868, the era of sailing vessels reached its peak, with 2,000 schooners officially registered. Lumber, shingles and stone were brought to Michigan City, and ships left with cargos of hay, potatoes, and huckleberries. Michigan City Salt Co. did a thriving business here, distributing more than 150,000 barrels annually to points in Indiana, Illinois, Kentucky, and Ohio. Fishing also became a major industry; one commercial fishery reported a $40,000 catch in one year.

Throughout the 19th century, the harbor was a busy place. Other lands along the shore remained undeveloped. Only gradually did Michigan City residents begin appreciating the lake for its recreational opportunities.

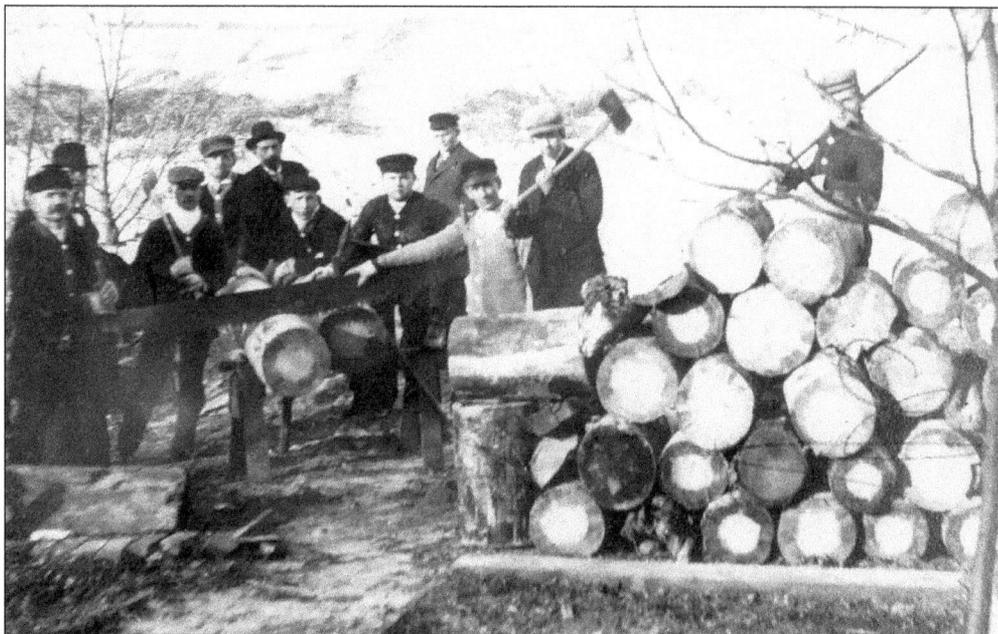

Clearing trees became the first order of business. In the 19th century, great forests of pine trees were leveled, to fill the early settlers' needs for lumber. Michigan City had a major port for shipping lumber, and a sawmill was established in the nearby town of Corymbo (later Michiana Shores). (MCPL)

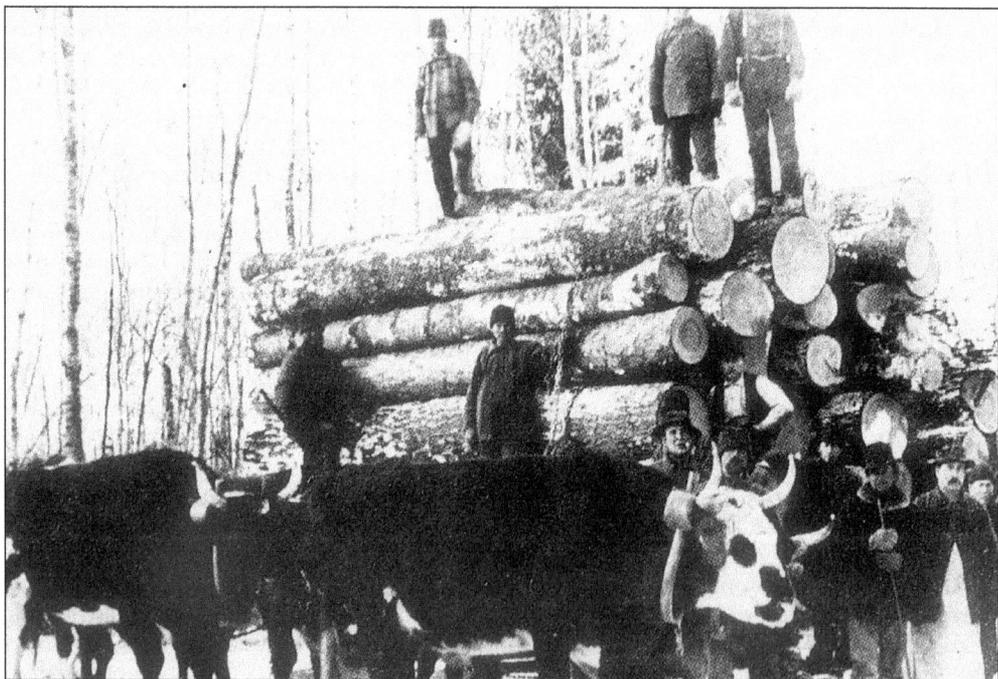

Teams of oxen pulled the carts that hauled lumber and other commodities to the lakefront, where they were shipped to other points across the Midwest. This photo of lumberjacks dates from 1894. (MCPL)

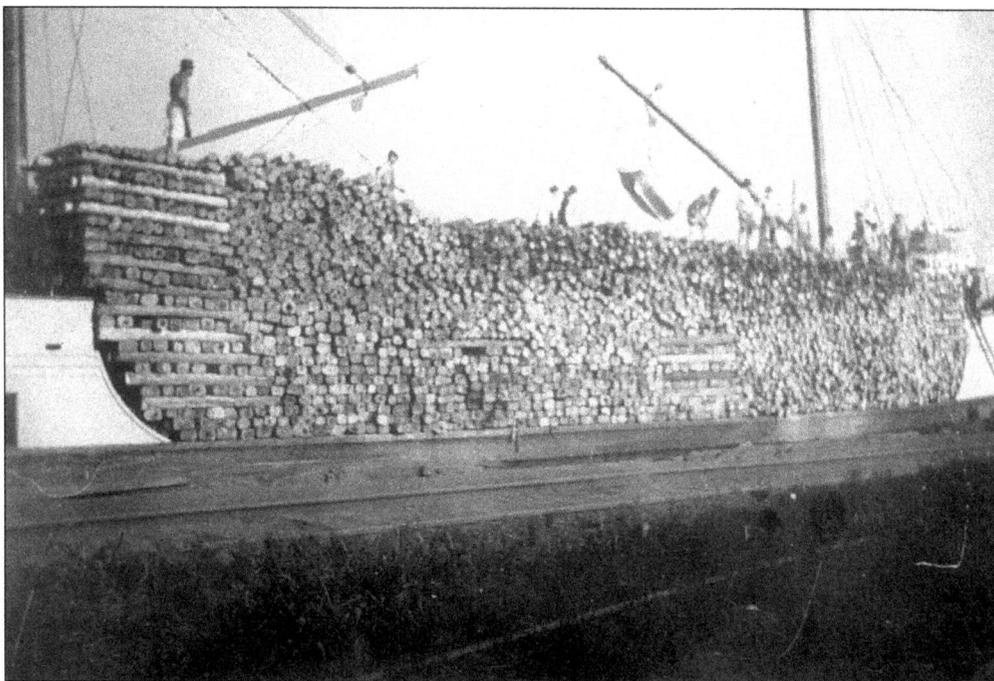

A lumber barge stacked high with cut lumber shows the importance of this industry to the development of Michigan City. (MCPL)

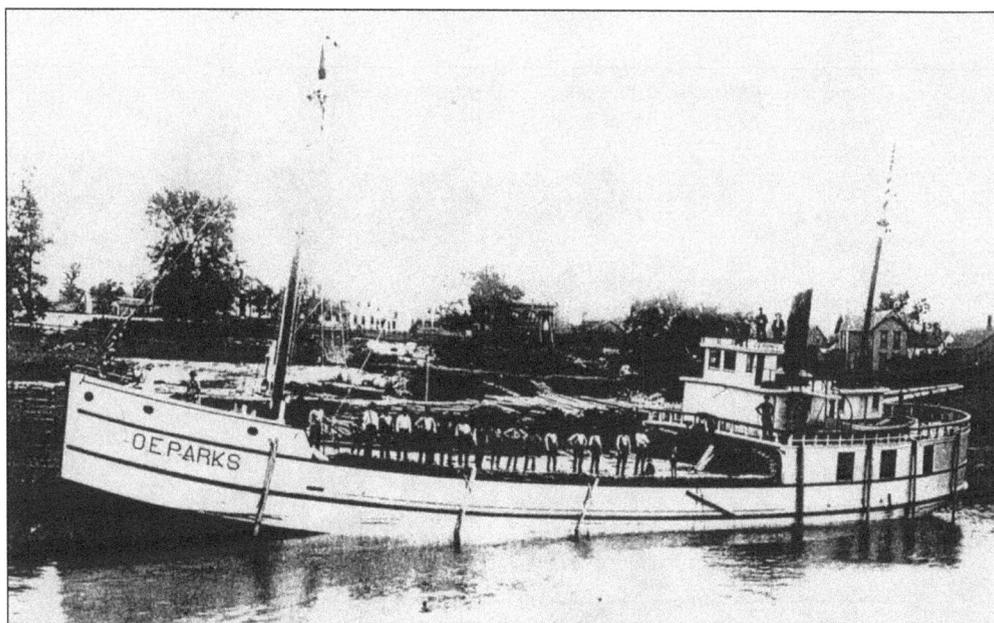

O.E. Parks, a vessel named after its captain, is shown unloading on the west bank of Michigan City harbor, between Sixth and Eighth Streets. After the lumber business shut down, Parks became the first captain of the Michigan City–Chicago excursion steamer, the S.S. *United States*. (Carter Manny Manuscript.)

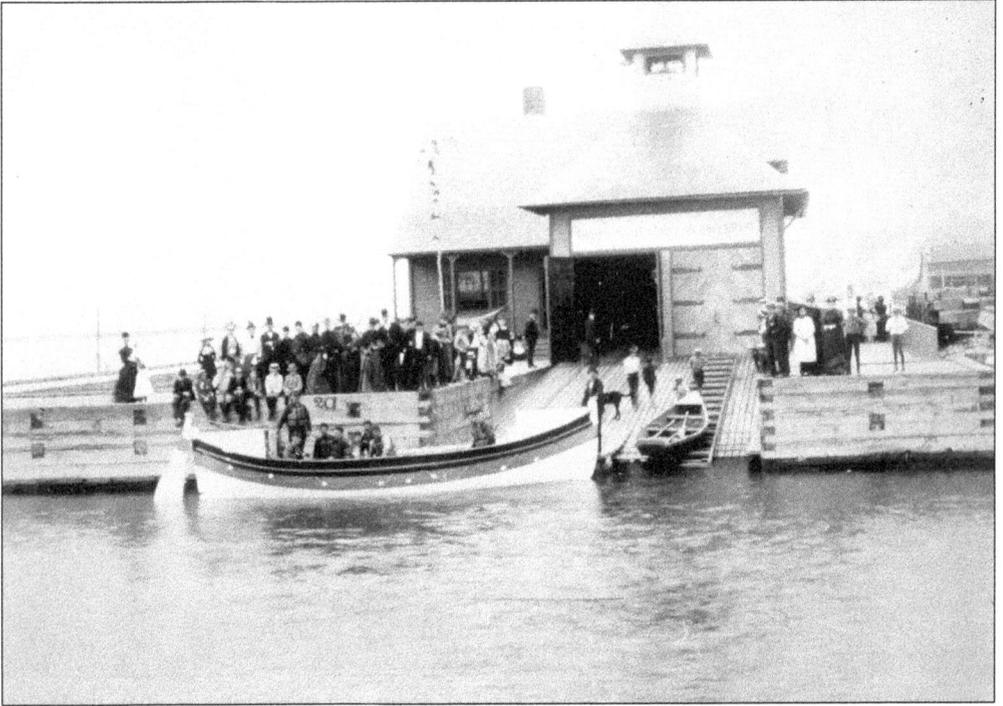

The lifesaving station was opened in Michigan City in 1889, under the command of Henry Finch. Crew members are pictured here in the 36-foot motorized rescue boat. The boathouse contained living quarters and a lookout tower. (MCPL)

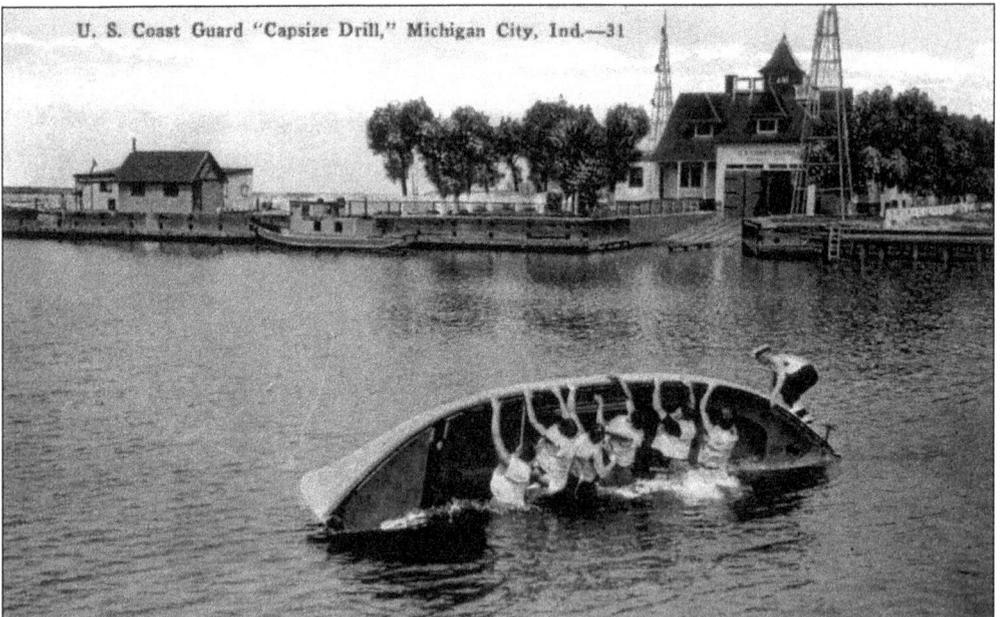

A lifesaving drill is conducted in the chilly waters of Lake Michigan, late in the 19th century. (Courtesy of Marsha Stonerook.)

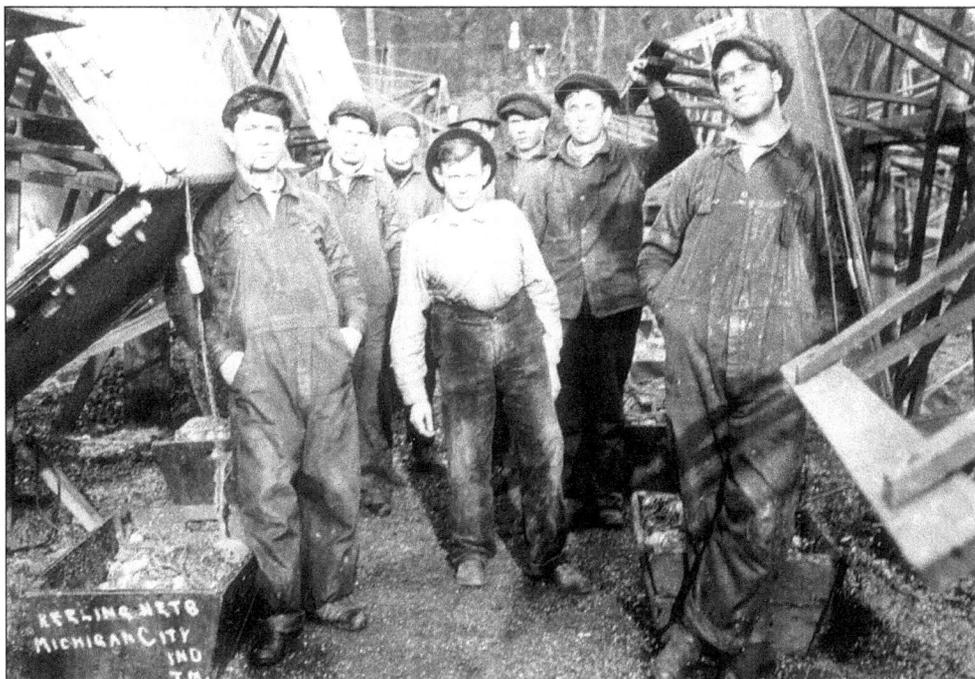

Commercial fishermen are pictured on the Michigan City waterfront with their reeling equipment, and "catch of the day" in wooden container (front left). In the early 20th century, commercial fishing brought in tens of thousands of dollars annually. (MCPL)

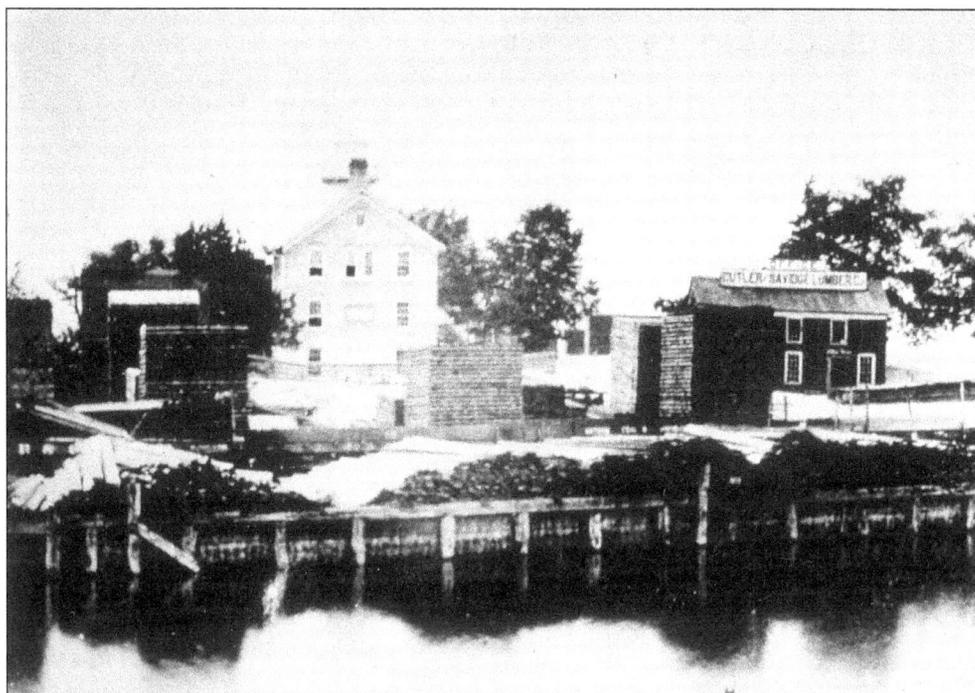

Stacks of lumber surround Michigan City's lighthouse (center) in this photo from the 1880s. The building at right is the office for Cutler/Savidge Lumber Company. (MCPL)

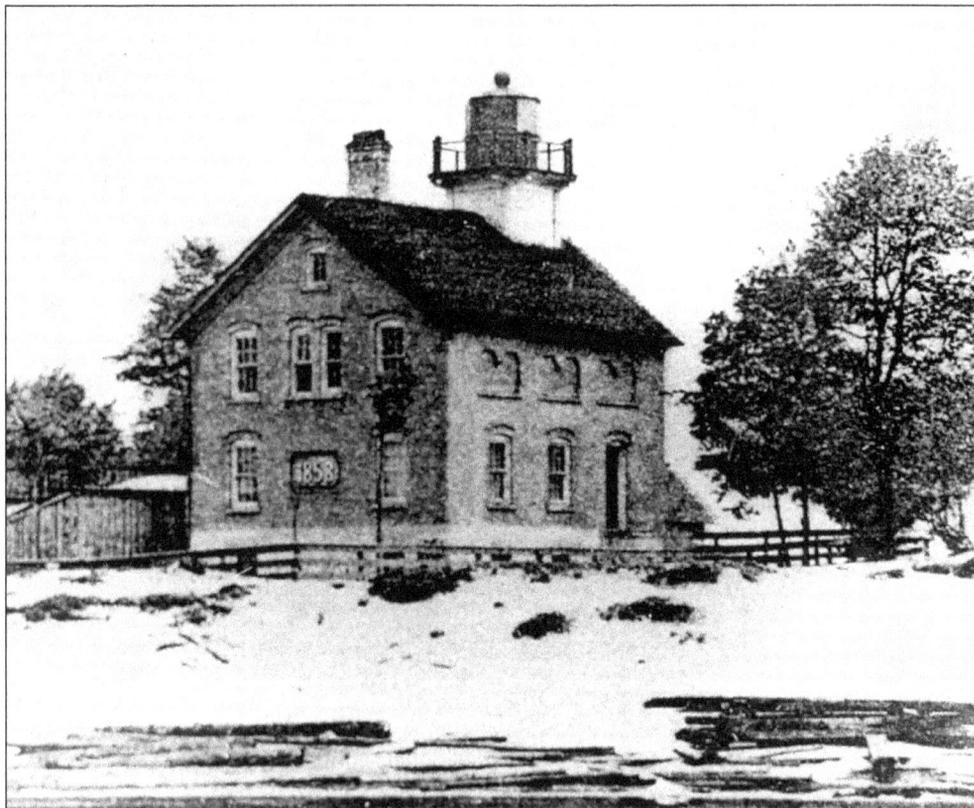

The Old Lighthouse was built in 1858. Its lantern, fueled with sperm oil, could be seen for 15 miles. The use of kerosene began in 1880. The building also served as a residence for the keeper and his family. Today it is a museum, listed on the National Register of Historic Places. (OLM)

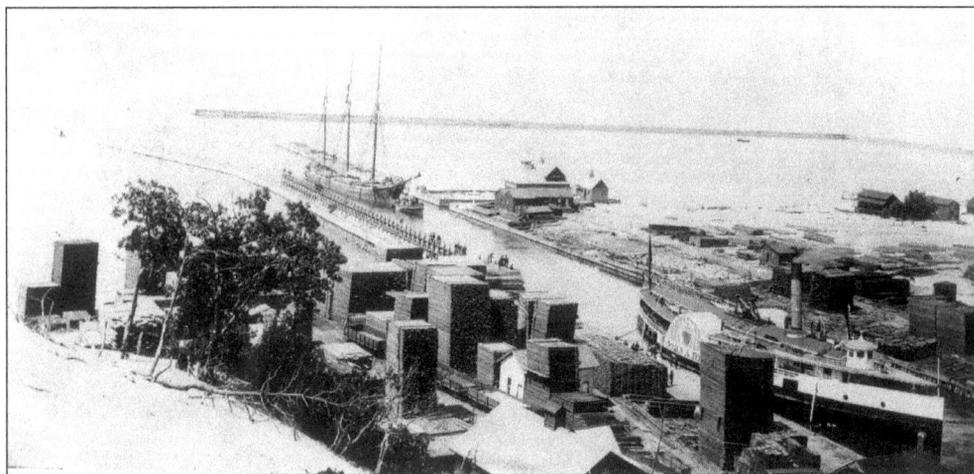

The Michigan City harbor is pictured here in 1892, with the three-mast schooner "Van Valkenburg" and the side-wheeler "John Dix." The Coast Guard station can be seen in the center, and piles of lumber are stacked in the foreground. (MCPL)

The lighthouse keeper's wife, Lottie Martin, spent all her married life in Lake Michigan lighthouses, and she knew how to dress for the winter. Her husband, Tom Martin, was the lighthouse keeper in Michigan City from 1911 to 1934. (OLM)

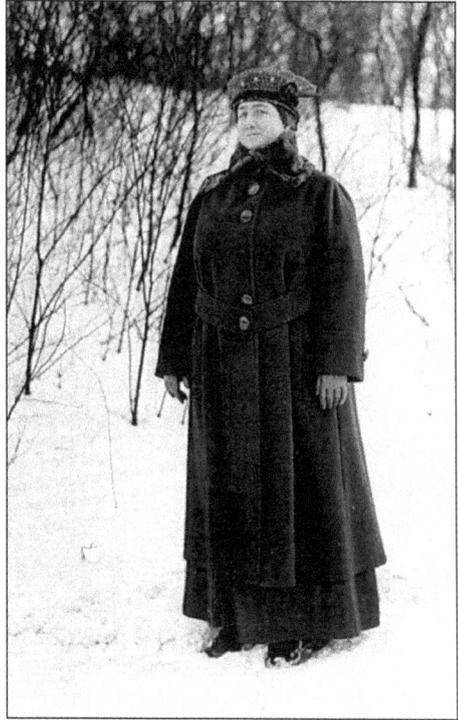

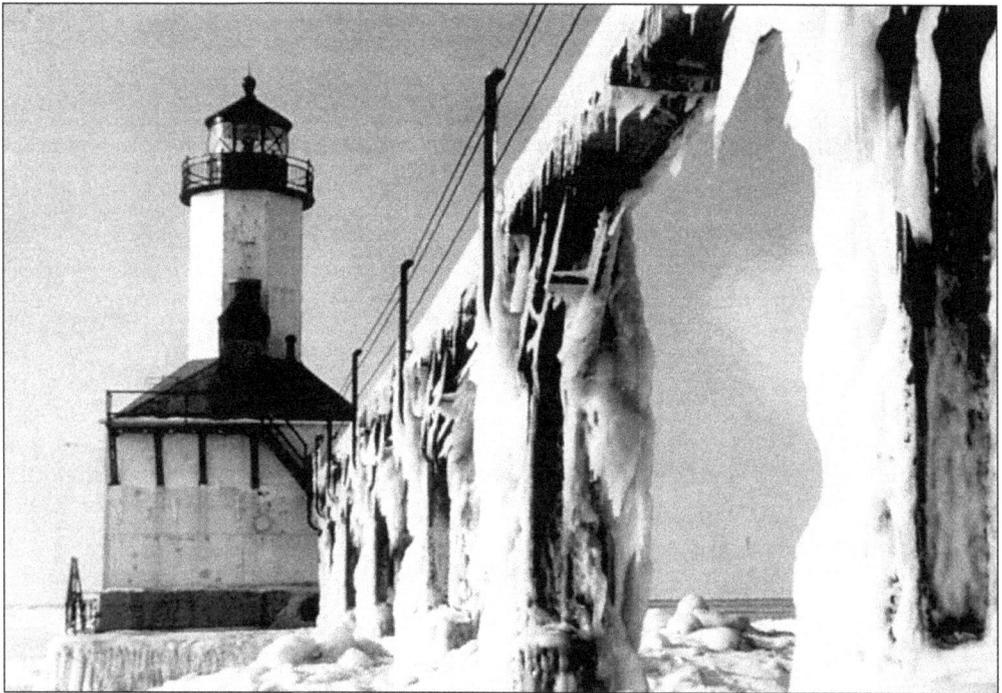

The lighthouse, built in 1904, has become Michigan City's favorite landmark. It is photographed in all seasons—here, with icicles dripping from the elevated walkway known as the "catwalk." For 29 years the catwalk was used by lighthouse keepers to access the light tower. In 1933, the light was electrified, and in 1939 the Coast Guard took over the service. (OLM)

The Hermit's Cottage was occupied by Gus Anderson, a fur trader and first resident of what is now Long Beach. This primitive cabin was observed as early as the 1880s, near the present Stop 17. Anderson survived on fish, huckleberries, wild game, and whatever home-baked treats he could wangle from the youths who discovered his hide-away—one of whom later became Dr. Ed Blinks, who built his home near this site. (Courtesy of *The Beacher*.)

The Wood Plank Streets, which used to float away during heavy storms, were replaced with cedar blocks on the main streets of Michigan City. (Courtesy of Thate Land Surveying.)

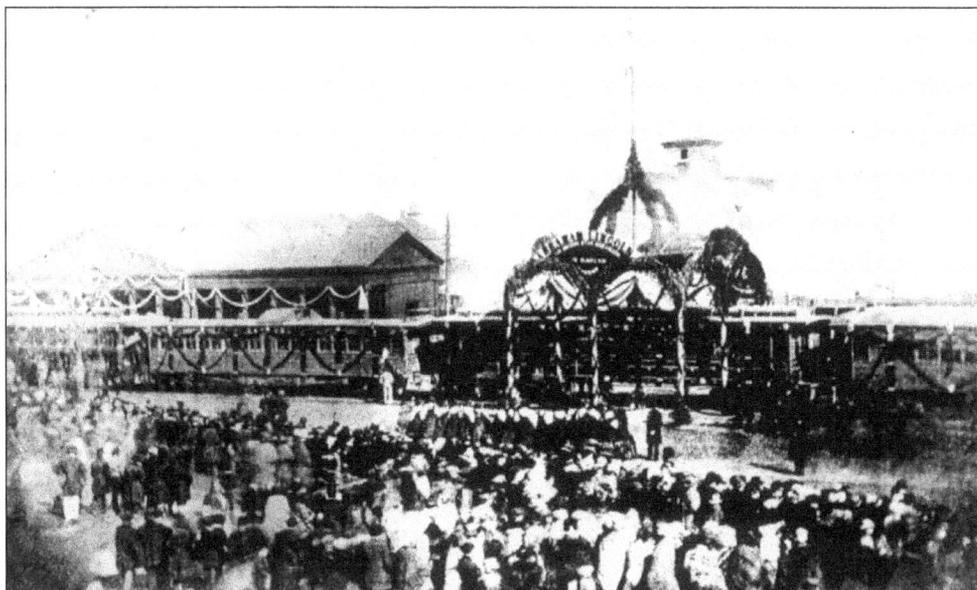

Lincoln funeral train, bearing the body of the beloved president, arrived in Michigan City on May 1, 1865, at 8:25 a.m., and stopped under a 35-foot memorial archway made of evergreen boughs, flowers, and flags. (OLM)

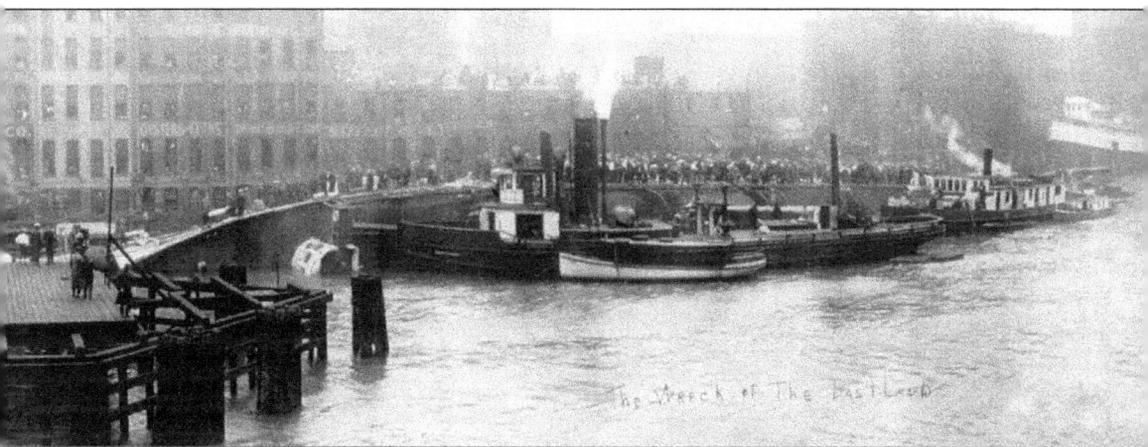

One of the greatest maritime disasters in U.S. history occured on July 24, 1915, when the Michigan City-bound steamship, *The Eastland*, capsized in the Chicago River, killing 844 excursionists. The ship had been chartered by Indiana Transportation Co. for the annual picnic held in Washington Park for employees of Western Electric Co. This photo shows survivors clinging to the hull, and other ships helping in the rescue effort. (Courtesy of Michael Fleming).

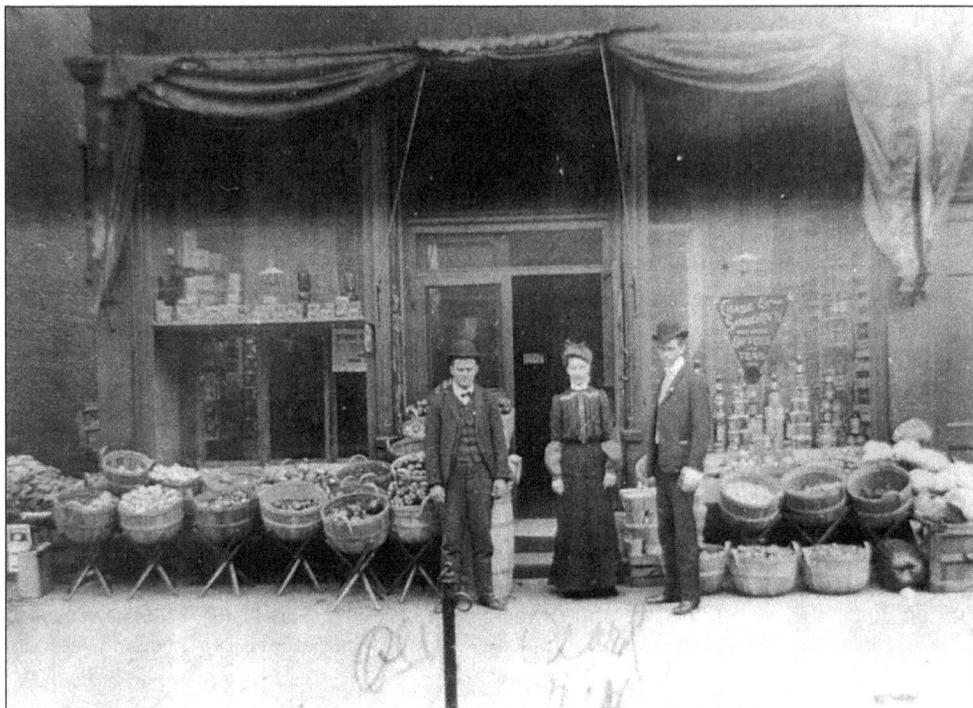

A grocery store at Second and Franklin Streets was one of the Glidden family's business enterprises. Orrin Glidden (left) became one of the major developers of the beach communities. (Courtesy of Jackie Glidden.)

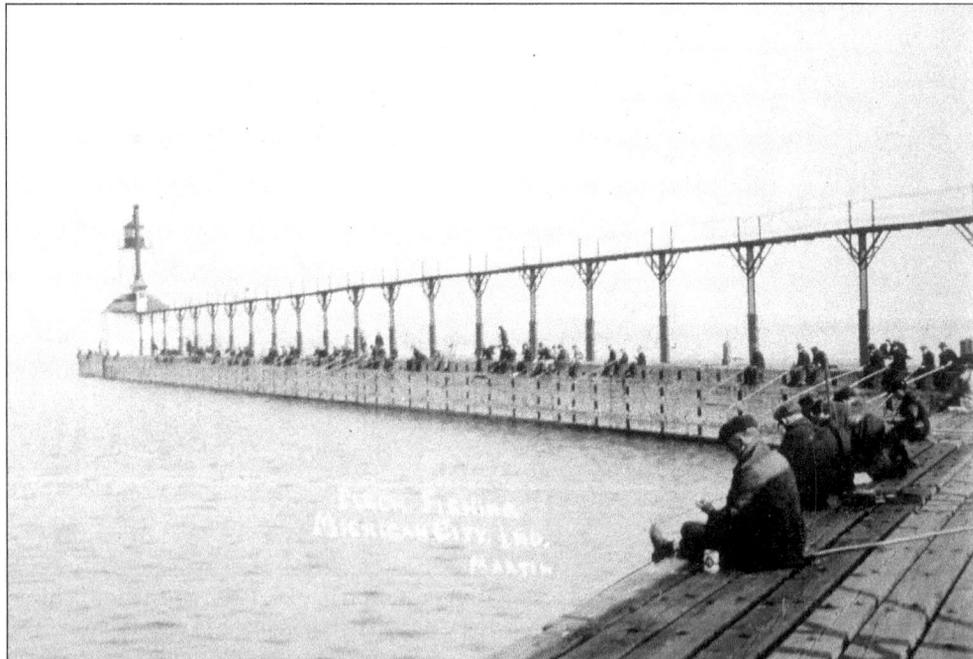

Perch fishing drew big crowds to the Michigan City pier, c. 1915. Notice the catwalk built to service the new lighthouse. (MCPL)

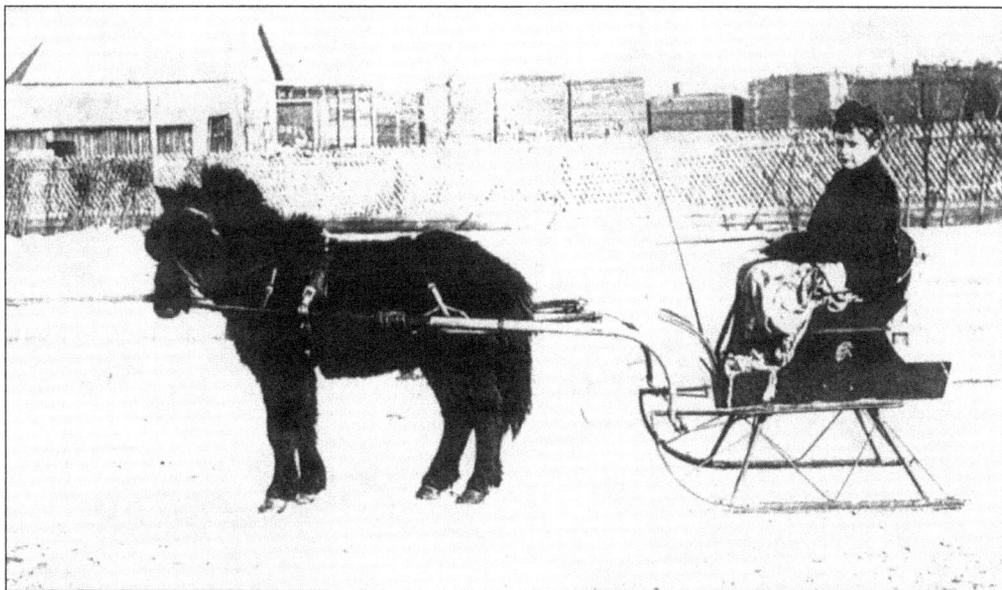

Carter Hugh Manny, who grew up to become a leading citizen, is photographed here in December 1899, with Ted, his black Shetland pony. Ted had been with Gentry's Dog & Pony Show and was brought here from Bloomington, on the train with Carter's mother, who had been convalescing in the South for her consumption. (Carter Manny Manuscript.)

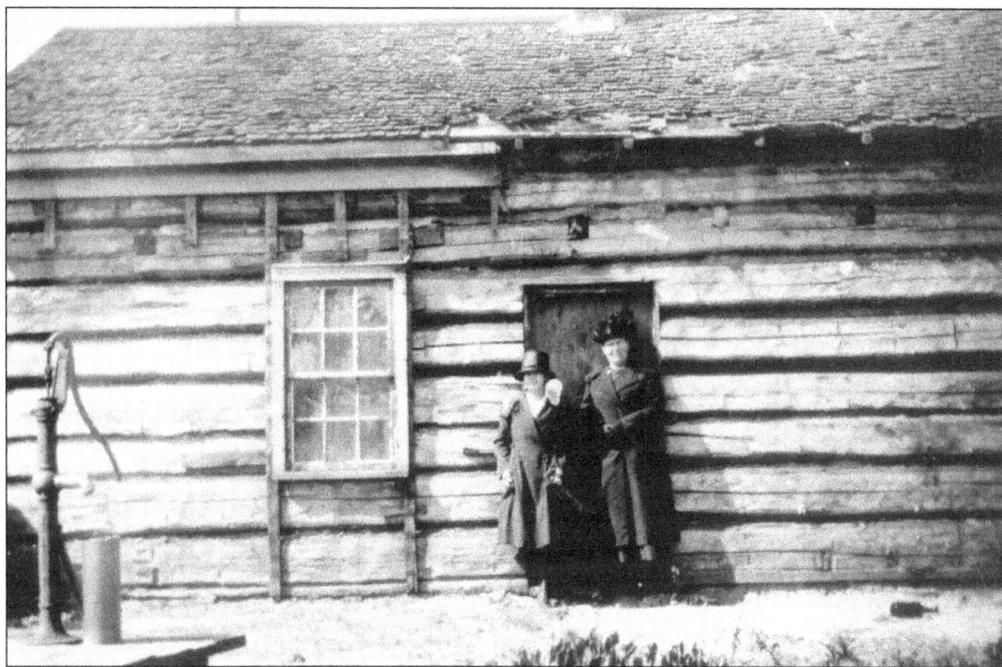

This log cabin was purchased by William B. Manny and moved to its present location on Lake Avenue, Sheridan Beach, in 1921. It is the oldest Michigan City home still in existence, dating from the 1840s. Originally it stood at the corner of Union and B Streets, now part of Blue Chip parking lot. The cabin complex has been altered and enlarged several times, and has been the home of Manny's grandson, Carter H. Manny Jr., since 1946. (Courtesy of Carter H. Manny Jr.)

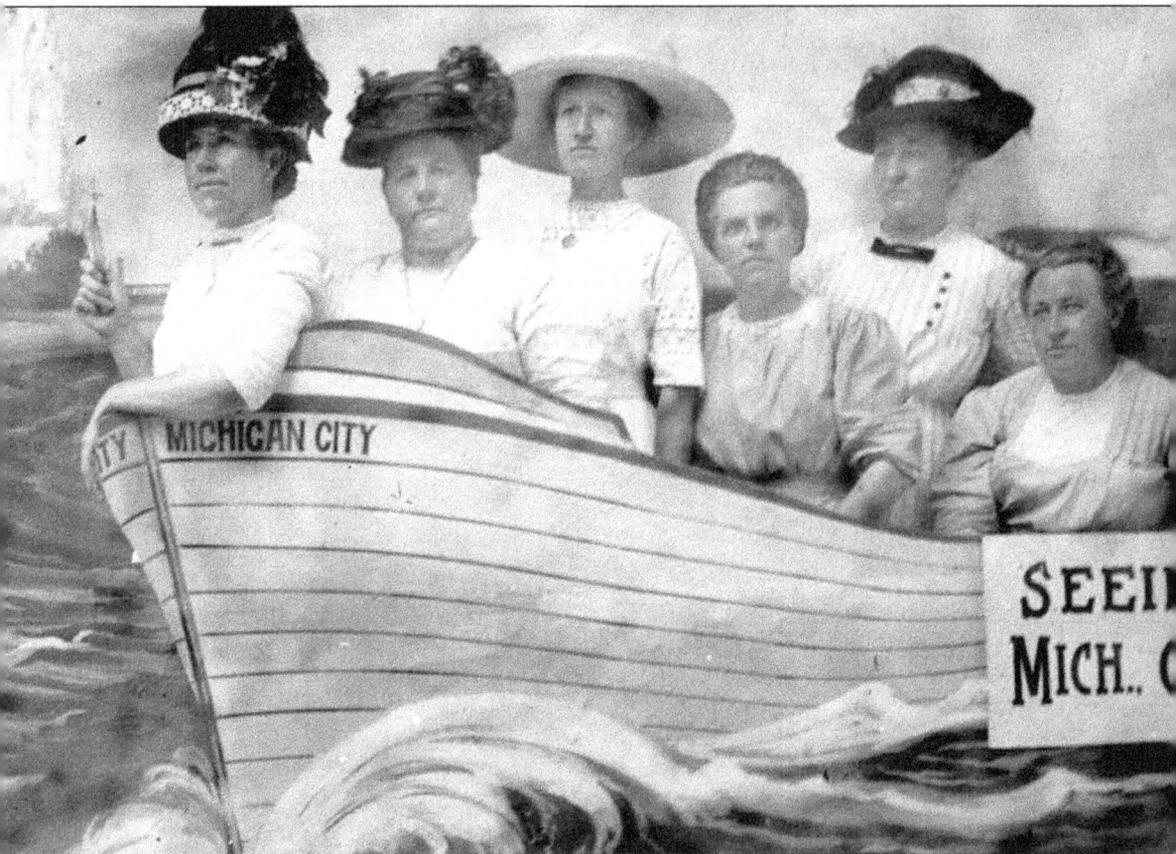

Seeing Mich City became a popular excursion for day trippers from outlying country towns, as well as Chicago. (MCPL)

Three

THE GREAT OUTDOORS

BY THE MID-1890S, Michigan City was a diversified industrial community with a population of 15,000. Workmen had come from all over the world to lay railroad tracks and to work at Haskell-Barker Car Co., founded in 1858. Many other industries had come to take advantage of cheap prison labor, after the Indiana State Prison was built in 1860.

"Michigan City being planted in the midst of sand hills, one might think that its sense of fun and humor had seeped away, as do the rains, and nothing but the dry realities of life were left behind. . . . Not so," insisted Carter Hugh Manny, a popular chronicler of the period.

Company picnics were held, fraternal organizations were formed, and young men took up such pastimes as banjo-playing, cycling, and row boating. "Saturday night was always one of considerable jollification," Manny recalled. Informal groups such as "The Dirty Dozen" got together for weekends of camping out. In the 1880s, the Ahkasawah Canoe Club was organized and a clubhouse was built.

Gradually, bathing in the chilly waters of Lake Michigan became popular. This activity was spurred on by the example of upper-crust seaside resorts and the pronouncements of medical hydropaths that such bathing had health benefits. Residential development, however, was slow in coming to lakefront property.

In 1893, a group of Michigan City business and political leaders formed the elite "Hermit's Club," with Mayor Martin Krueger as its first president. Ground was broken on Groundhog Day for their clubhouse, "The Hermitage," located on a dunetop just east of town. A road leading to this private enclave was carved out of the sand and named Hermitage Avenue—later changed to Lake Shore Drive, the name it still bears today.

Although Indiana's shipping industry lost out to the railroads and to the larger port in Chicago, Lake Michigan continued to lure visitors, many of them coming to see the sights in Michigan City. Any number of attractions grew up along the lakefront and Franklin Street, the main thoroughfare. The greatest attraction was the giant Hoosier Slide, which was promoted as a recreational challenge and an ideal spot for wedding ceremonies. Local businessmen offered prizes to newlyweds. Excursions were also conducted to the prison, where tourists could watch the striped-suited convicts at work.

Federal laws changed the situation at the prison, and commercial interests won out over recreation at Hoosier Slide. Sand-mining companies took out 13 million tons of sand, and by 1920 Hoosier Slide was gone. The land was later bought by NIPSCO for a power generating plant, which is still there today.

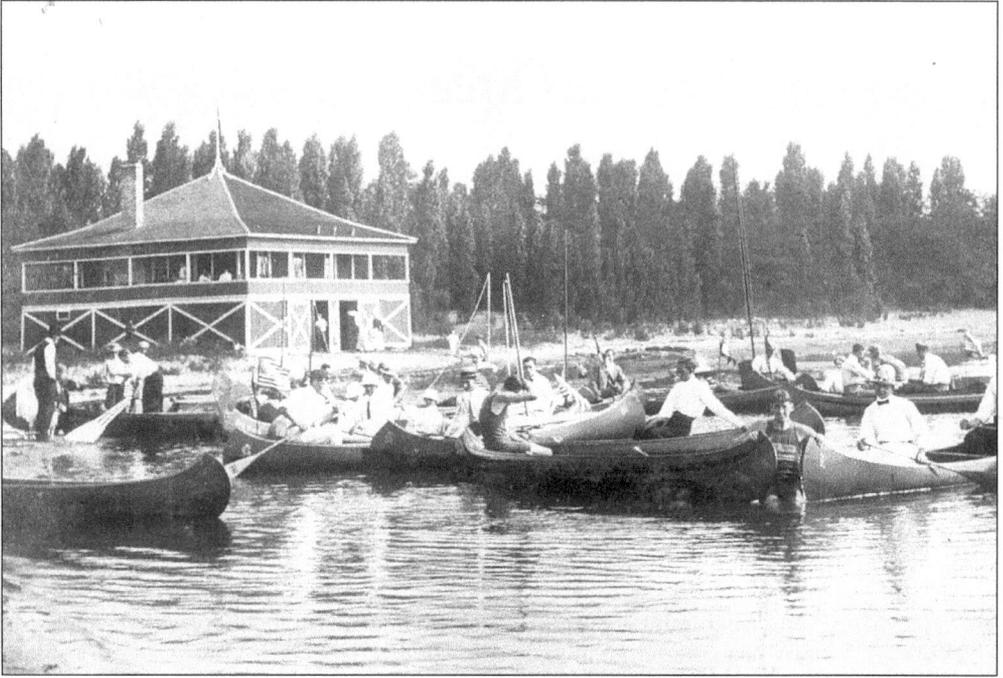

The Ahkasakewah Canoe Club was an important social organization from 1882 until the mid-1920s. The lakefront clubhouse was constructed in 1910 and torn down in 1928. (MCPL)

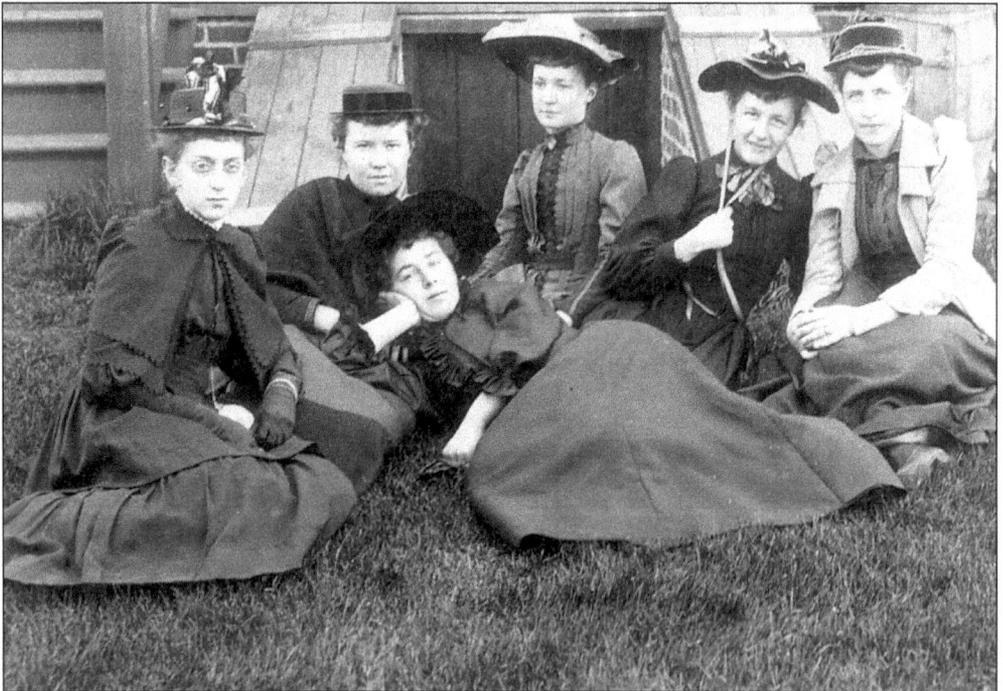

Five ladies on an outing are dressed in their Sunday best, with serge suits and elaborate hats. (MCPL)

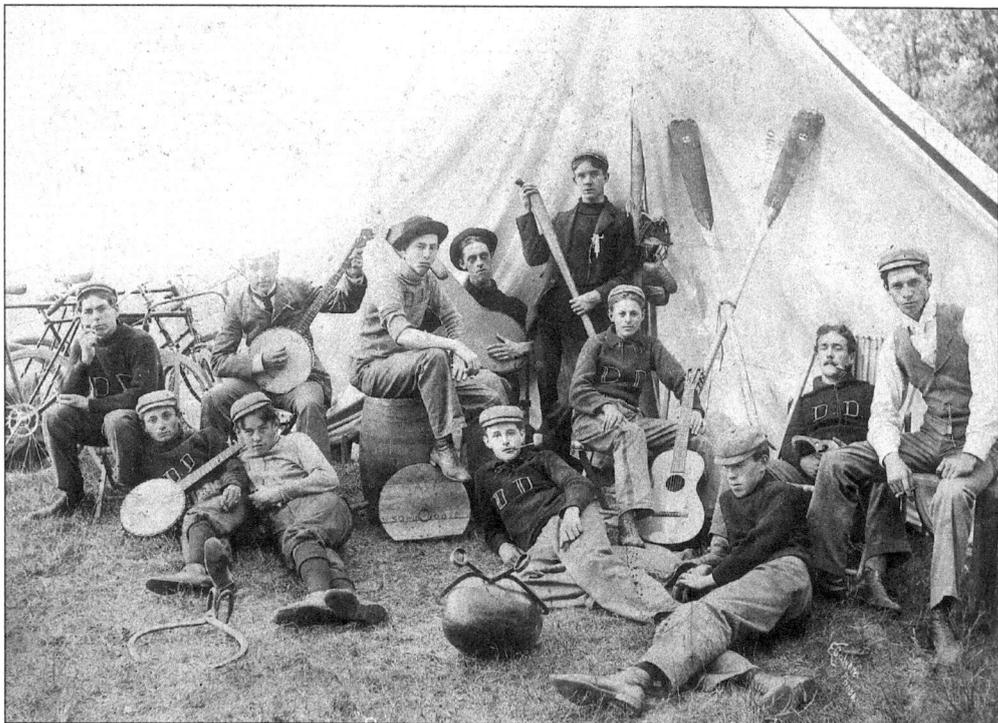

The Dirty Dozen was a social group comprised of young men "from some of the best families" in Michigan City. Pictured, from left to right, are: Walter Beahan, Fred Bartholomew, Samuel Beahan, Truesdell Vail, Roy Hamrick (with oar), James Orr, Harvey Rogers, William Hutchinson (with banjo), Willard McPherson, Arthur Howe, and Frank Bartholomew. (Courtesy of John Vail.)

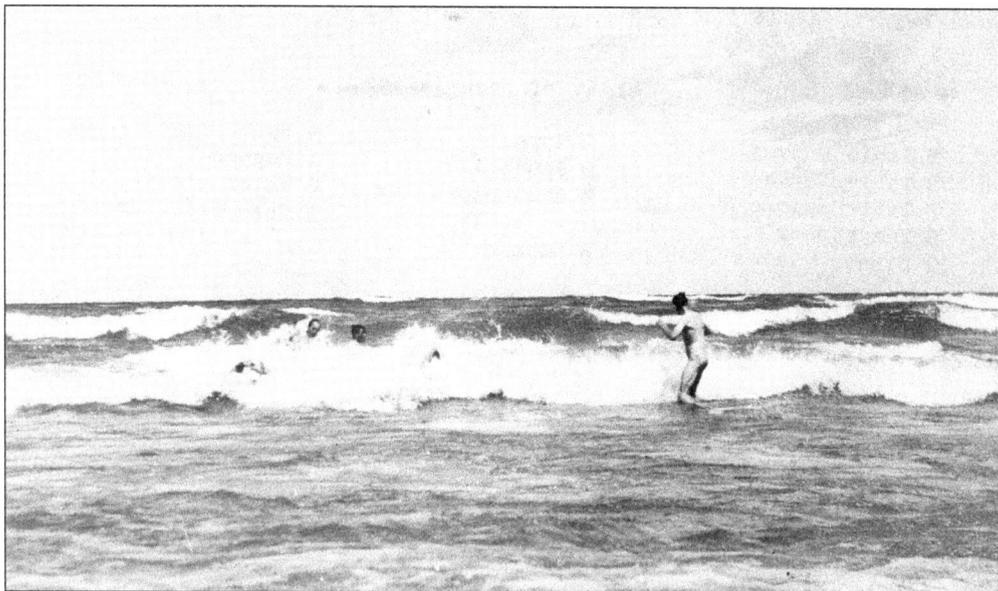

Skinny-dipping was allowed (for men only) when it was possible to keep the women at a distance. This activity reportedly took place on the west side of Mount Baldy. (IUNA)

GANG HEADQUARTERS.
General Order No.1.

August 30th, 1892.

N P Rogers

You are commanded to appear in proper apparel at the "old spot" in Blair Park on Labor Day, September 5th, 1892, at 9 o'clock A.M. prompt to assist in preparing food, arranging tables and performing such other menial duties as may be imposed upon you by Prof. Porter, Chief Soup Mixer.

Carriages for the ladies will be in attendance at residences at 10 o'clock A.M., or as soon thereafter as possible.

Below find a list of cooking utensils and material which you are required to have on hand in order to arrange all things in perfect "apple pie order". Fail not at your peril.

List of Necessaries.

2 Table knives	2 Cups	1 Salt
2 Table forks	2 Saucers	1 Pepper
2 Table spoons	2 Soup plates or	2 Water glasses
2 Tea spoons	bowls	1 Cold fried Spring
2 Dinner plates	2 Napkins	of '92 chicken

Gang Headquarters sent out notices of members' responsibilities for upcoming cookouts. Carriages were to be sent for the women. (Courtesy of John Vail.)

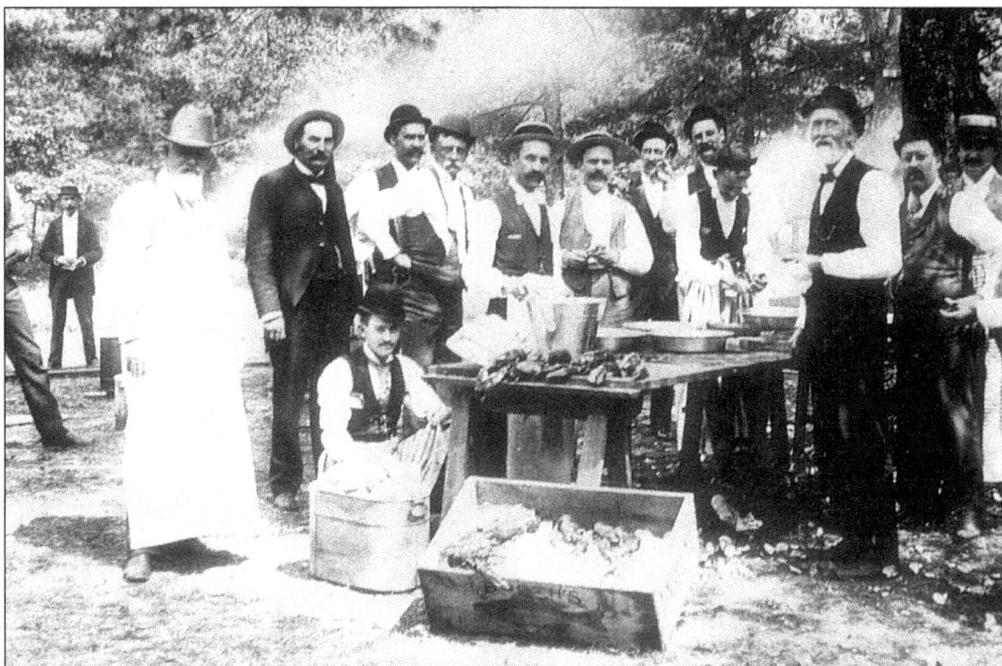

The men cooked at these events, the menu varying from clambakes to lobster boils to chicken roasted over an open fire. Standing at far left is Uriah Culbert; kneeling beside the lobster pot is Harry Barnes. (MCPL)

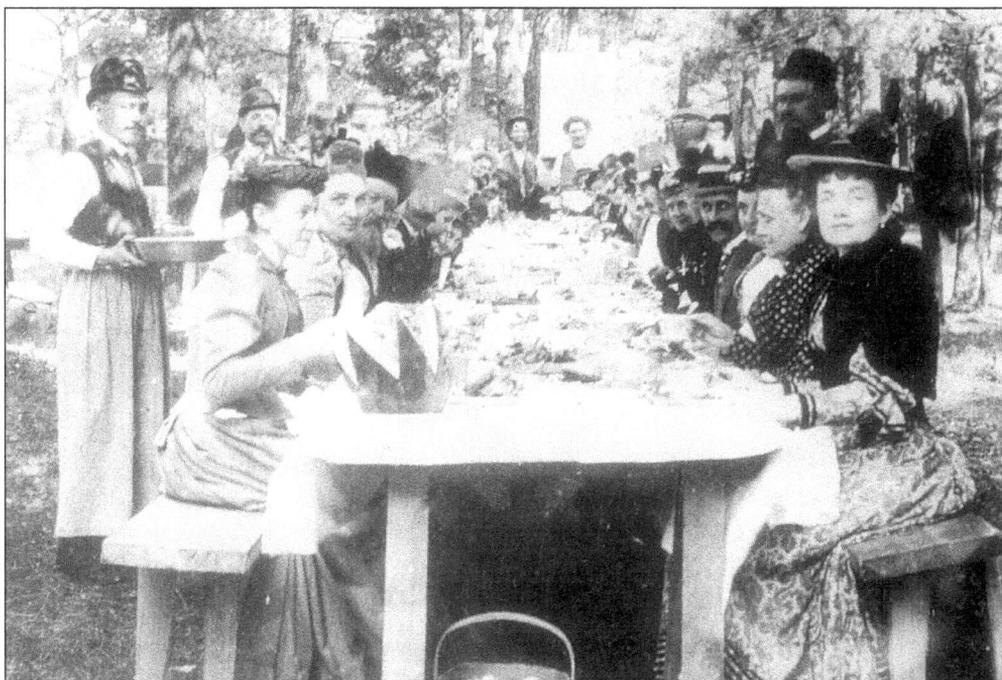

Ladies were served by Harry Mitchell Barnes (left), personal secretary to John H. Barker, and other "gang" members. Seated are Mrs. Barnes (front left) and Mrs. Schoenemann (front right), who ran a millinery shop in Michigan City. (MCPL)

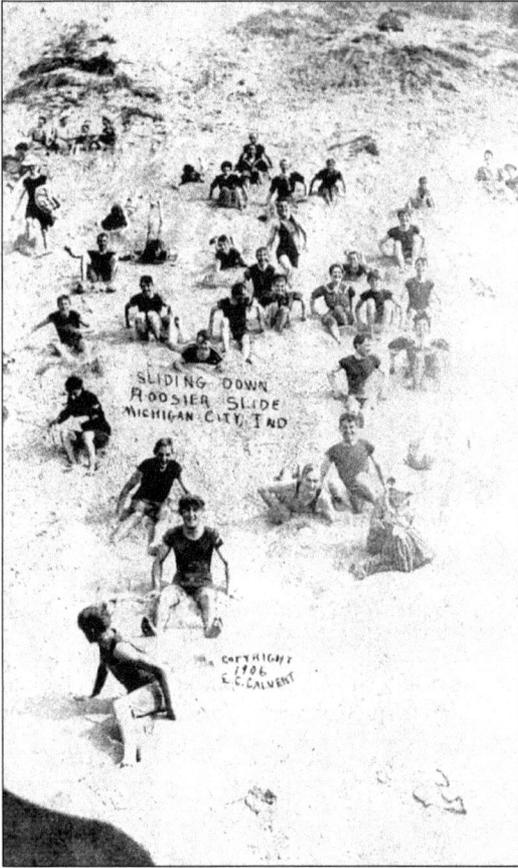

Sliding down Hoosier Slide used to be a popular sporting event. Then Hoosier Slide Land Company was formed and began mining the sand for landfill in Chicago parks and glass-making enterprises in Indiana. Two of the major customers were Ball Brothers of Muncie and Pittsburgh Plate Glass of Kokomo. By 1918 there were five sand companies, one operated by William B. Manny, and by 1920 Hoosier Slide was gone. (OLM)

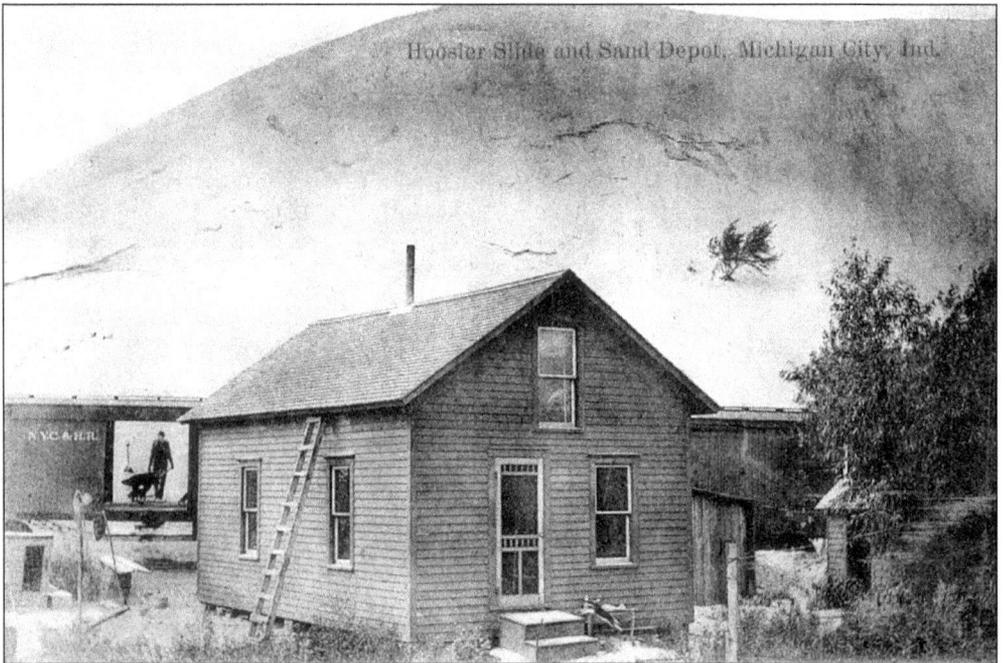

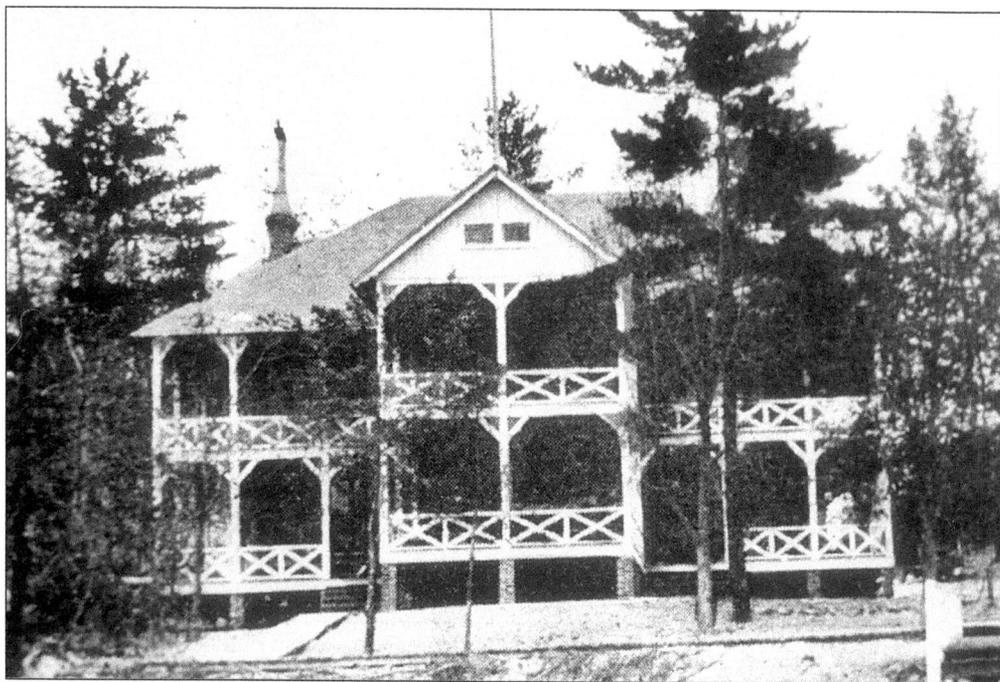

The Hermitage was built out in the "wilderness" of the dunes by members of the exclusive "Hermit's Club." The first president was M.T. Krueger, and Walter Vail was treasurer. The yellow poplar log building was constructed near the present-day Stop 5. The "Hermits" held their first banquet on Groundhog Day, 1894, and their last on Groundhog Day, 1904. In 1919, the building was purchased by Haskell & Barker Social Club, for use by employees of the railroad car manufacturer. The Hermitage later became a rest home, and finally burned in 1978. (MCPL)

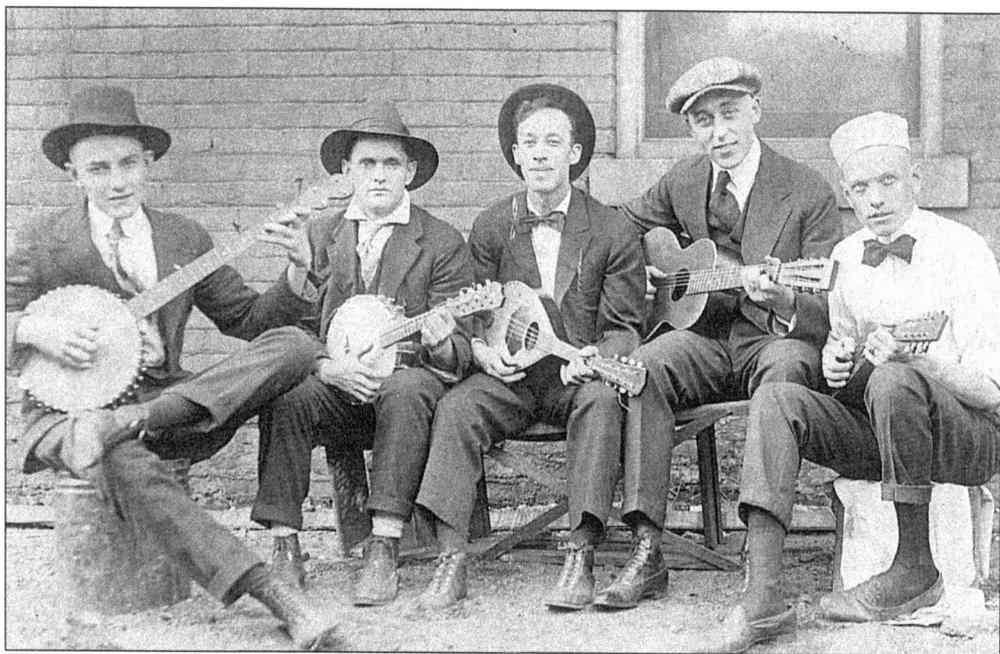

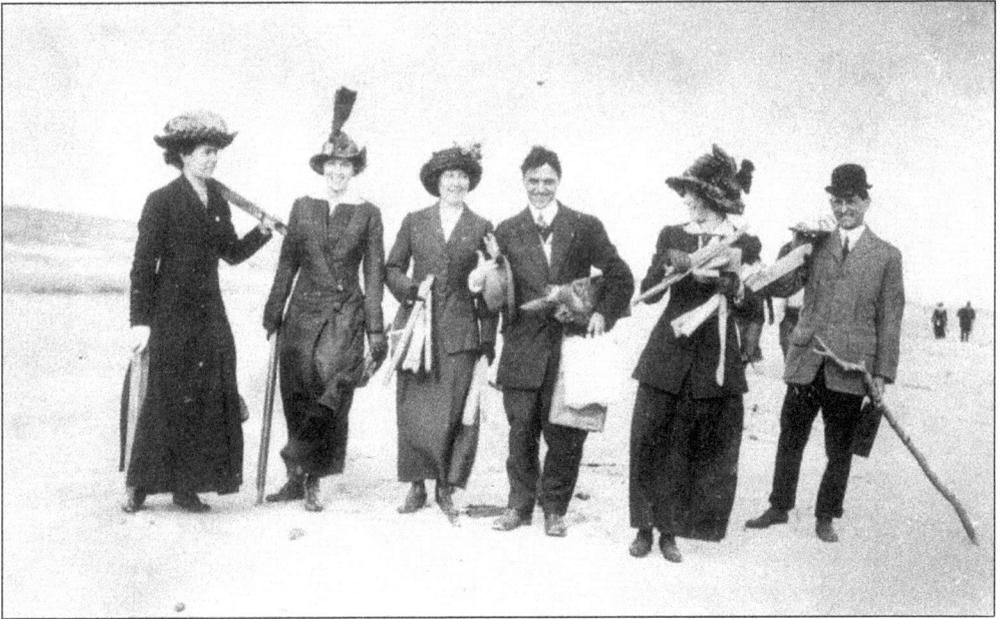

Gathering firewood on the beach, young couples are preparing for an outdoor feast. (IUNA)

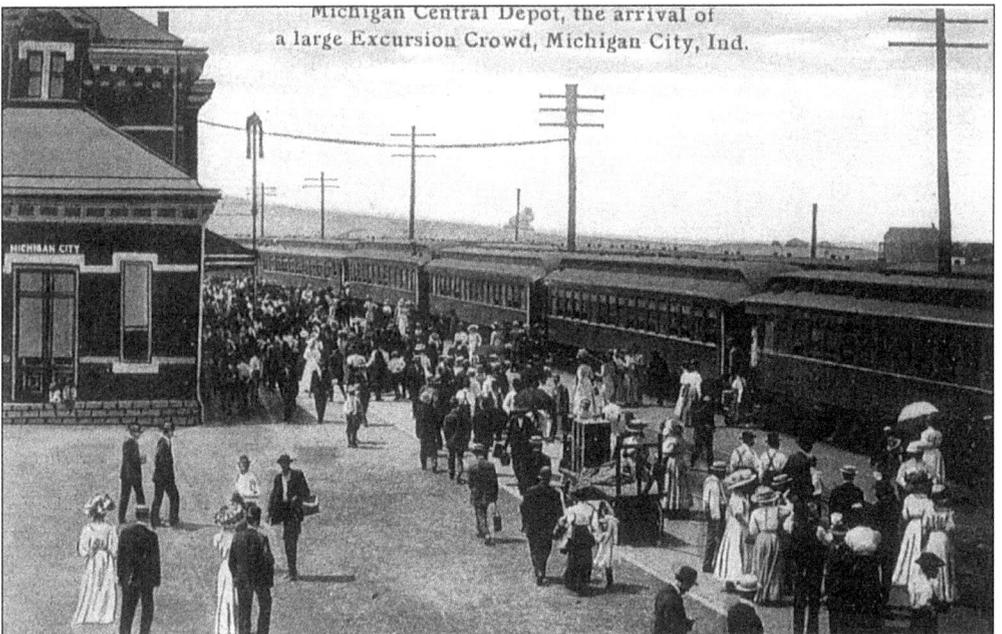

Michigan Central Depot, the arrival of a large Excursion Crowd, Michigan City, Ind.

Michigan Central passengers were dropped off at the depot which, years later, became a restaurant. In 1907, the Michigan Central operated 10 freight trains daily and 12 passenger trains running each way, all of which stopped in Michigan City. Daily passenger trains were also run by the Monon, Lake Erie & Western, and the Pere Marquette. (OLM)

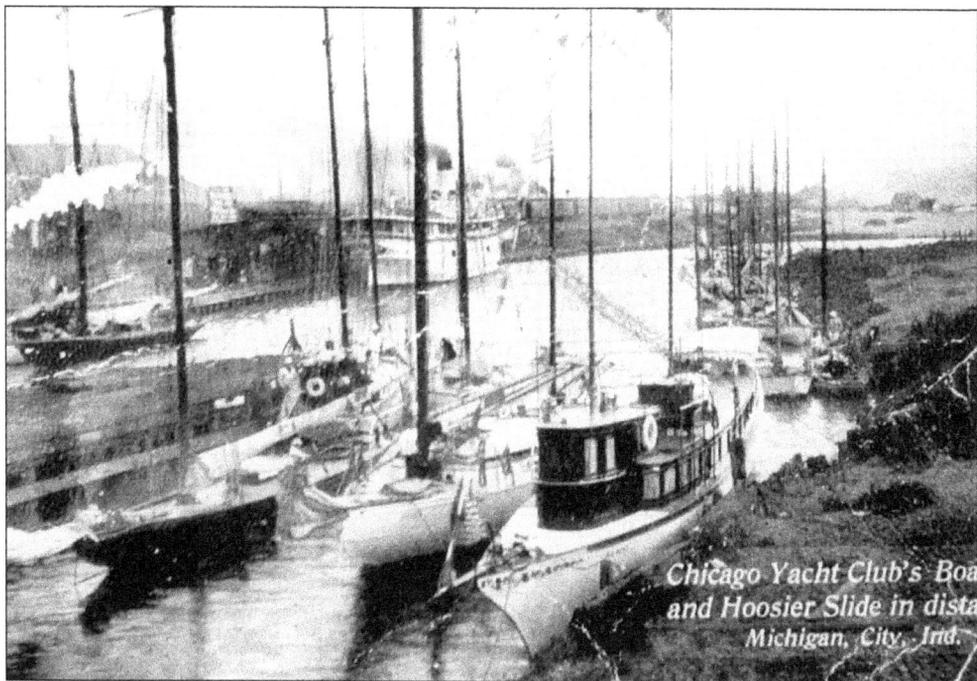

Chicago Yacht Club boats, pictured here in 1909, began coming to Michigan City as early as 1891, when the Columbia race was started. This annual event is the longest-running yacht club race in the United States. (MCPL)

Dunes Highway was completed between Michigan City and Gary in 1922. (OLM)

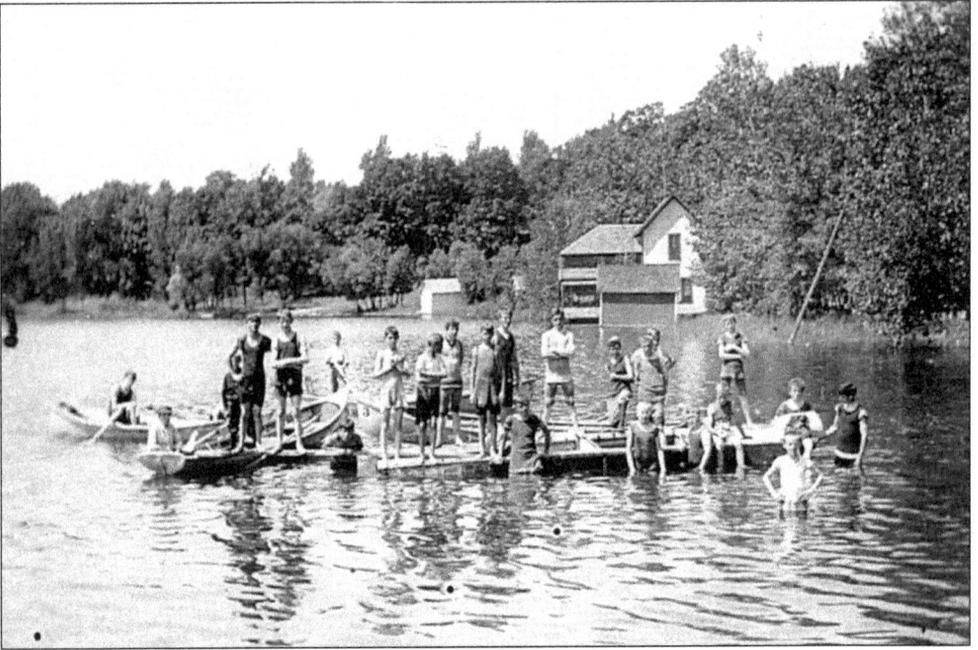

Swimming and diving off rafts, canoeing, and row boating—youth camps provided good old-fashioned fun. Campgrounds had one tent designated for clean-up headquarters. Note the brooms, mops, and clothes hung out to dry. (OLM)

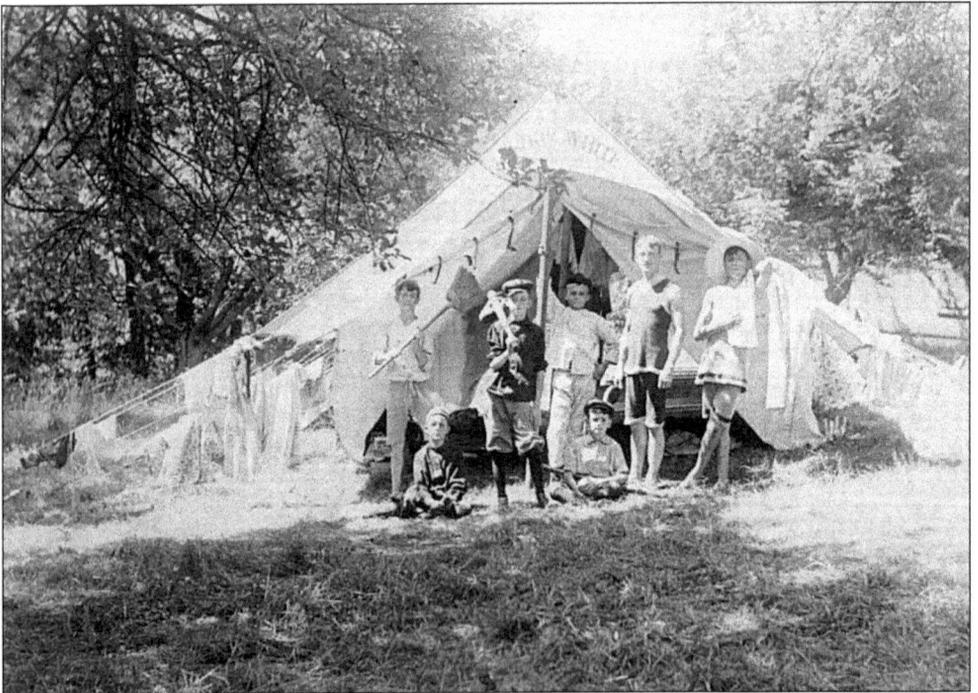

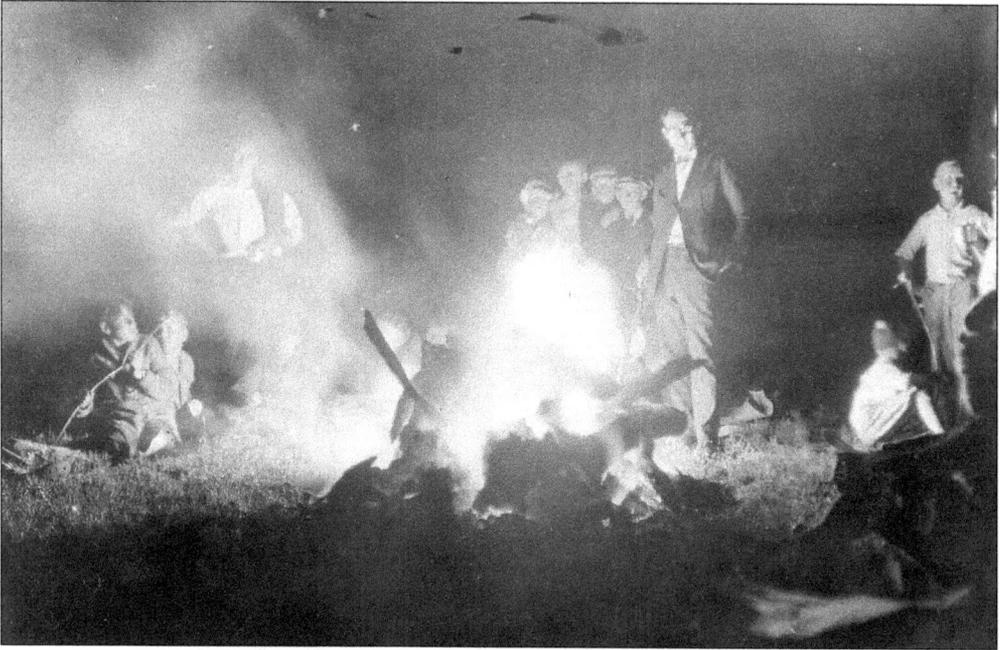

Gathered around the campfire, Michigan City boys were introduced to camp activities through the YMCA and other groups organized by local leaders. Family vacations also centered on lakeside activities. (Courtesy of Long Beach Community Center.)

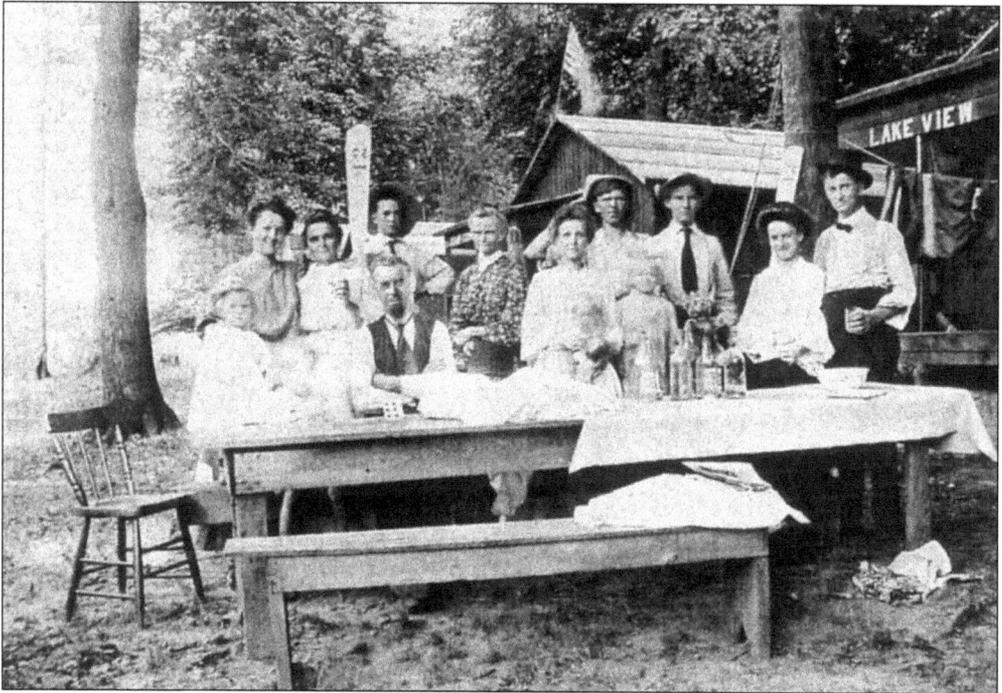

The Prairie Club

Organized for the promotion of outdoor recreation in the form of walks and outings, the dissemination of knowledge of the attractions of the country adjacent to the City of Chicago, and the preservation of suitable areas in which such recreation may be pursued.

BULLETIN No. 102. CHICAGO, January, 1921

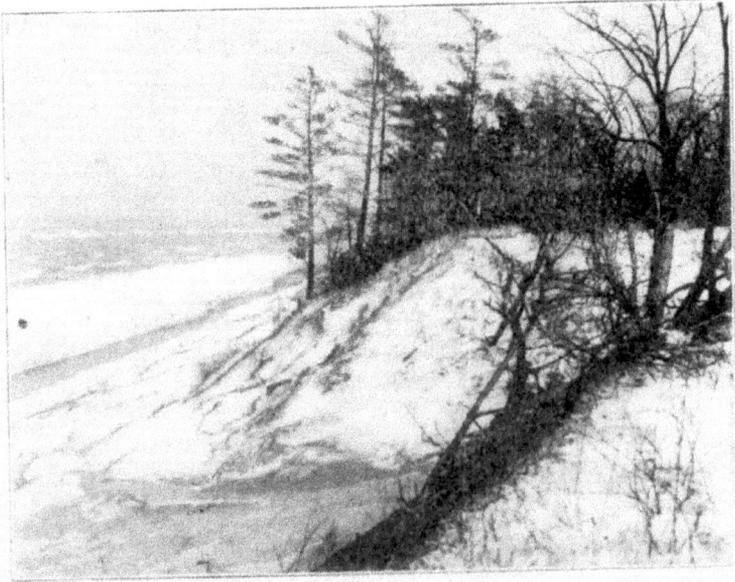

WINTER IN THE DUNES.
Prize Photo by Mrs. W. E. Walker.

There is a pleasure in the pathless woods,
There is a rapture on the lonely shore,
There is society where none intrudes,
By the deep Sea, and music in its roar:
I love not man the less, but Nature more,
From these our interviews, in which I steal
From all I may be, or have been before,
To mingle with the Universe, and feel
What I can ne'er express, yet cannot all conceal.
 —*Byron*

Prairie Club newsletters helped to develop a large membership of Chicago-area intellectuals, botanists, and environmentalists, who began to frequent the dunes *c.* 1910. (Courtesy of Westchester Public Library.)

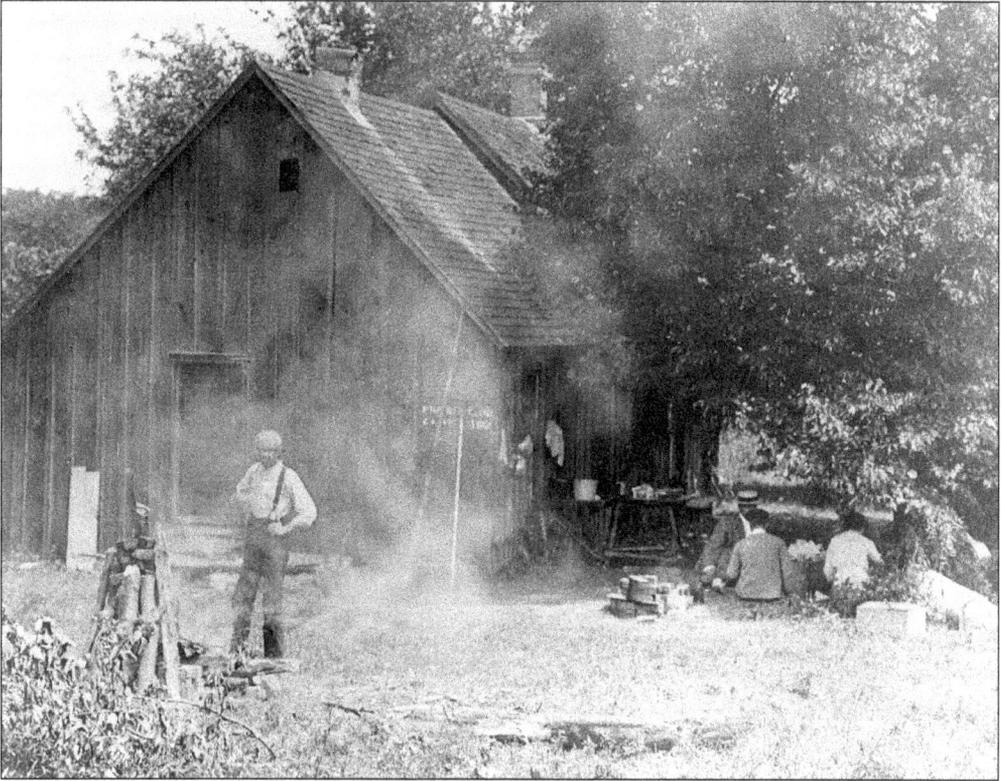

A cook-out at the old barn winds up a typical Prairie Club day, after hiking in the dunes. Campsites were set up creatively by Prairie Club members, using blankets for shelter and Model Ts for headquarters. (Courtesy of Westchester Public Library.)

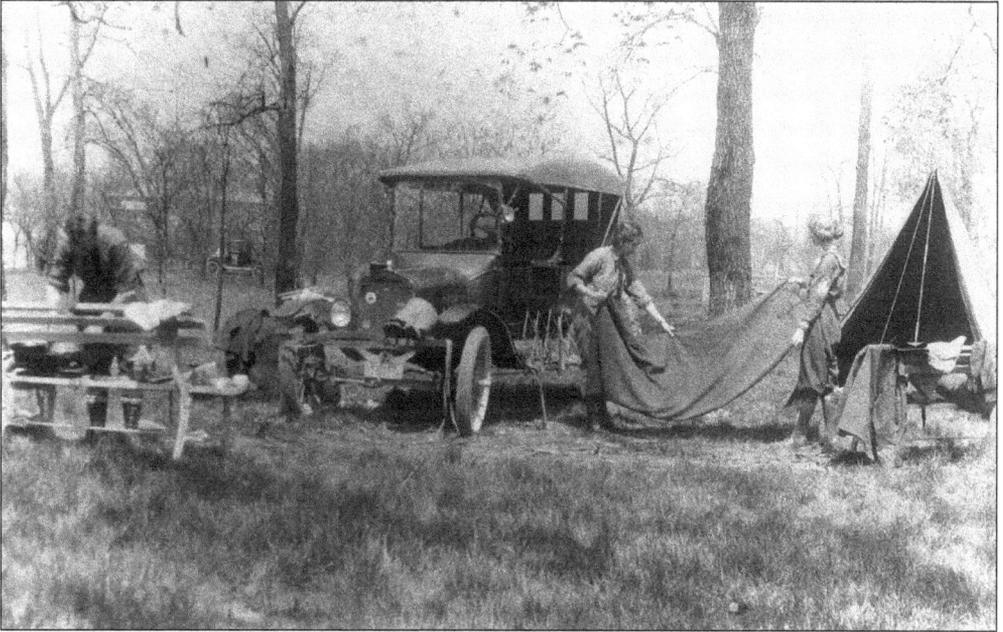

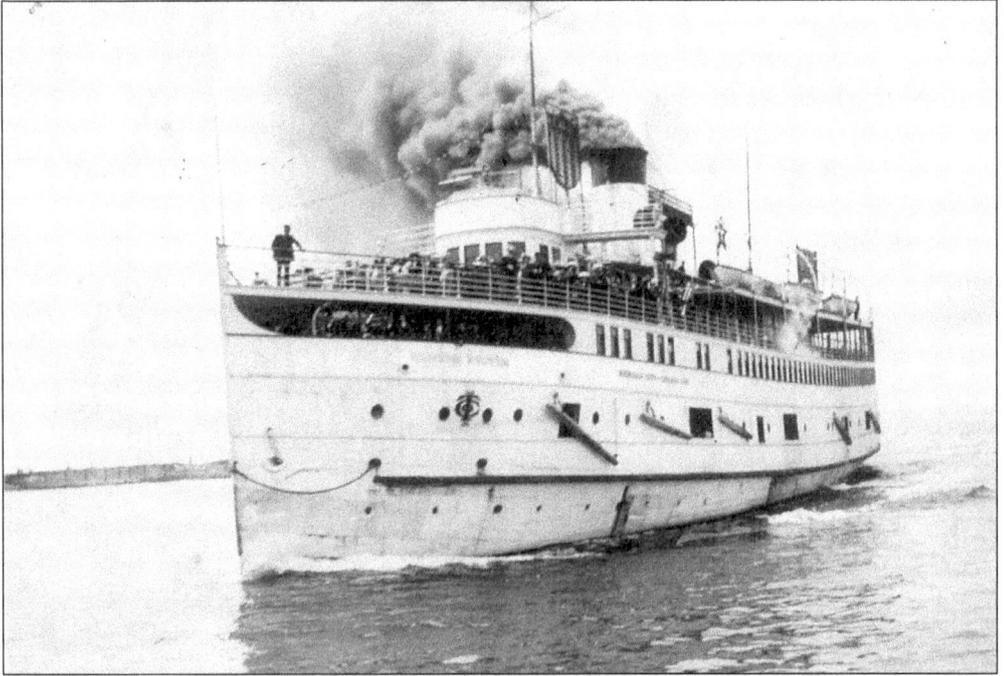

S.S. *United States* was one of the major excursion boats bringing visitors from Chicago. It was operated by Indiana Transportation Company, whose president was Michigan City attorney Isidore I. Spiro. The railroads also brought in many travelers, including south-county passengers who rode this train along Johnson Road from LaPorte to the Michigan City depot. (MCPL)

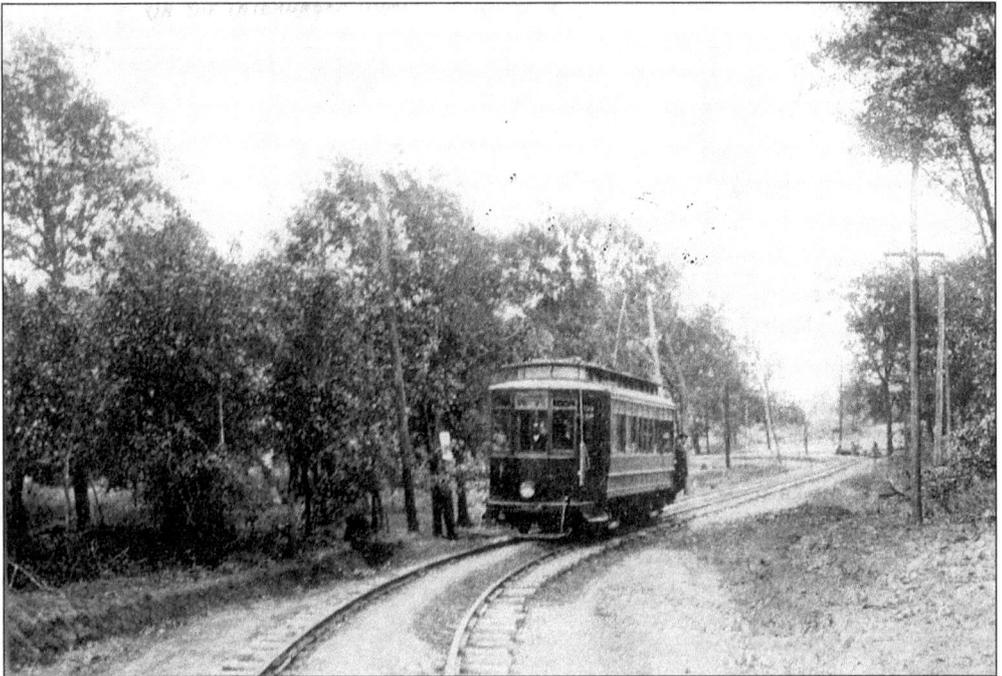

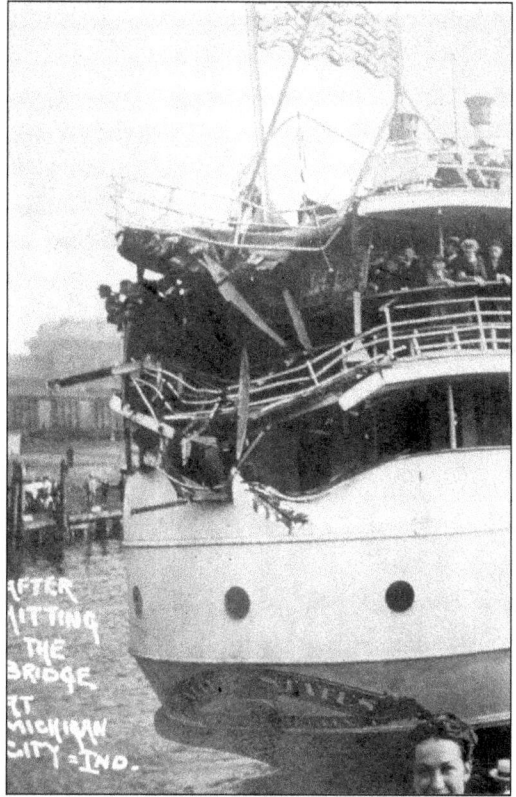

Backing into the Franklin Street Bridge, the S.S. *United States* was unable to maneuver the tight turn in Trail Creek. The Franklin Street Bridge was damaged in the accident, which occurred on June 24, 1910. There were no serious injuries, and the steamship returned to Chicago later that afternoon. (MCPL)

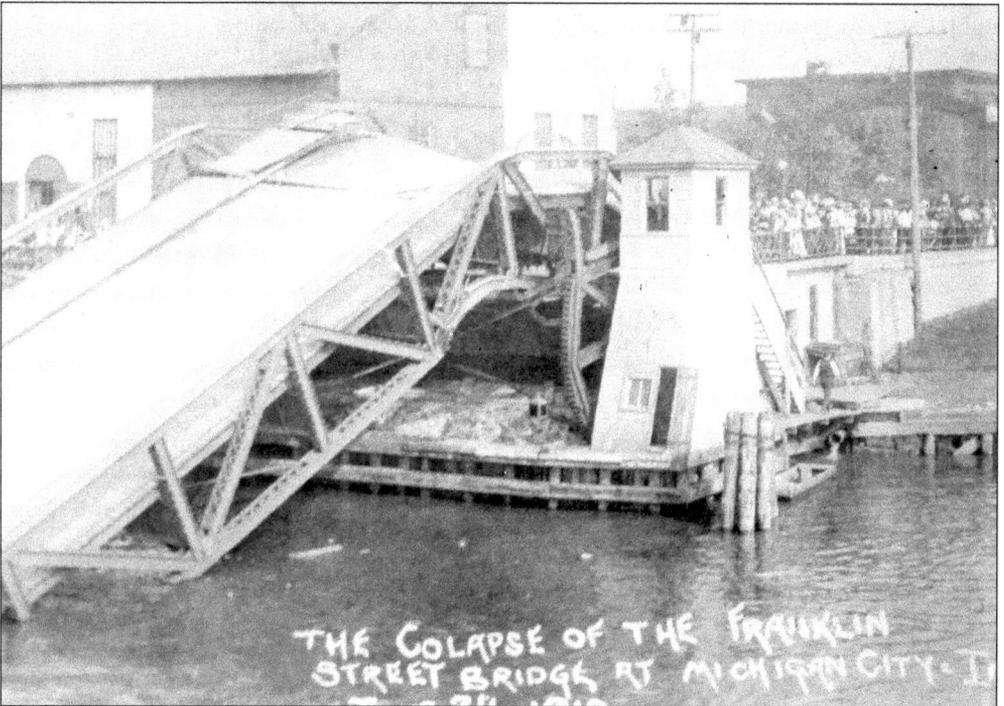

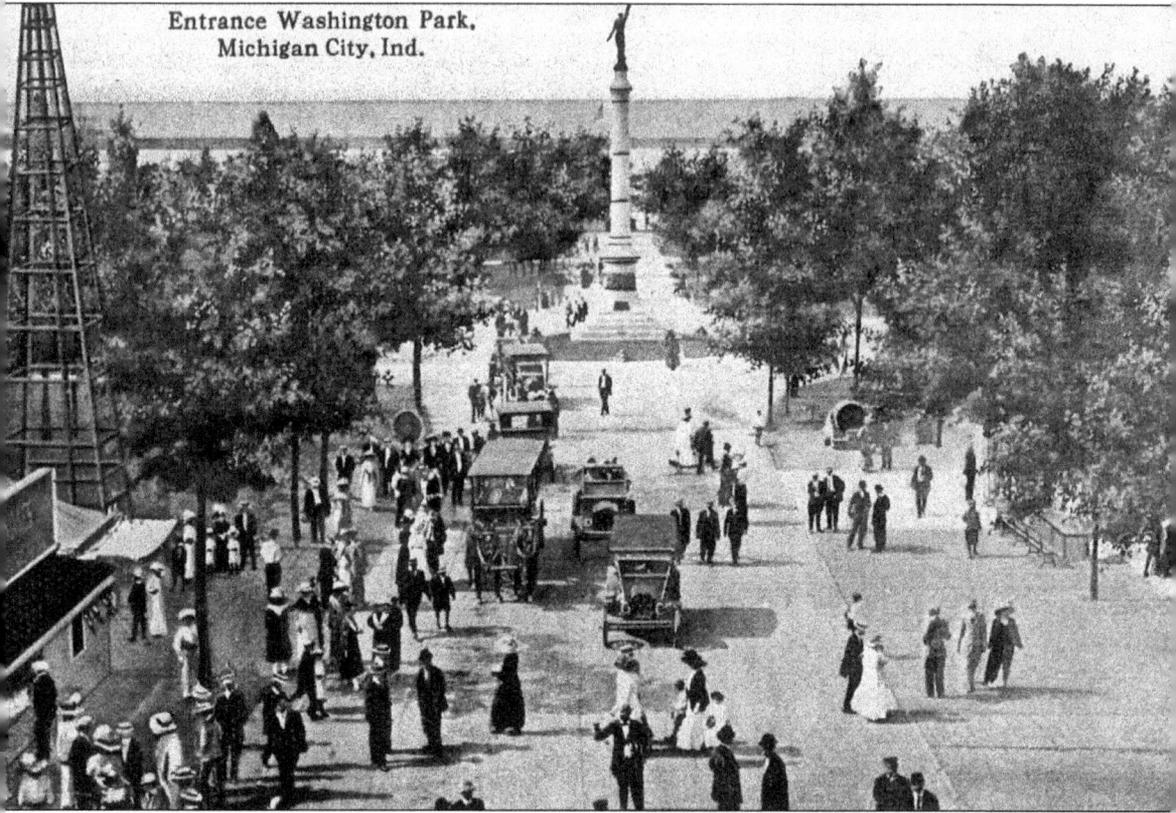

Throngs of visitors came to Washington Park during summer weekends in the early 1900s. The tall monument (center) was a memorial to Civil War soldiers and sailors and was donated to the city by John H. Winterbotham, manufacturer of barrels in Michigan City. (MCPL)

Four

WASHINGTON PARK

MICHIGAN CITY'S LAKEFRONT became a public playground primarily because of the development of Washington Park; and Washington Park came into being largely through the efforts of six-term Mayor Martin T. Krueger. More than any other official in the city's first 100 years, Krueger epitomized the virtues of public service and left a legacy that extended far beyond his death, in 1945, at age 92.

When he became mayor in 1889, the lakefront was a wasteland, cluttered with debris from the defunct lumber industry and inhabited only by "dissolute men and women." The land was being eyed by local businessmen, for its industrial potential. Krueger's dreams of a park were hindered by the shortage of city funds and the need for a new bridge over Trail Creek.

A further hindrance was the negative attitude of the community. "I remember talking to one elderly lady, a client of mine, one of our best families," Krueger recalled. "She could not see what use a bridge could be, except to increase taxes. Taxes were her sore spot and she said, 'I have lived in this city over thirty years and have never yet been on the shore of Lake Michigan, and I have not missed anything thereby."

Nevertheless, Krueger pursued his vision, traveling to Indianapolis to get enabling legislation and exercising his persuasive powers over city councilmen, until at last Washington Park became a reality. Every local citizen was invited to bring a tree to plant. Business leaders caught the spirit of civic pride and contributed generously. John H. Winterbotham, a barrel manufacturer, commissioned a 60-foot-tall monument honoring Civil War soldiers to stand at the entrance.

Public facilities were constructed to serve the crowds that began flocking to Washington Park. A bathhouse was installed, plus a huge water slide, then a dance hall, skating pavilion, and baseball field. A large amusement park was developed, with refreshment stands and popular rides including a roller coaster, whirling swing, and merry-go-round.

Excursion boats began operating from Chicago and bringing in as many as 10,000 visitors in a weekend. Travel increased with the completion of the Chicago South Shore & South Bend Railroad, in 1908, and the growth of the auto industry in the 1920s. An open-air bandstand was built for community concerts, and the Oasis Ballroom brought in big-name bands. In 1924, an imposing colonnaded building, the Peristyle, was donated to the park by industrialist John H. Barker. In 1928, the zoo was established. It became a showpiece, with houses for bears and tigers, a monkey tower, and a bird aviary. The entertainment-seekers were joined by new types of excursionists, the nature-lovers and environmentalists. And eventually Washington Park became the center of community cultural activities, as well as a tourist destination.

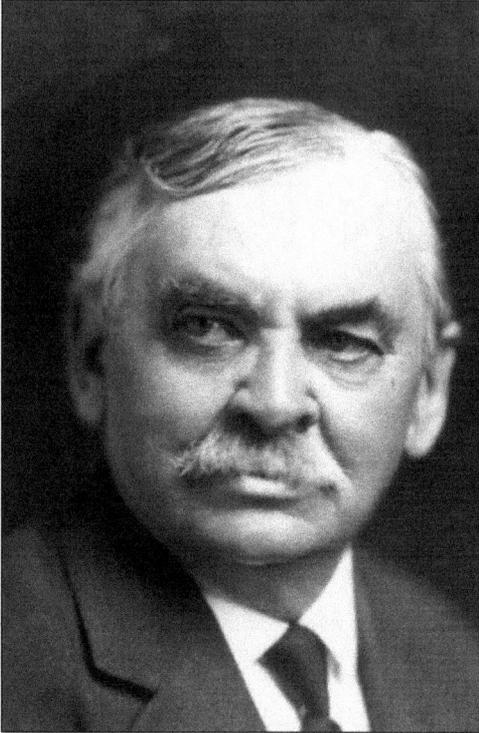

Mayor Martin T. Krueger (1841–1945) had the vision and determination to transform the lakefront from a "no-man's land" into Washington Park. Born in Germany, Krueger came to Michigan City as a youth and worked on farms before beginning his studies of the law. He became a state legislator, city clerk, mayor, and school board member. (MCPL)

The Krueger House on Eighth Street was where the six-term mayor lived in Michigan City. He also had a deluxe log cabin in Sheridan Beach, across the street from his friend William B. Manny. Krueger donated part of his Michigan City acreage to the city for Memorial Park, honoring veterans of World War I. (MCPL)

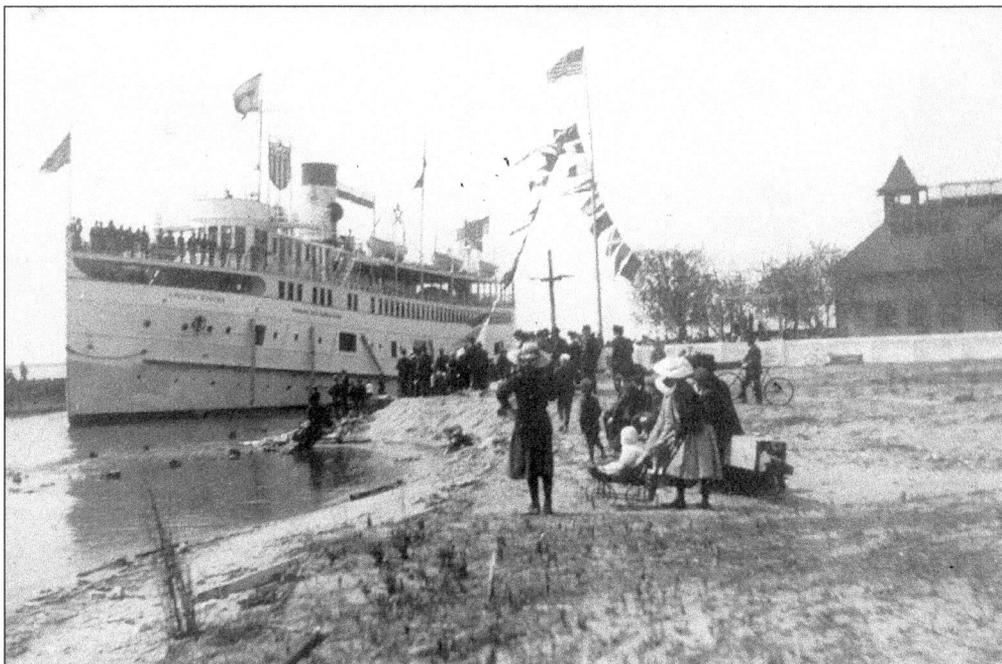

Steamships arrive in Michigan City harbor, with "flags a-flyin' and horns a-blowin' and all fixin' to celebrate the holiday in the park." (MCPL)

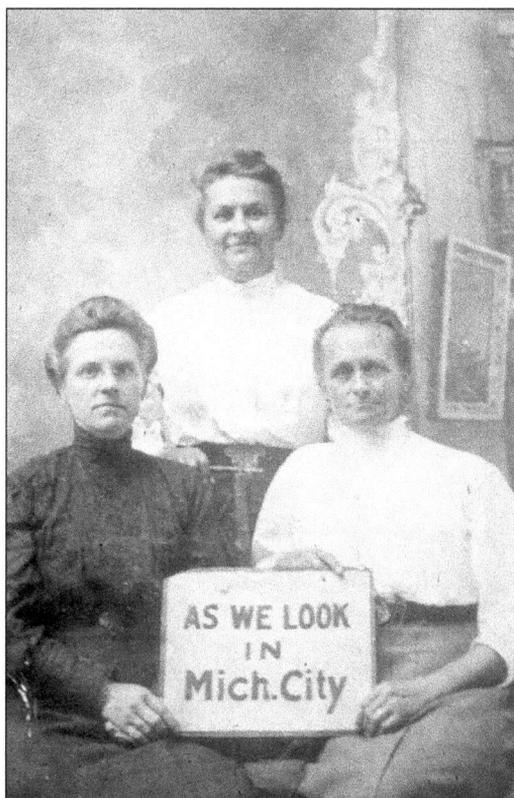

"As We Look in Mich City" depicts turn-of-the-century ladies who stopped at Michael Bodine's studio to pose for their souvenir photo. (MCPL)

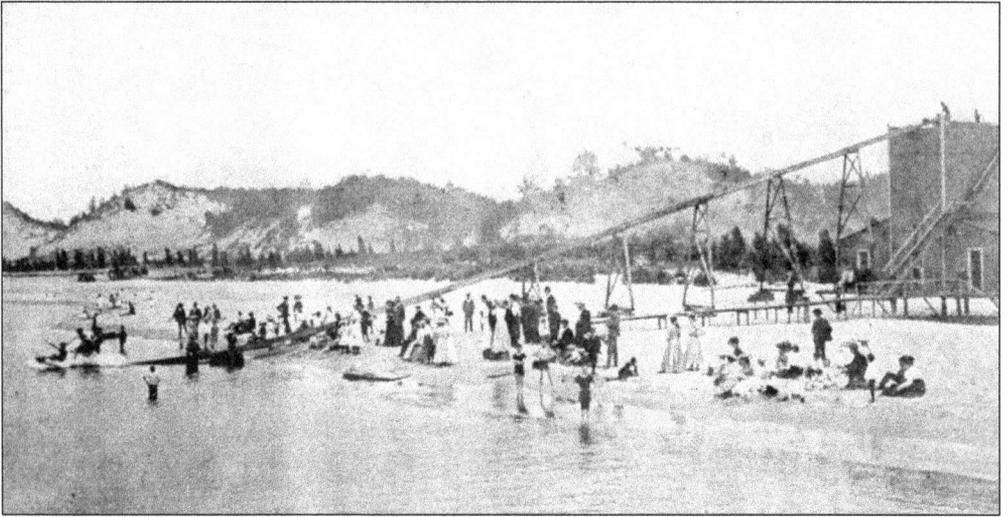

A water slide was one of the earliest amusements installed for beachgoers. The Wonderland sign points the way to games of chance and other concessions on the waterfront, pictured here in 1912. The park also had rides, a shooting gallery, and Maxie Blumenzweig's pennant and souvenir stand. (OLM)

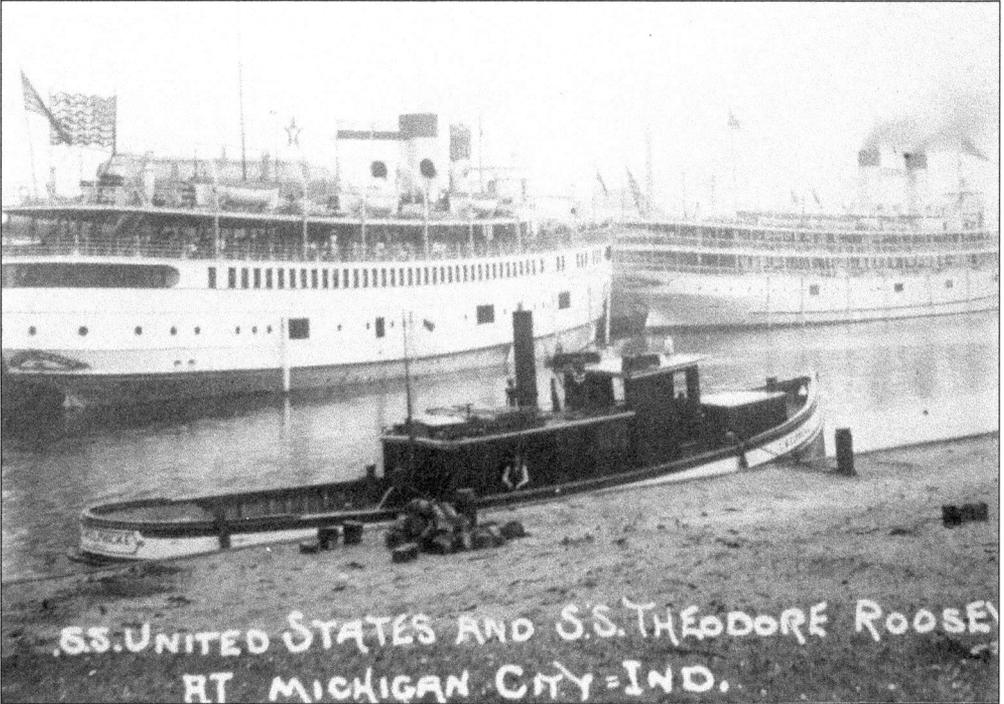

S.S. UNITED STATES AND S.S. THEODORE ROOSE
AT MICHIGAN CITY=IND.

Excursion boats carrying thousands of passengers are docked in the Michigan City harbor. The peak of the excursion business was 1914, when 10,000 visitors arrived in a single day, in six steamers. Some tourists went to the amusement park, to ride the Whirling Swing. Others headed up Franklin Street to find a restaurant and a good home-cooked Hoosier meal. (Courtesy of Thate Land Surveying.)

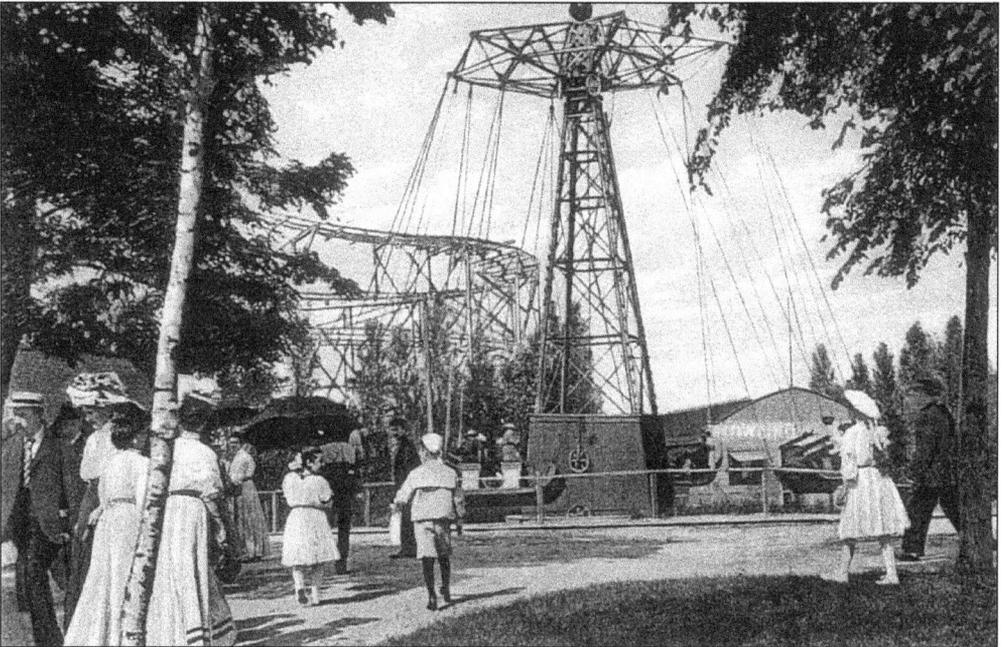

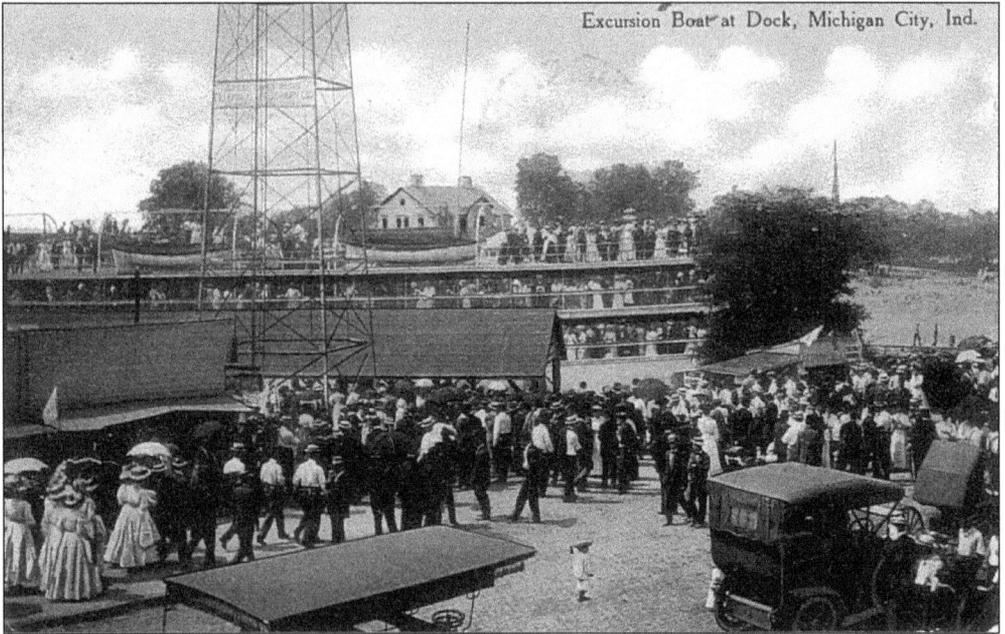

Welcoming excursionists, Michigan City residents flocked to the piers where the steamships arrived from Chicago. As the passengers disembarked, a German band broke into a rousing march and led the tourists in the direction of Washington Park. The Merry-Go-Round was a favorite spot to pose for group portraits. (MCPL)

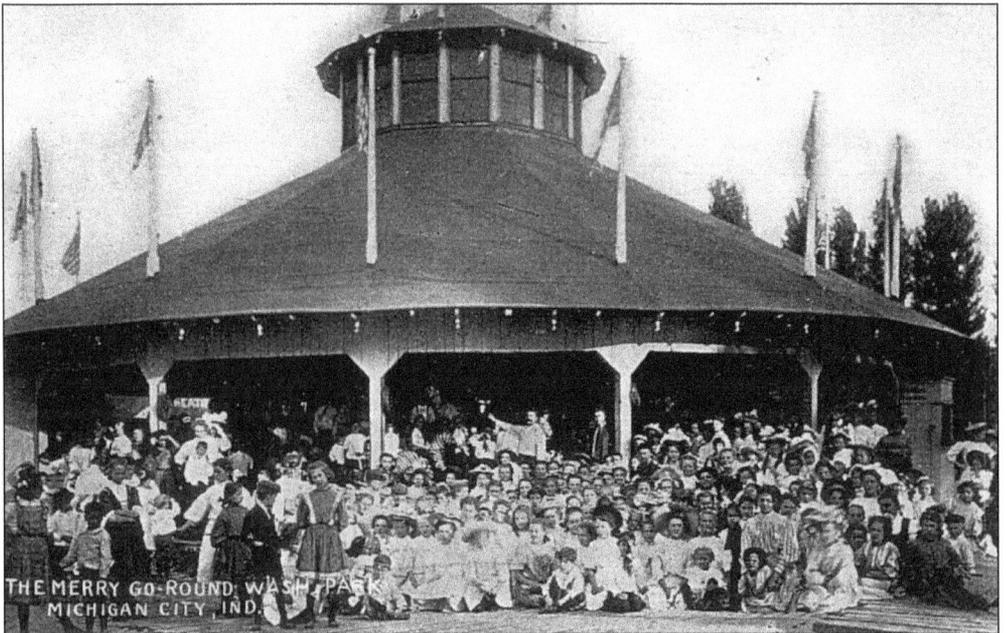

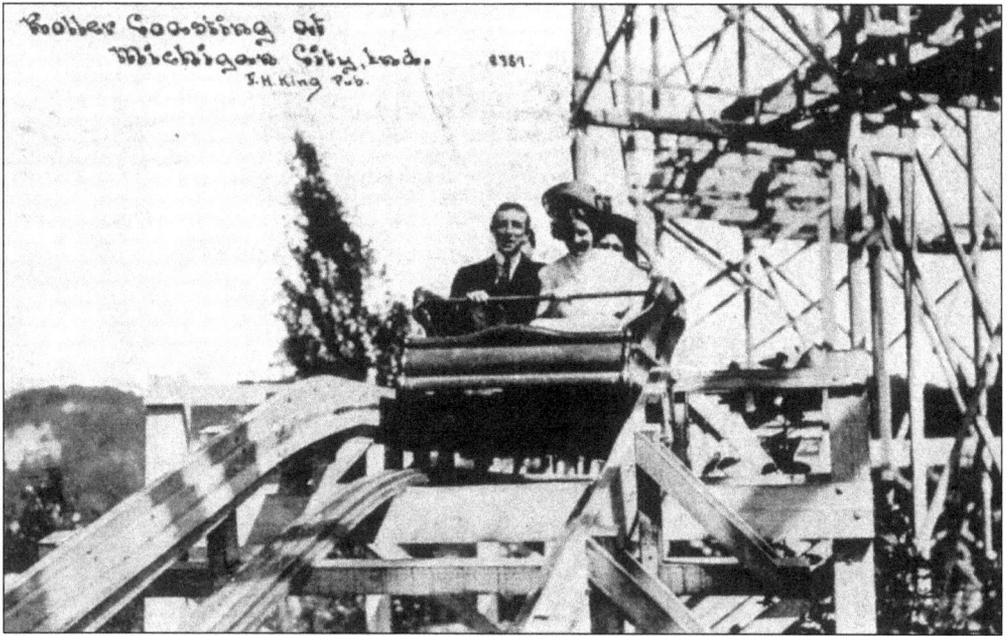

Roller-Coasting was a thrilling experience for day-trippers visiting the amusement park in Michigan City. (Courtesy of Thate Land Surveying.)

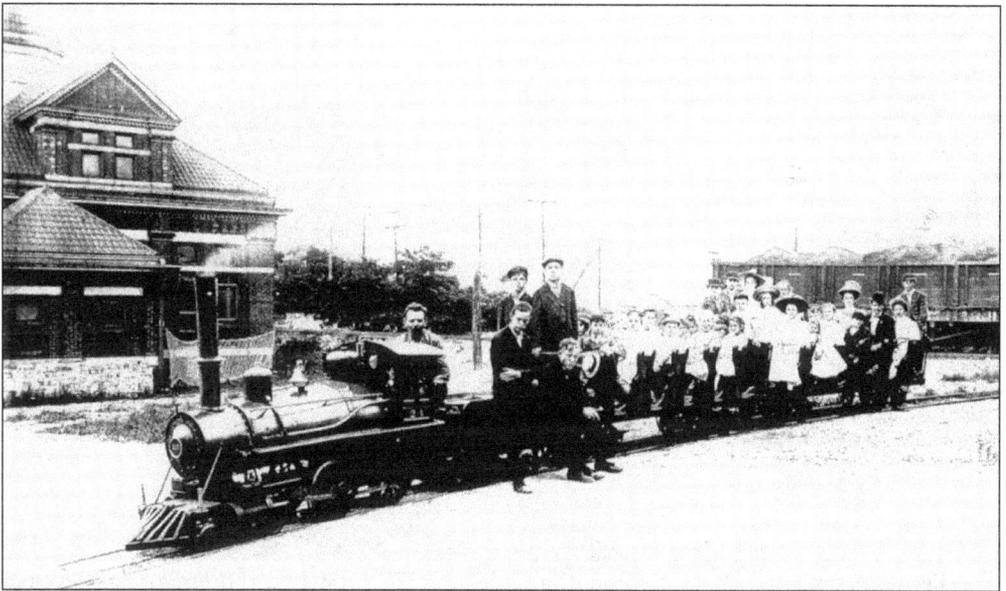

A miniature train provided rides to Washington Park. Pictured (left to right) are Charlie Holtgren, engineer; Carter H. Manny, whose father owned the park concessions, c. 1905–1910; and Elmer Dunlap, ticket collector. The waterworks building is shown at left. (Carter Manny Manuscript.)

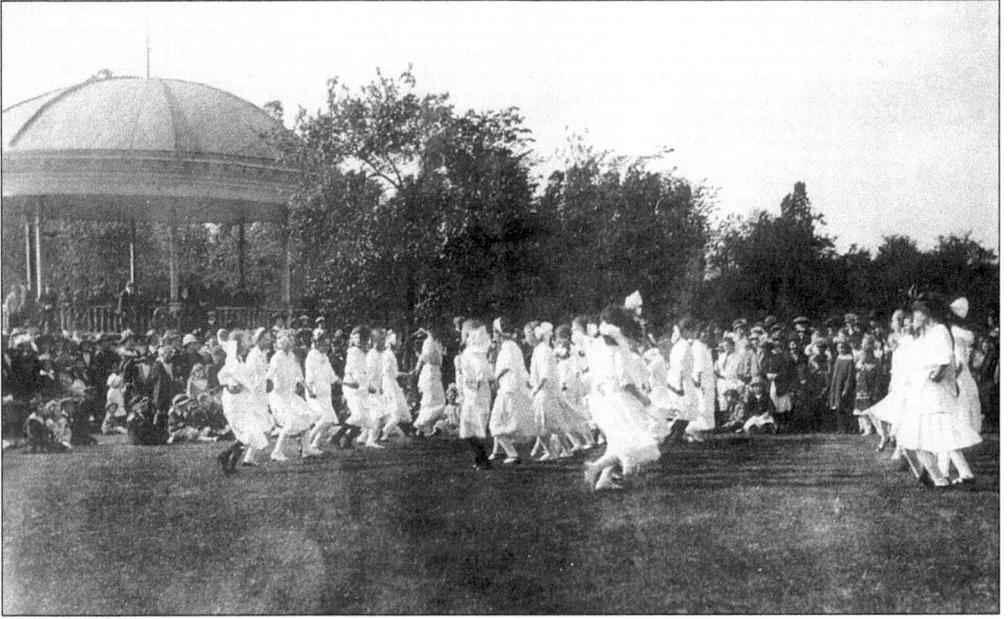

Girls' Week was a community event celebrated annually in the park, with a parade, dancing, and other festivities at the bandstand. There was also a Boys' Week. Local citizens liked to gather at the bandstand, which was built in 1911. It was designed by Harry M. Miles, city engineer. (MCPL)

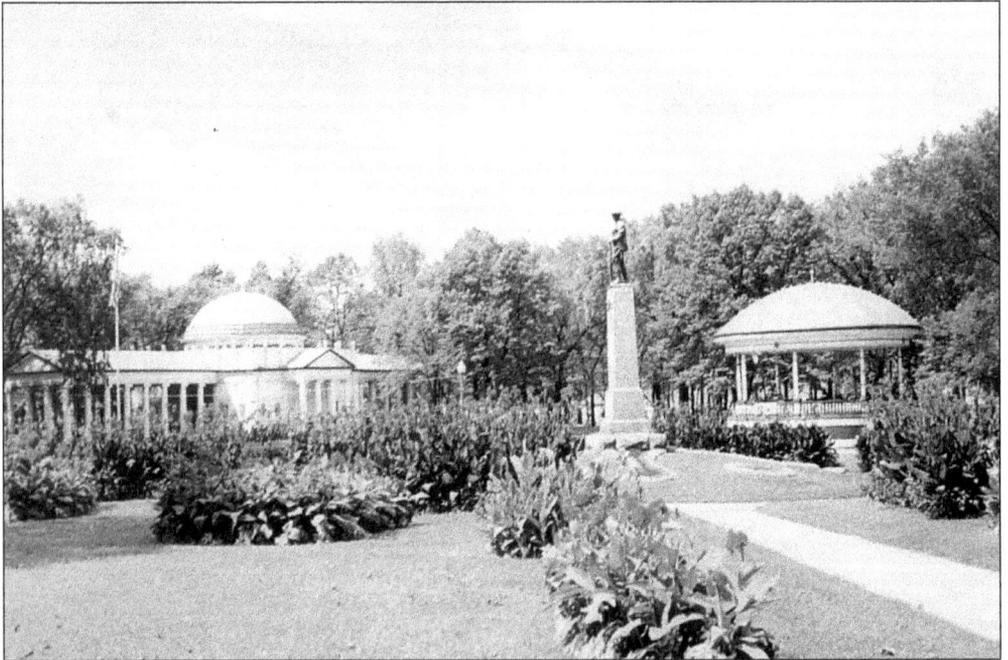

The Peristyle, designed in the fashion of a Greek temple, brought an international flavor to Washington Park in the 1920s. This impressive structure was a gift to the city from industrialist John H. Barker. The bandstand is shown at the right, and a World War I memorial sculpture is in the center. (MCPL)

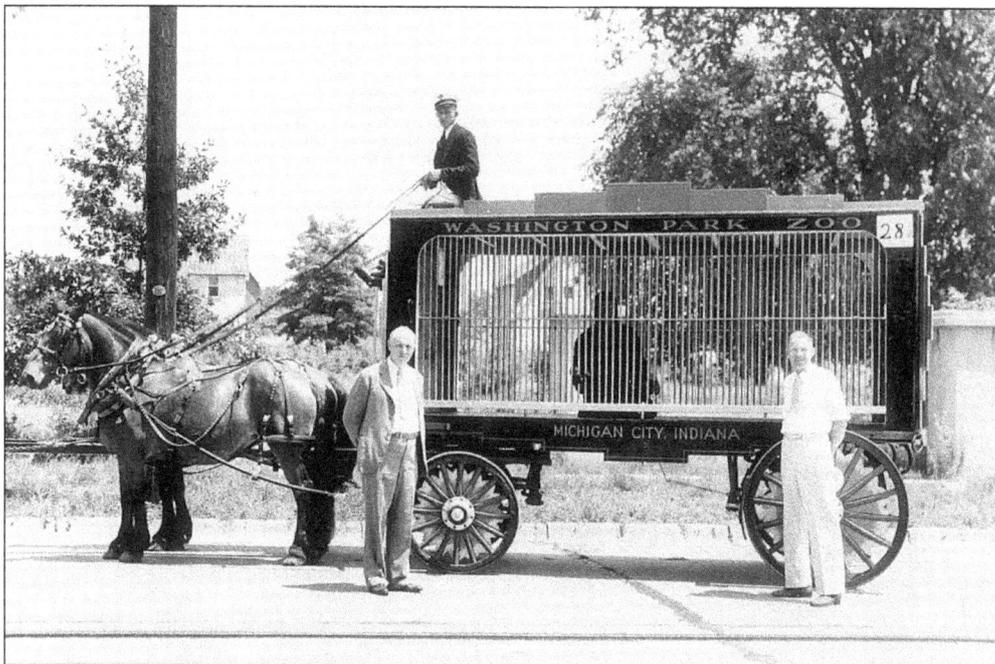

The Zoo Wagon parades through the park, showing off one of the prize animals from Washington Park Zoo, which was established in 1928. The zoo originated at the Fourth Street fire station, where firemen cared for homeless animals such as an alligator and a bear left behind by a traveling circus. City Manager Albert R. Couden had the zoo moved to the park. (MCPL)

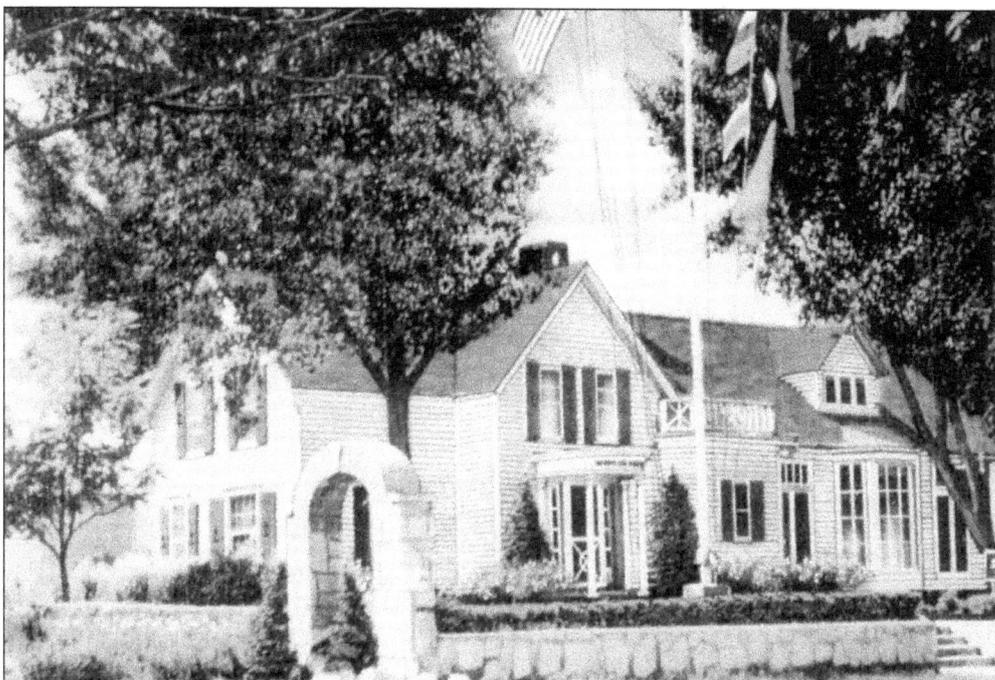

Michigan City Yacht Club was formed in 1933, with Harry Frey as its first commander. The building was constructed in 1936, west of Washington Park. (MCPL)

THE

RAMONA RESORT

With Its

MOTHER GOOSE VILLAGE

110 LAKE SHORE DRIVE
SHERIDAN BEACH

"ON LAKE MICHIGAN"

Michigan City, Indiana

Summer
Cottages and Rooms
FOR RENT
By

DAY, WEEK or SEASON

Featuring

MICHIGAN CITY'S only HOTEL
or
MOTEL with a PRIVATE BEACH

Miss Ramona Spencer PHONE:
MGR. MICHIGAN CITY
 TR 4-7700

Cottages - 1 to 3 rooms

Accommodates 6 - 8 persons

ALL COTTAGES have new large
G.E. Refrigerators, Complete
Kitchen Equipment, Washrooms
with Showers

Cottage sides open and screened
on all sides, permitting cross-
ventilation both ways —
cool lake breeze

Our "MOTHER GOOSE" VILLAGE is a miniature village of 29 buildings. The office is in the main house "THE RAMONA". Each of the 20 small cottages (1 to 3 rooms each) are named Mother Goose Rhyme names such as King Cole, Dickory Dock, Miss Muffett, etc. Also, there is one larger building of 8 rooms called Mother Goose Hall. There are miniature lamp posts and miniature streets throughout named Make-Believe Ave., Slumberland Lane, Sandman Trail, and of course the main thoroughfare is the Mother Goose Blvd.

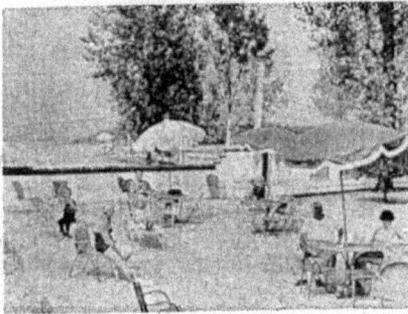

Mother Goose Village went up just east of Washington Park, offering overnight and weekly accommodations for vacationers. Cottages were named after favorite storybook characters. The 29-unit resort stood on the grounds of the present Dunescape condominiums. (Courtesy of Thate Land Surveying.)

52

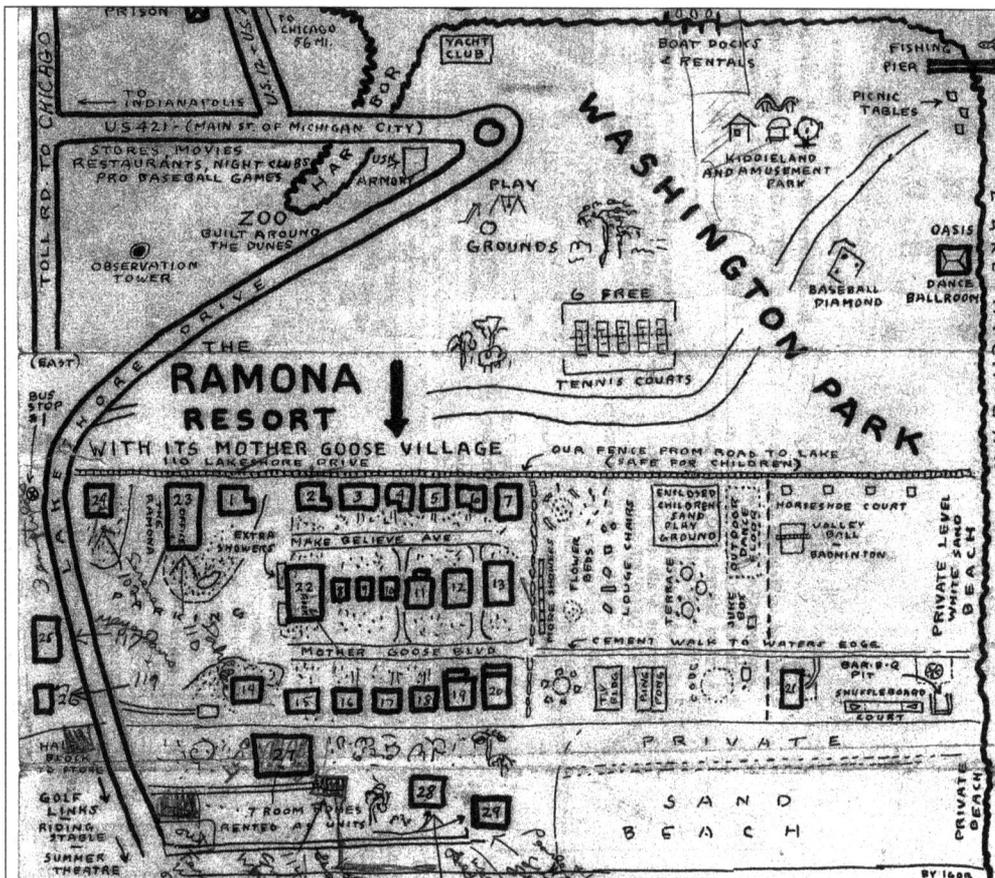

WASHINGTON PARK

PRISON
CHICAGO 56 MI.
YACHT CLUB
BOAT DOCKS & RENTALS
FISHING PIER
TO INDIANAPOLIS
PICNIC TABLES
US 421 (MAIN ST. OF MICHIGAN CITY)
STORES MOVIES RESTAURANTS, NIGHT CLUBS PRO BASEBALL GAMES
ARMORY
KIDDIELAND AND AMUSEMENT PARK
PLAY
ZOO BUILT AROUND THE DUNES
GROUNDS
OASIS
OBSERVATION TOWER
BASEBALL DIAMOND
DANCE BALLROOM

(EAST)
THE RAMONA RESORT
WITH ITS MOTHER GOOSE VILLAGE
110 LAKESHORE DRIVE
OUR FENCE FROM ROAD TO LAKE (SAFE FOR CHILDREN)
6 FREE TENNIS COURTS

BUS STOP #1
EXTRA SHOWERS
MAKE BELIEVE AVE.
ENCLOSED CHILDREN'S SAND PLAY GROUND
HORSESHOE COURT
VALLEY BALL BADMINTON
FLOWER BEDS
MOTHER GOOSE BLVD.
CEMENT WALK TO WATERS EDGE
PRIVATE LEVEL WHITE SAND BEACH
BAR-B-Q PIT
SHUFFLEBOARD COURT
PING PONG
TV TABLE

GOLF LINKS RIDING STABLE
SUMMER THEATRE
7 ROOM DELUXE UNITS RENTED
SAND BEACH
PRIVATE
PRIVATE BEACH

BY IGOR

1. PETER PAN
2. CINDERELLA
3. MARJORIE DAW
4. JACK SPRATT
5. PIED PIPER
6. THREE BEARS
7. TOM THUMB
8. JACK IN THE BEANSTALK
9. RED RIDING HOOD
10. TOMMY TUCKER
11. MOTHER HUBBARD
12. MISS. MUFFETT
13. CURLYLOCKS
14. KING COLE
15. HUMPTY DUMPTY
16. JACK & JILL
17. JACK HORNER
18. BOY BLUE
19. BO-PEEP
20. DICKORY DOCK
21. DING DONG BELL
22. MOTHER GOOSE HALL
23. THE RAMONA (OFFICE)
24. PARKVIEW
25. WINDEMERE
26. SHAMROCK
27. SANS SOUCI
28. LA ROSE
29. SUNNY SHORES

| | OFF SEASON RATES | | SEASON RATES | |
| | From May 1st until start of season in June, and after Labor Day. | | Holidays, (Daily Rate) slightly higher Rates on 5 day periods | |
	WEEKLY	DAILY	WEEKLY	DAILY
1 Room Cottage (2 double beds & cot & partition if desired)	$30 to $70	$8 to $14	$75	$16
2 Rm. Cottage (3 double beds — separate bedroom) also Shamrock Cottage — 3½ room house across street — by itself	$35 to $80	$10 to $15	$85	$18 to $22
Marjorie Daw — 2 large room Cottage (4 double beds) No screened porch	$40 to $90	$12 to $16	$100	$20 to $25
3 Rm. Cottages (4 double beds—screened sleeping porch)—End Cottages nearest lake. Ding Dong Bell — at lake 3 rooms with long porch & private patio overlooking lake — 3 double beds and 3 cots if you wish.	$45 to $95	$12 to $18	$100	$22 to $30
Large 7 room home as a unit—basement with shower, furnace. Private beach separate & spacious yards	$55 to $125.	$20 to $24	$160	$30 to $35
Room for 2 (double bed)	$12 to $35	$3 to $5	$25 to $45	$4 to $7
Rooms for 3 & 4 (double bed & cot — 2 double beds — depends on room)	$15 to $45	$6 to $8	$30 to $45	$8 to $12
Annex rooms — use of house & community kitchen. Rooms for 2	$15 to $30 $20 to $45	$3 to $5 $6 to $8	$25 to $30 $35 to $40	$4 to $7 $8 to $12

Ramona Resort, named for proprietor Ramona Spencer, operated Mother Goose Village. (Courtesy of Thate Land Surveying.)

53

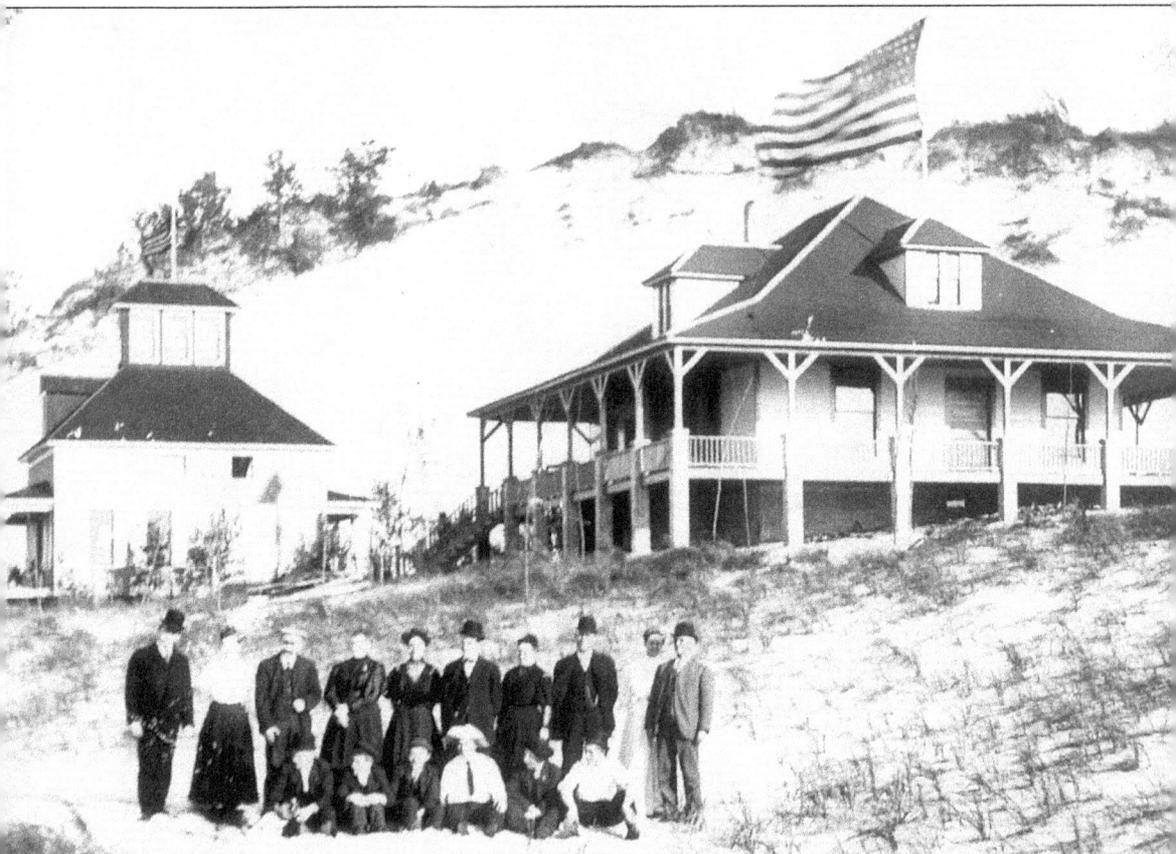

The first cottages built in Sheridan Beach were the Wellnitz (left) and Dahlke cottages. They stood just east of Washington Park. Family portraits are taken here in front of the Dahlke cottage, which was owned by the operator of a sand-sucking operation from Chicago. (MCPL)

Five

SHERIDAN BEACH

WILLIAM B. MANNY was a railway agent and Isidore I. Spiro was a lawyer; together they founded Sheridan Beach. In 1907, they acquired all the land east of Washington Park, up to the Hermitage. These two entrepreneurs formed the Sheridan Beach Land Co., with offices at Fourth and Franklin Streets, Michigan City. Their intention was to establish a resort community.

Even earlier, there was a sprinkling of cottages along the lakefront. As early as 1902, Ella Kimball Barnes pitched a tent on the beach to serve as the family's summer residence. She and her husband Harry Barnes, private secretary to John H. Barker, were among the first year-round residents of Sheridan Beach. The first permanent beach house was built in 1905 by Oscar A. Wellnitz, who had a bakery on Franklin Street. Other early beach dwellers were Captain Dahlke, owner of a Chicago "sand-sucker" operation, and Professor Brewster, a retired University of Chicago professor.

In order to improve access to the land, the developers had to "wash down" the dunes, using fire hoses. The construction of a lift bridge in 1906, replacing the old swing bridge across Franklin Street, aided greatly in the beach development. On May 23, 1907, the Sheridan Beach addition to Michigan City was approved, and lots were offered at $250 to $300. Spiro and Manny built "the Pioneer," their first rental property, at 302 Lake Shore Drive. Prefabricated Sears houses (still standing) were later built on Lake Avenue.

In July 1907, Michigan City Judge Harry B. Tuthill platted the 25-lot Shawmut Park Addition, up to Prospect Street. In April 1909, the Lakeside Addition was laid out by developers T.P. Turner and Orrin S. Glidden, with streets named after family members. Glidden, another Michigan City baker, built the Shawmut Hotel to attract visitors and real estate investors.

In 1914, Isidore I. Spiro died at the age of 51, without seeing the fulfillment of his ambitions. William B. Manny went on to acquire at least eight pieces of property, his favorite being the historic Log Cabin. The Sheridan Beach Hotel opened in 1920, and in the next few years, property was bought up by quite a number of Michigan City's business leaders—bankers, lawyers, and owners of hardware stores and department stores.

In 1928, Manny made the last expansion of Sheridan Beach, north of Lake Shore Drive, between California and Nevada Avenues. This final platting of land also included a provision which forever protected the beaches of Michigan City for the public.

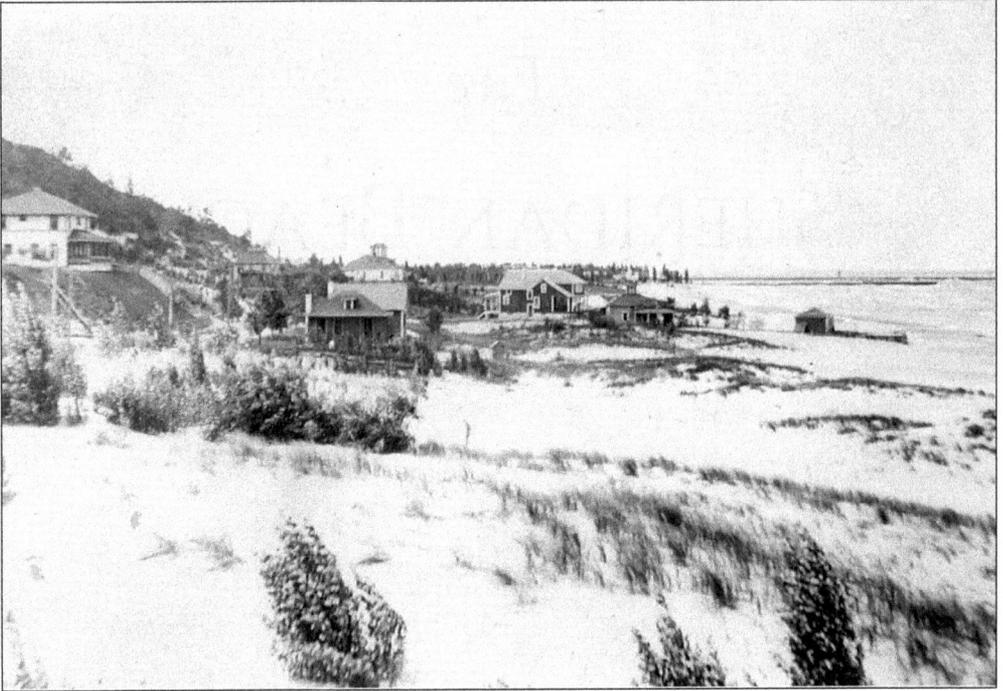

Along the windswept coast, a few early cottages are pictured here, nestled into the sandy hills. The Barnes cottage can be seen (center), the Wellnitz cottage in the distance, and the Wolf cottage (at left). (MCPL)

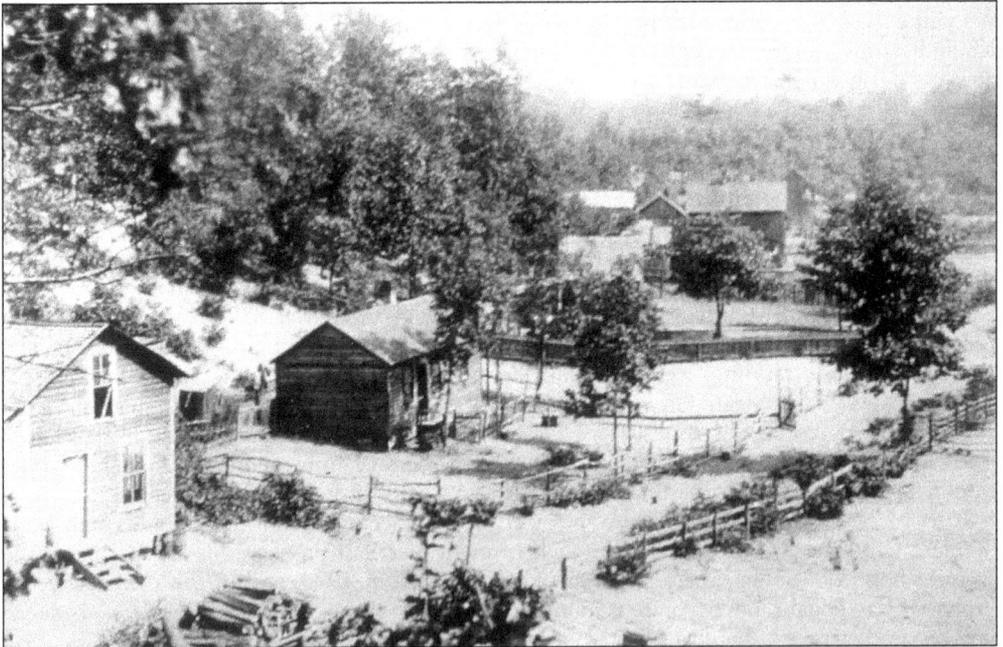

Hungry Hollow, a community built on the backside of Yankee Slide, had simple huts occupied by workmen during Michigan City's lumber epoch. Today Hungry Hollow is a residential district, and the site of this photo has become a baseball field. (MCPL)

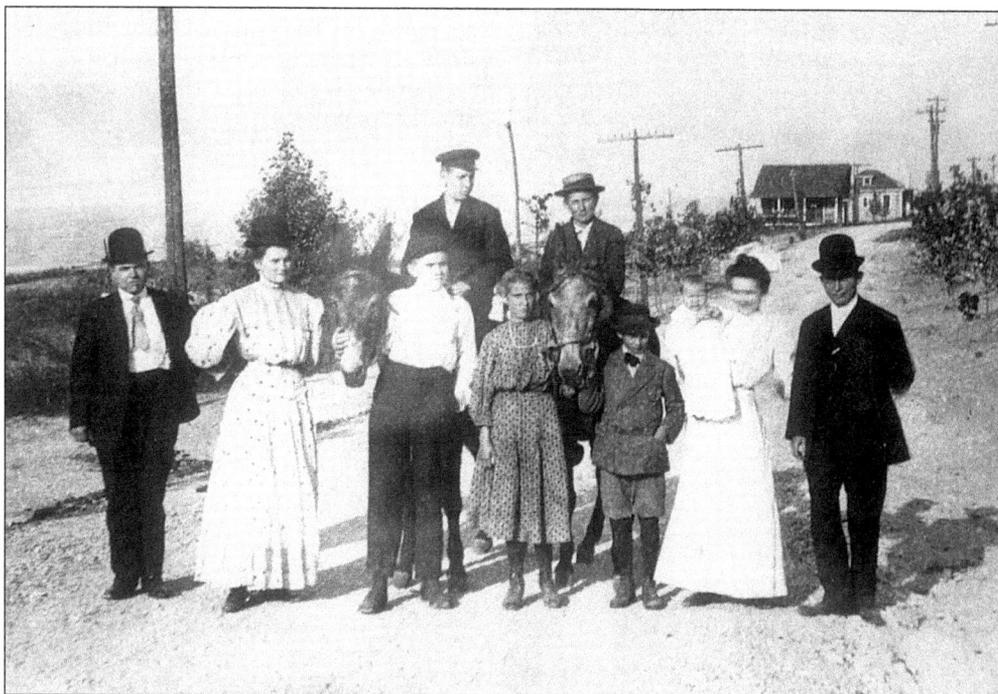

An old-time family is pictured on the gravel road that led to Sheridan Beach cottages in the early years of the 20th century. (MCPL)

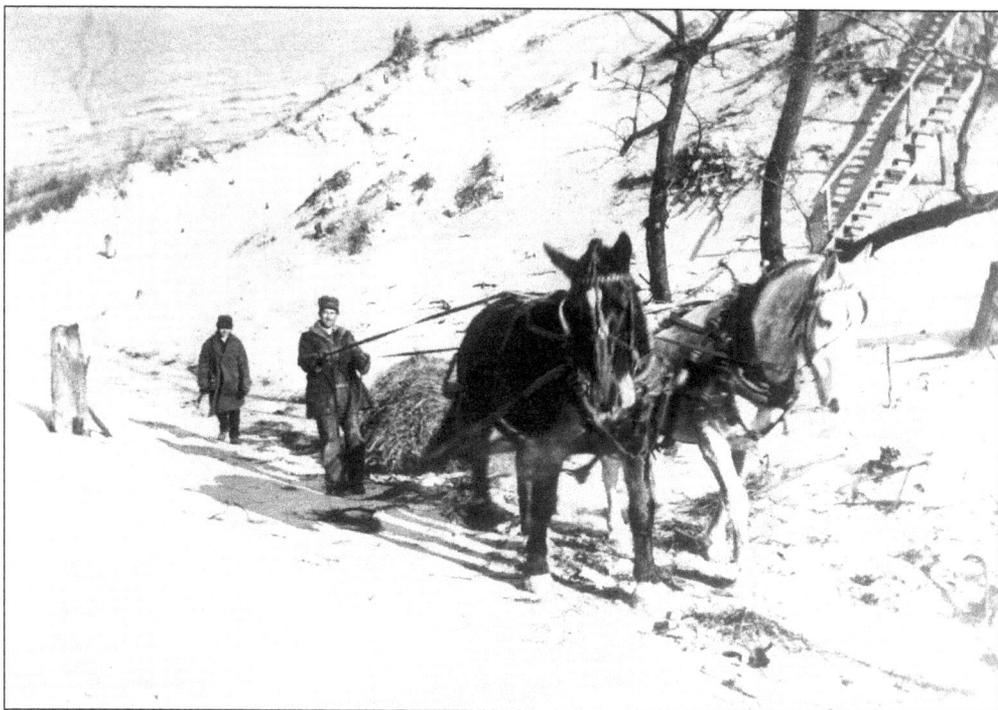

A horse-drawn sled is hauling a Christmas tree for a beach dweller who has stayed in his cottage for the winter. (IUNA)

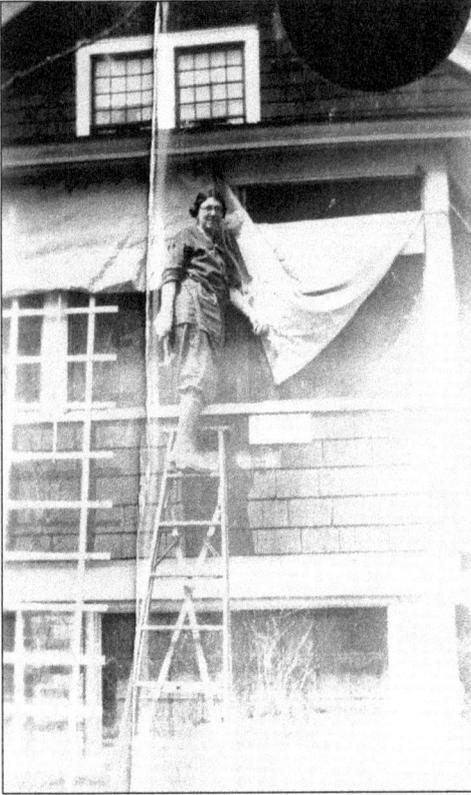

Roof repairs are being made by Ella Kimball Barnes, shown here on a ladder at her Sheridan Beach cottage, c. 1922. (Courtesy of Carter H. Manny Jr.)

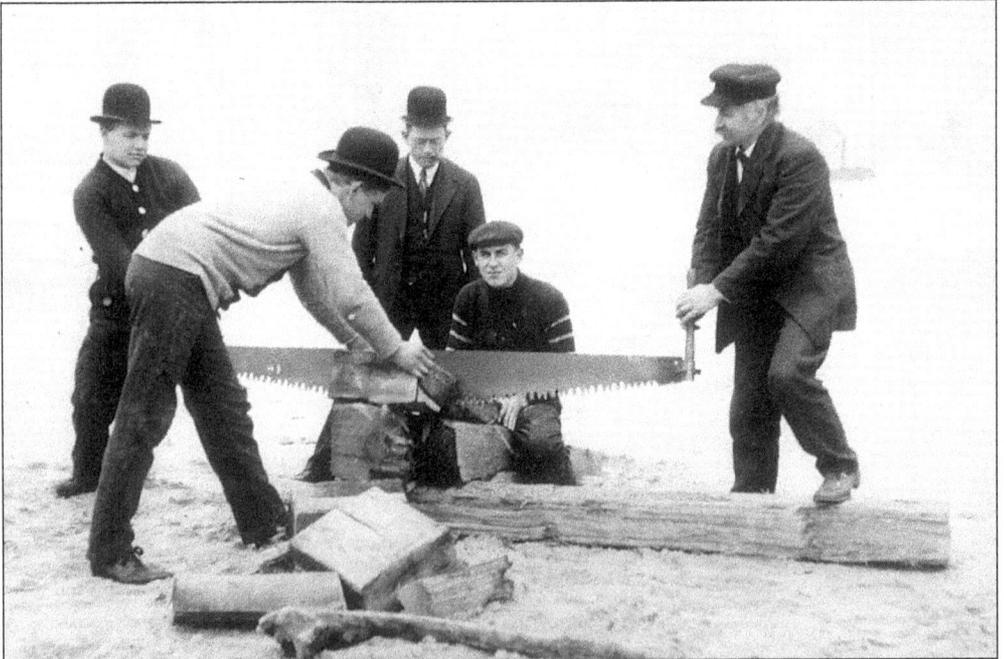

Sawing wood, another of life's necessities, could be accomplished here without removing one's hat. (MCPL)

The Barnes Cottage, built prior to 1910, is still standing east of the Dunescape condominium development. (Courtesy of Carter H. Manny Jr.)

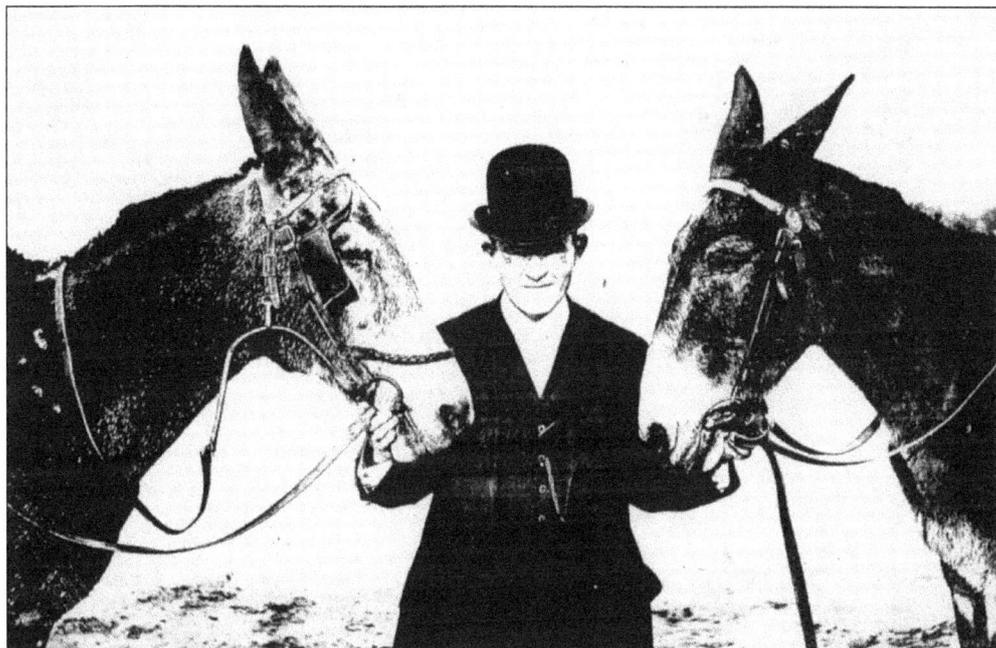

Harry Barnes, who came to Michigan City to work as John H. Barker's private secretary, is pictured in a stunt photo with a couple of mules. (Courtesy of Carter H. Manny Jr.)

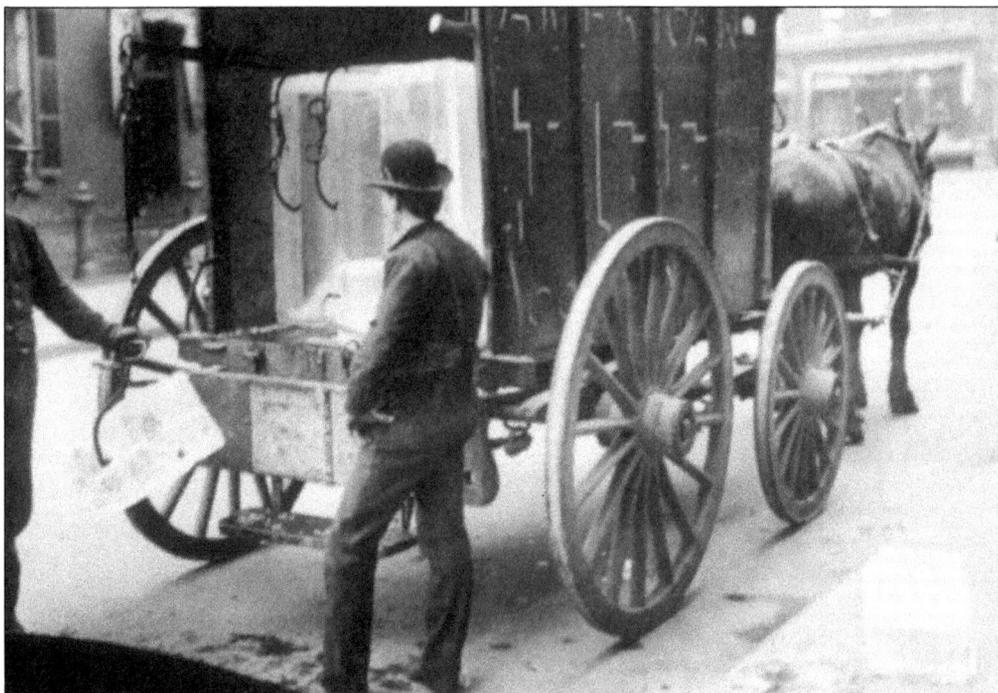

The ice wagon made daily deliveries to residents of the beach communities. In the late 19th and early 20th century, ice was harvested at the smaller inland lakes of LaPorte County, and stored for summer usage. (MCPL)

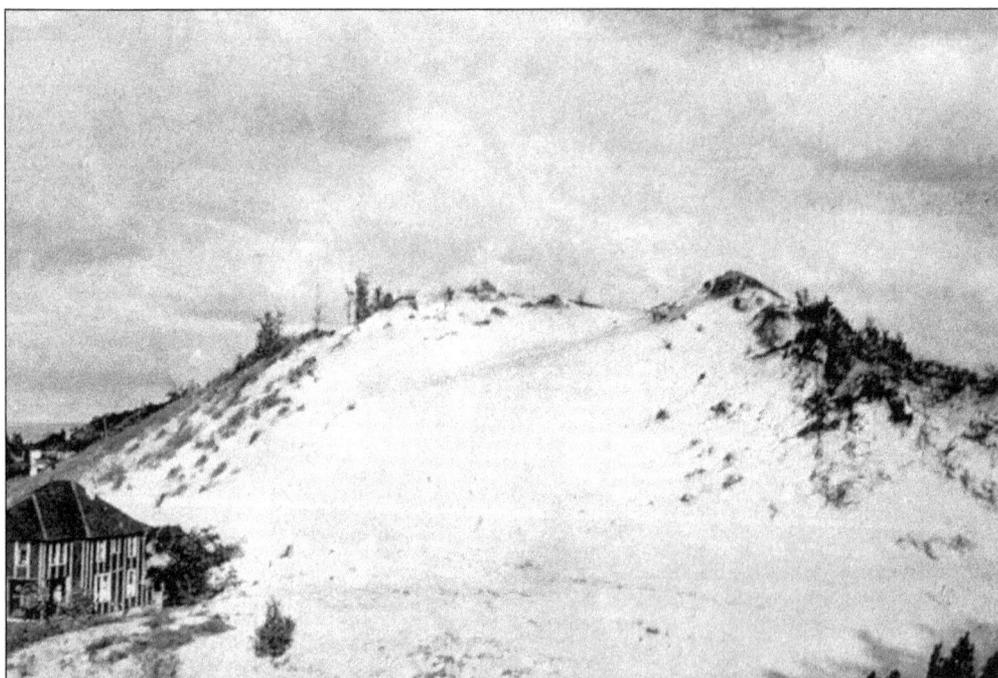

Yankee Slide is shown here with one of the units from Mother Goose Village. This cottage was covered in tarpaper, held in place with battens applied on the outside. (MCPL)

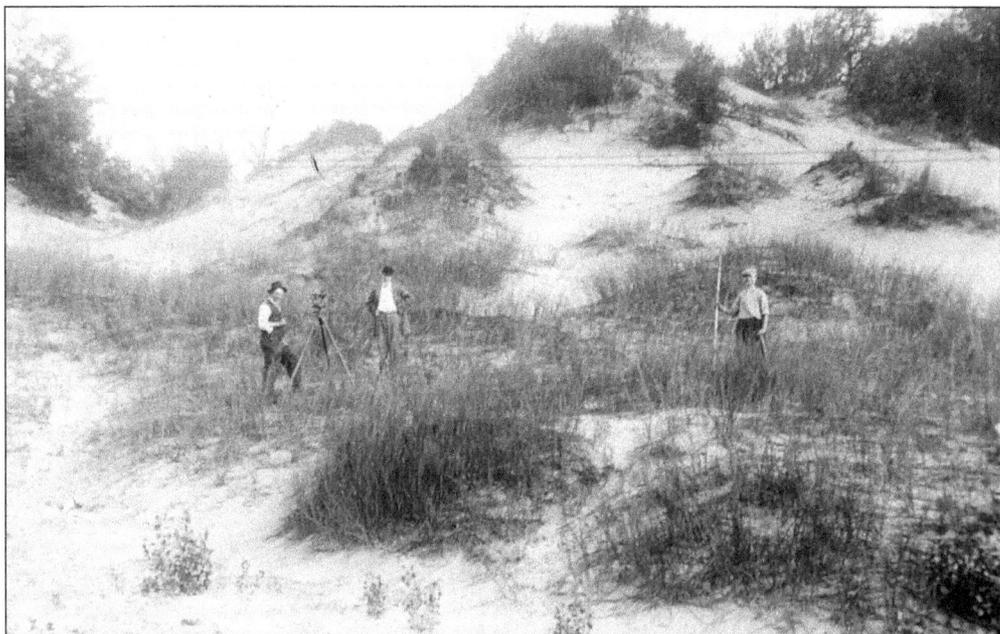

Surveying the land is the first of many challenges facing the developers who planned to bring in roads, utilities, and finally houses to the sandy hills covered with scrub growth. (MCPL)

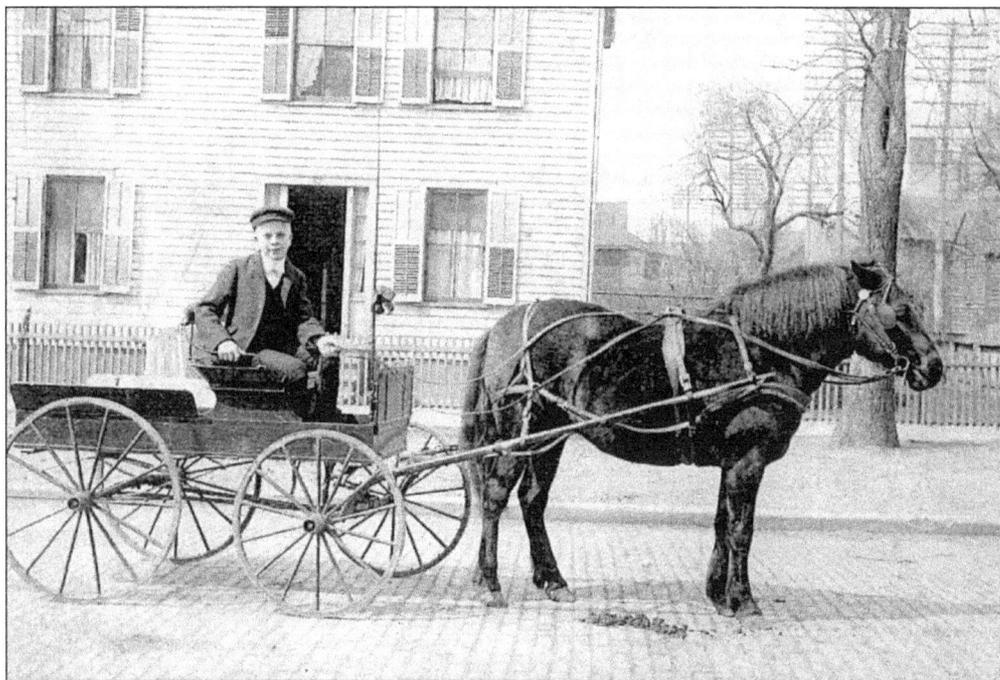

Henry Miller is pictured c. 1905, in the horse-drawn cart he used to deliver groceries. Henry began working for his father, William, at the age of 9, and by age 14 advanced to cutting meat. The Miller Market had been founded by his grandfather, Jacob, who moved to Michigan City in 1876 and established the family business at Tenth and Franklin Streets. (Courtesy of Fred Miller.)

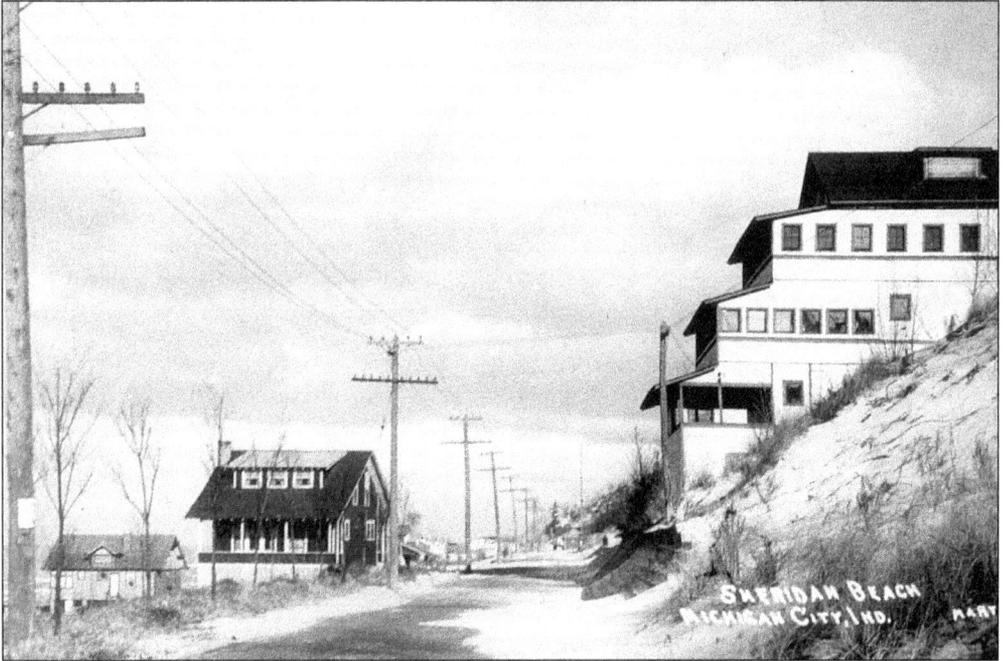

The Shawmut Hotel (right) was built on the hillside by Orrin S. Glidden, one of the early real-estate developers. Glidden was a Michigan City bakery owner who envisioned Sheridan Beach as a resort community. (MCPL)

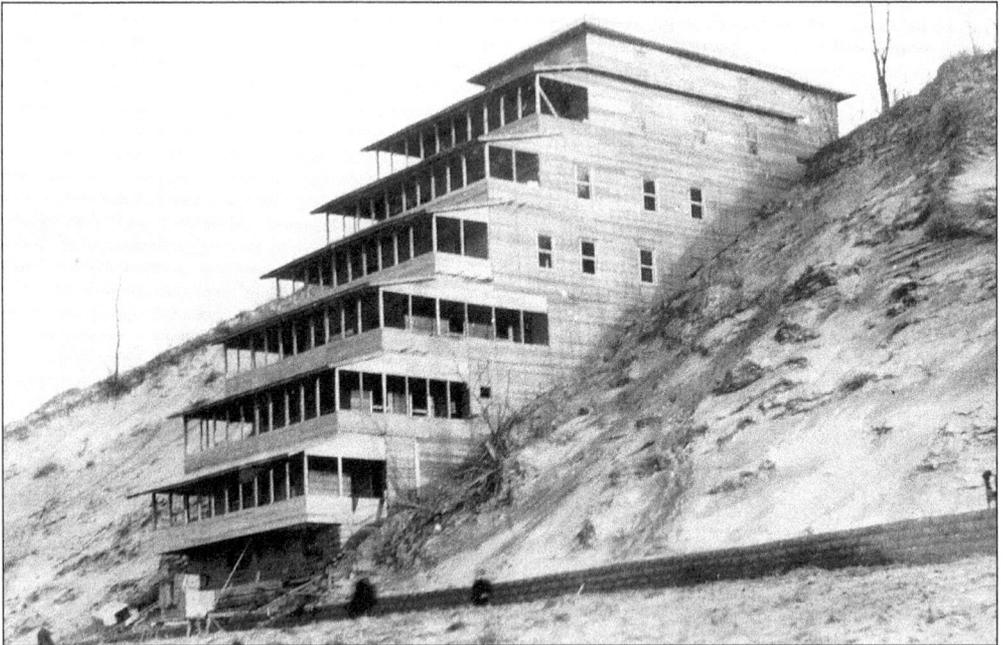

"Glidden's Folly," the building was nick-named when it was extended to seven stories. The hotel later was converted to apartments, and subsequently was torn down. Glidden speculated in real estate in Michigan and Wisconsin, as well as Indiana, but lost most of his investments during the Depression. (MCPL)

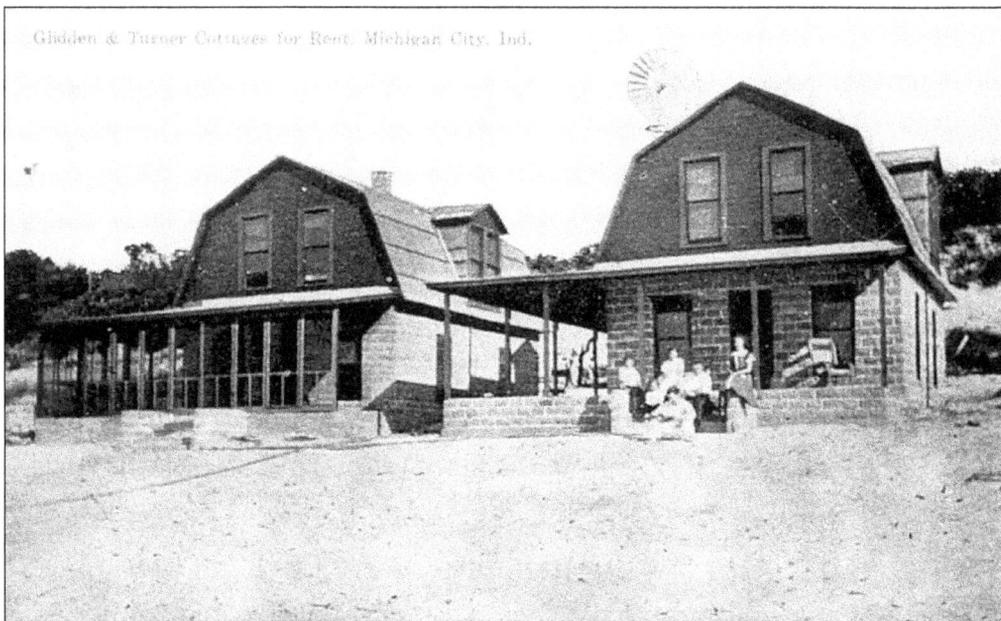

Glidden Rental Cottages were built right on the sand, facing the water. This is a rare photo, depicting two of the earliest cottages built in Sheridan Beach by Frank Glidden, for his brother Orrin S. Glidden, and Orrin's wife Olive Turner Glidden. (Courtesy of Jackie Glidden.)

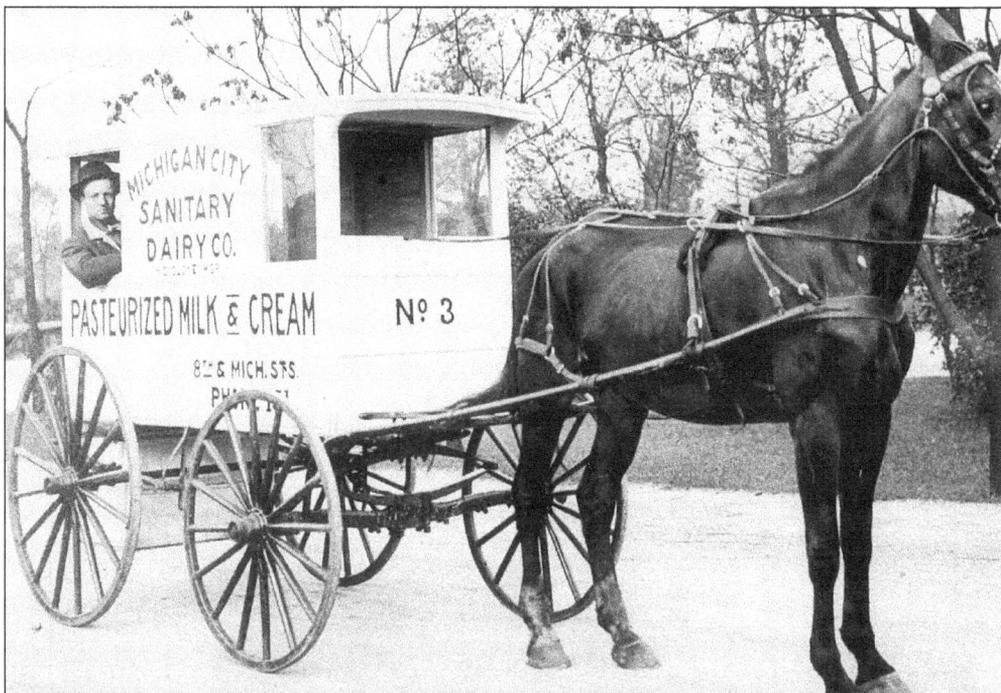

The Milk Truck also made daily deliveries to customers in the city and the outlying beach communities. Michigan City Sanitary Dairy Co., with M.C. Gloye as manager, operated at 8th and Michigan Streets. (MCPL)

VACATION OUTING, 1911

Do you intend taking a summer vacation? If so, you will do well to investigate the advantages offered at Sheridan Beach, at Michigan City, Indiana, which is the finest bathing beach on Lake Michigan; but a short distance from Washington Park, and surrounded by the most picturesque hills and beautiful scenery, pure, exhilarating atmosphere, free from noise and other disturbing influences, and just the place to rest and enjoy your vacation.

Every advantage to be had in the way of boating, fishing, swimming, autoing, driving and many other pastime pleasures may be had at reasonable rates, and you may supply the table with fresh fish, and from the farms with sweet, fresh milk, butter, eggs, vegetables and young chickens in season.

An hourly hack line to and from the city will be run to accommodate the public at a fare of 10 cents, and groceries and provisions will be delivered free of charge.

Vacation Outings were advertised in 1911 to out-of-towners who had already discovered the entertainments of Washington Park. (MCPL)

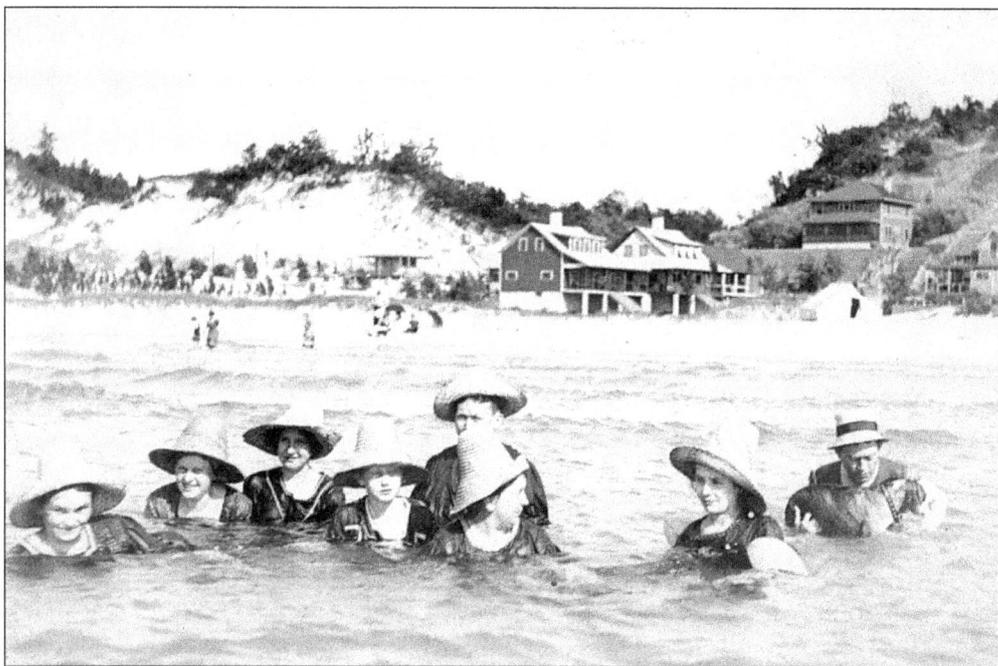

Swimmers in the chilly waters of Sheridan Beach kept their hats on, and brought along the family dog. Ada Barnes (second from left) lived at the beach year-round and walked through the dunes to Elston High School. She later married Carter Hugh Manny Sr. (MCPL)

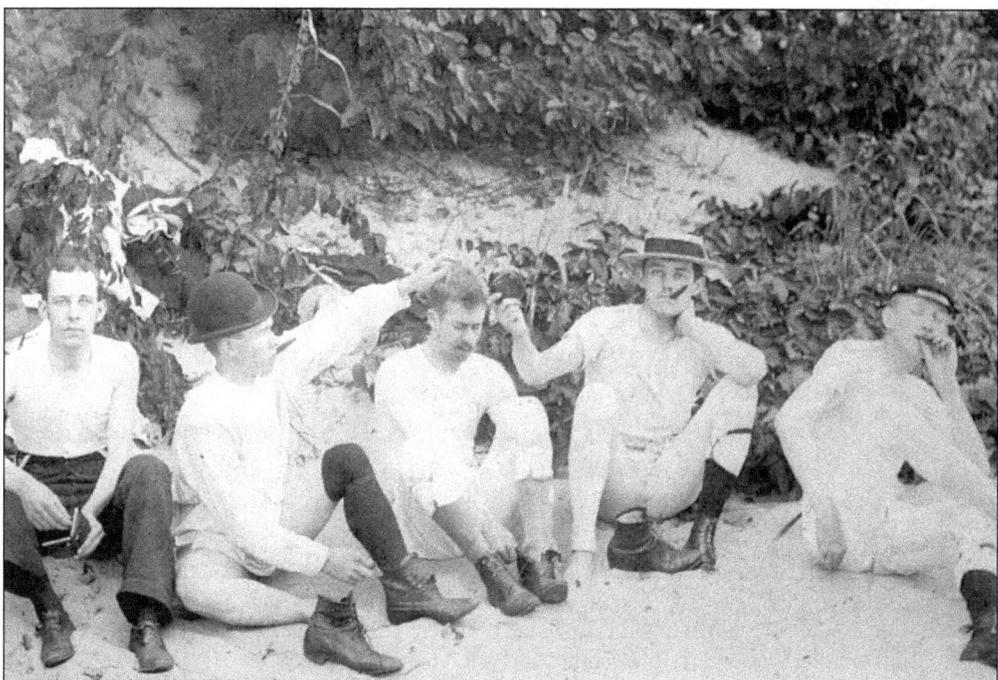

Dapper young men are pictured at the beach in their skivvies, gartered stockings, high-top shoes, and of course their hats. (MCPL)

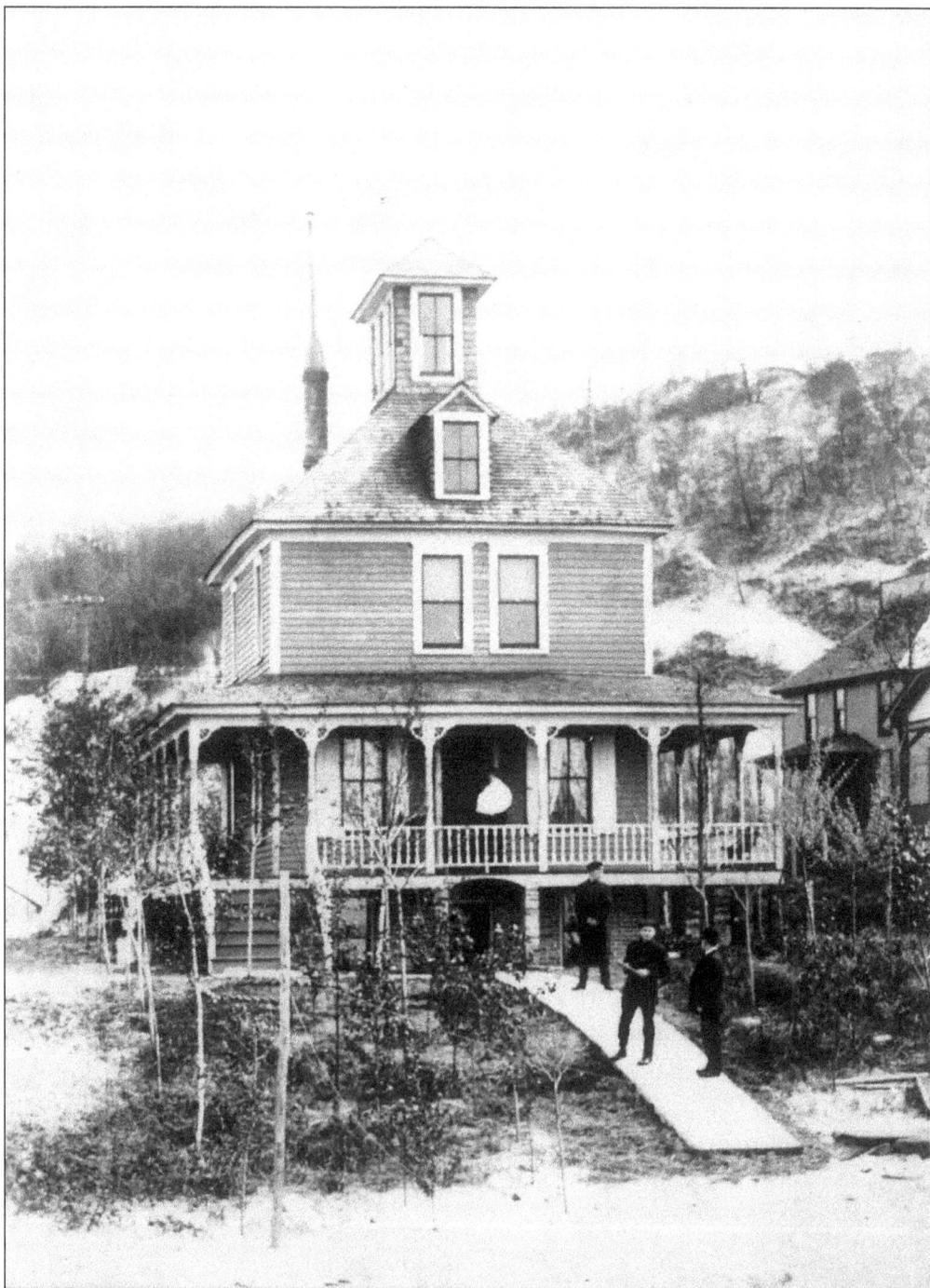

The Wellnitz Cottage was the first permanent residence in Sheridan Beach. It was built in 1905 by Oscar Wellnitz, a Michigan City bakery owner. The cottage, with its wide porches and observation cupola, stood east of Washington Park. (MCPL)

"Restwell" was owned by Michael Kromshinsky, who had a gentlemen's clothing store on Fourth and Franklin, in the building later restored by a medical foundation. His two unmarried sisters and two daughters, all of whom were school teachers, lived in the family home on Spring Street. Kromshinsky and his wife Emma moved to "Idlewild" cottage in 1921, and in 1925 to "Restwell," which is still standing. (BKS)

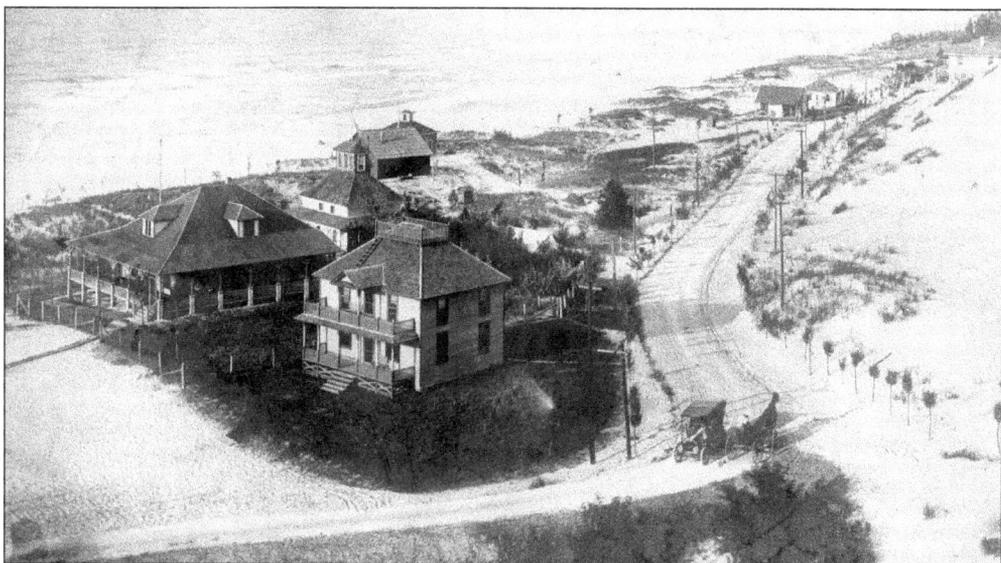

The intersection of Lake Shore Drive and Washington Park Boulevard was photographed, c. 1904, by Harry M. Barnes, showing Prof. Brewster house (center), Dahlke house (with open porches), the Wellnitz house (with cupola), and the Barnes cottage (beyond Wellnitz). In the upper right corner is the Wolf cottage, and across the street to the left is the real estate office of I.I. Spiro and W.B. Manny, the first developers of Sheridan Beach. (Courtesy of Carter H. Manny Jr.)

Sheridan Beach resident Ella Kimball Barnes is pictured here in 1910 at the home of her sister Katherine Jenks, in Waterford. The photo was taken by her husband, Harry M. Barnes. (Courtesy of Carter H. Manny Jr., their grandson.)

Ann Baxter, who went off to Hollywood and became a famous movie star (*All About Eve*) is pictured here (left) at Sheridan Beach, with Kendrick Cannon and Carter Manny Jr., in August 1927. Anne grew up in Michigan City. Her mother, Frances Baxter, and uncle, John Lloyd Wright, were children of the famous architect Frank Lloyd Wright. (Courtesy of Carter H. Manny Jr.)

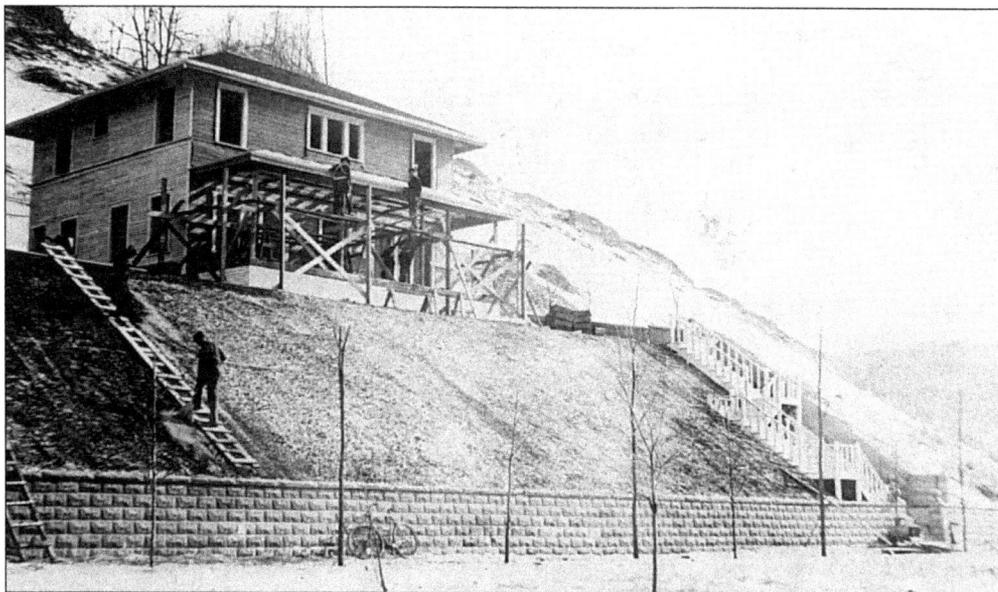

Wolf Cottage was built near the site of the Sheridan Beach Hotel for its president and manager, John Wolf. The two-story house was considered "a sort of bell cow" to lead other home-builders and vacationers to Sheridan Beach. Wolf had plenty of experience, as the manager of the Vreeland Hotel in Michigan City and the Rumely Hotel in LaPorte. (OLM)

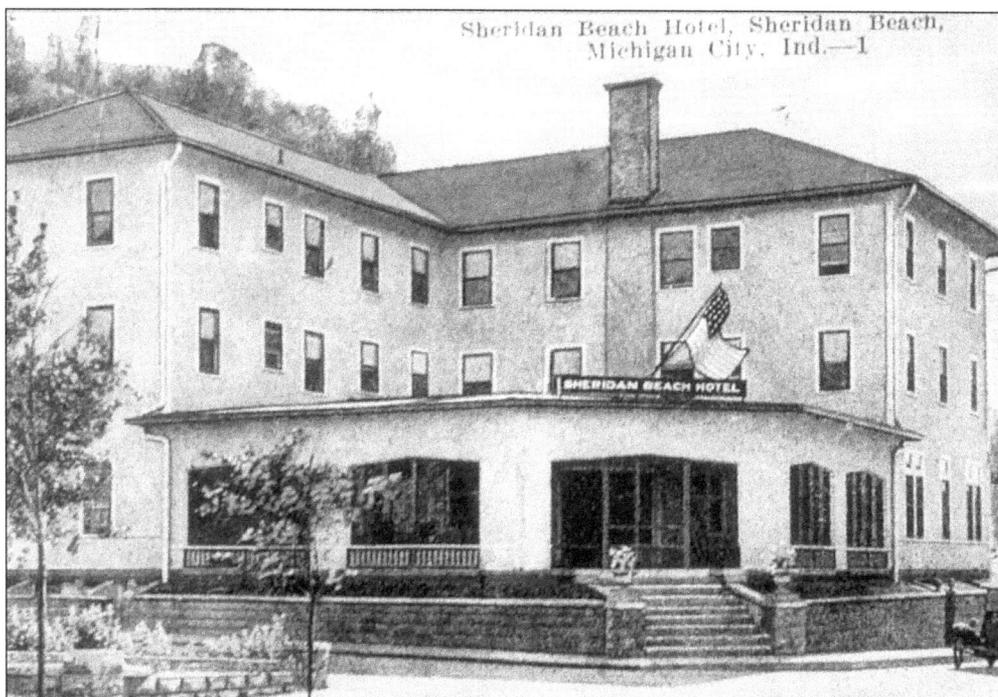

Sheridan Beach Hotel, with 51 guest rooms and a fancy restaurant, opened to the public on June 28, 1920. It stood at the corner of Lake Shore Drive and Lake Avenue. The hotel did a brisk business in the summer and had numerous year-round residents. The building was destroyed by fire in September 1956. (MCPL)

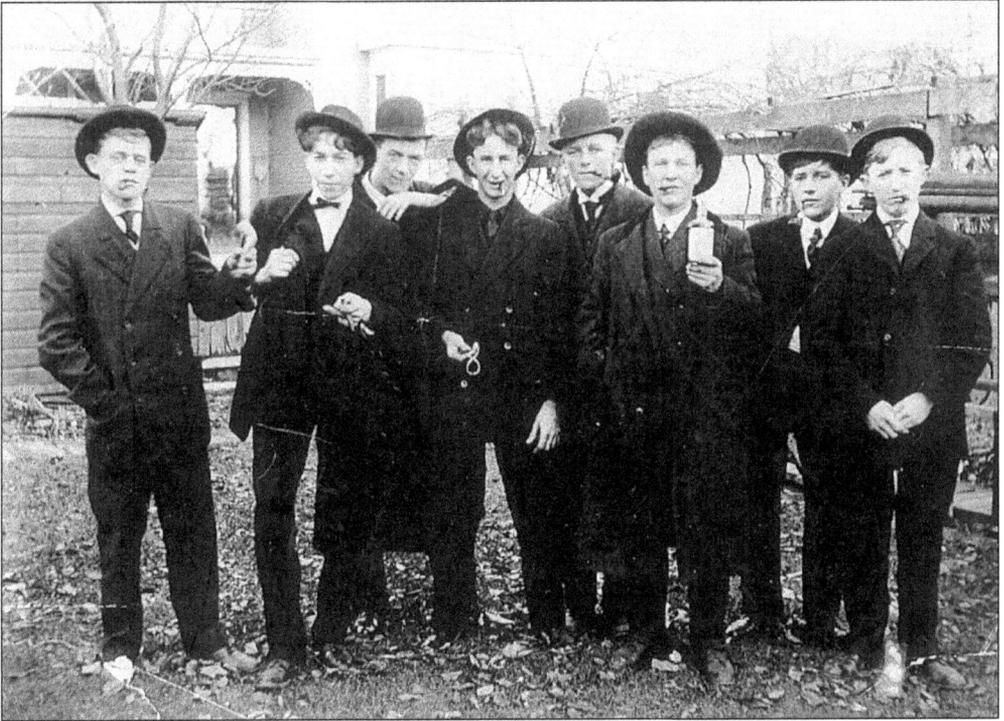

A bottle of moonshine, a pipe, or a good cigar, and what else does a young man need for an afternoon—except a photographer to record the occasion? (OLM)

Riding the waves was another challenging way to spend the afternoon on Lake Michigan. (MCPL)

Irving Solomon, a Chicago lawyer, was offered the job of running the Schoenhofen-Edelweiss brewery, which he did for 12 years after Prohibition ended, and then returned to the practice of law. He and his wife Edith, who had a cottage in Sheridan Beach, are pictured here on board the S.S. *Michigan City*. (Courtesy of Jerry and Carol Solomon.)

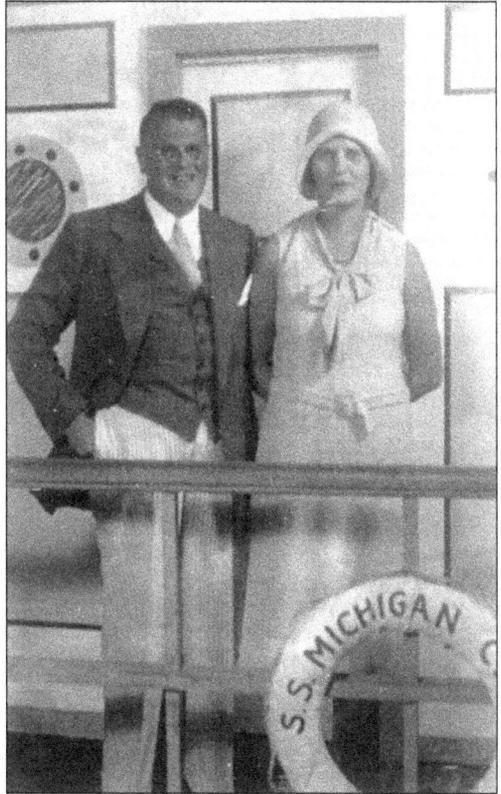

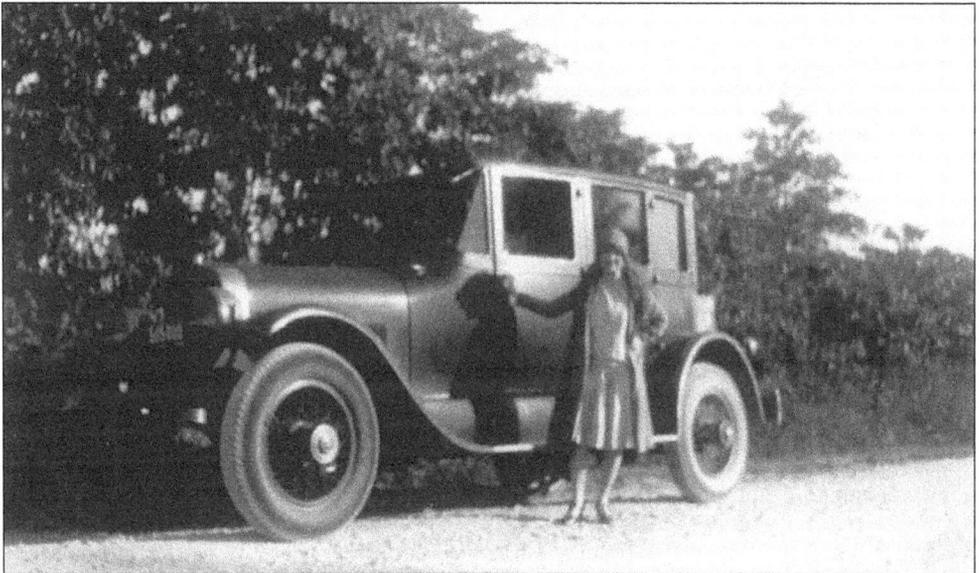

A high-fashion neighbor is pictured here beside her high-stepping automobile. (Courtesy of Marsha Stonerook.)

PROGRAM OF EVENTS

Schoenhofen Company — First Annual Picnic

Sunday, August 16, 1931

Address of Welcome.................Irving J. Solomon

RACES AND EVENTS

1. Girls' Race—6 years and under.
2. Boys' Race—6 years and under.
3. Girls' Race—7 to 10 years.
4. Boys' Race—7 to 10 years.
5. Girls' Race—11 to 15 years.
6. Boys' Race—11 to 15 years.
7. Young Ladies' Race—16 to 22 years.
8. Young Men's Race—16 to 22 years.
9. Married Ladies' Race—23 to 90 yrs
10. Ladies' Calling Contest.
11. Fat Ladies' Race—165 lbs. & over
12. Fat Men's Race—200 lbs. & over
13. Balloon Blowing Contest.
14. Boys' Pie Eating Contest—8-15 yrs
15. Backward Race—Girls 10-15 years
16. Men's Pipe Smoking Contest.

BALL GAME—Office vs. Sales Department

Special Novelties will be introduced by the following under the direction of

W. F. Lange, Master of Ceremonies:

Morris Hartman...................Vocal Selection

Wm. Faude
Walter Busch
Wm. Engelhardt
Frank Heimrath
} Schoenhofen German Quartette

SPECIAL—Dance of the Waves—By Chas. Kuehl and Bill Lange

Imitation of a Trained Sea Lion—by Fred Bement

The program of events included fun for everyone at the Schoenhofen-Edelweiss Company Picnic. Note the age and size requirements for the "young ladies" and "young men's" races, also for "fat ladies" and "fat men." The picnic was held annually (photo on next page) at Irving Solomon's cottage on Lake Shore Drive. (Courtesy of Jerry and Carol Solomon.)

This is a picture from the Schoenhofen Company Picnic. (Courtesy of Jerry and Carol Solomon.)

Long Beach beautiful—a dreamy vacation spot was depicted on the 1920s brochures, showing ladies of leisure lounging on park benches and golfers strolling arm-in-arm. (OLM)

Six

LONG BEACH
A Dream

LONG BEACH, which was to become the largest and most socially-oriented of the beachfront communities, posed a whole new set of problems for potential developers. Much of the land was more suitable for growing cranberries, or wild rice, than for building houses. Shrewd developers eventually transformed the cranberry bog into a golf course; and "Three-Mile Ditch," which drained the bog, became St. Lawrence Avenue. But in the early 20th century, golf courses and winding avenues were merely dreams. Even the beach was inaccessible.

"Sha Ha Walla Beach," the name first applied to the Long Beach lakefront, supposedly had Indian origins. By the mid-1890s, Judge Harry B. Tuthill had acquired most of the land by way of tax sales and quit claim deeds, and platted a 94-lot development along the lakefront. A few lots were sold to Dr. Alvin Tillotson and his son-in-law Dr. Edward Blinks, who jointly opened the first hospital in Michigan City. Blinks and his teenage "gang" had earlier discovered the "hermit's hide-out," during their frequent explorations of the dunes. Edward Blinks developed a great fondness for the lake, swam daily, and spoke often of its healthful qualities. Another development in the beach area was a YMCA camp, which operated for a few years.

Otherwise, there was little interest in the lakeside property until 1914, when Orrin S. Glidden began investing. Glidden already owned land further east, in the future Duneland Beach and in Sheridan Beach, where his brother Frank had constructed more than 50 houses. Glidden purchased 30 Long Beach lots in 1915 and another 10 acres in 1917, and with his wife, Olive Turner Glidden, developed the First Addition to Long Beach. Glidden also started up a golf course on land that he owned.

Dreams of a fabulous residential community began to be realized when Orphie Gotto, who ran a coal and feed store in Michigan City, went into the real estate business with Orrin Glidden. In 1918, they purchased 200 lots east and south of the First Addition, much of which became the Highlands, and the next year they platted Long Beach Terrace.

Advertisements for Long Beach took on an other-worldly air, promoting "a fairyland of nature lovers, a symphony of color aglow with grandeur and filled with the charm and romance of the far-famed and fascinating dunes." Romance and charm were just part of the dream for this land that had recently been a cranberry bog. The future was also to include prize-fighting, horse-back riding, ballroom dancing, visitors from foreign countries, and international celebrities, especially from Chicago.

LONG·BEACH

We have just opened a new addition to our beach of 453 lots, all on the beach. This will be your last chance to get a lot on the east beach.

The price is still reasonable and the terms are to suit the purchaser. A small amount down and the balance in monthly payments.

These Lots Border on the Finest
Bathing Beach in the World

And as we are close to Chicago, with best of transportation facilities, these lots will soon be sold.

Also Remember we give you a written guarantee to refund your money when the lot is paid for, if you are not satisfied

Remember we have gas, water, electric lights, telephone and a paved street to these lots. Also automobile transportation with a 5c fare. We will be glad to show you what we have.

Remember you are not placing yourself under obligation to buy by going out to see them

See or phone

O. S. GLIDDEN ‖ Frank GLIDDEN
Phone 458 ‖ Phone 594

Long Beach ads were placed in local newspapers as early as 1914 by real estate speculator Orrin S. Glidden, who owned a bakery and lunchroom in Michigan City, and his brother Frank, who built homes. Their addition had 453 lots and paved streets. (MCPL)

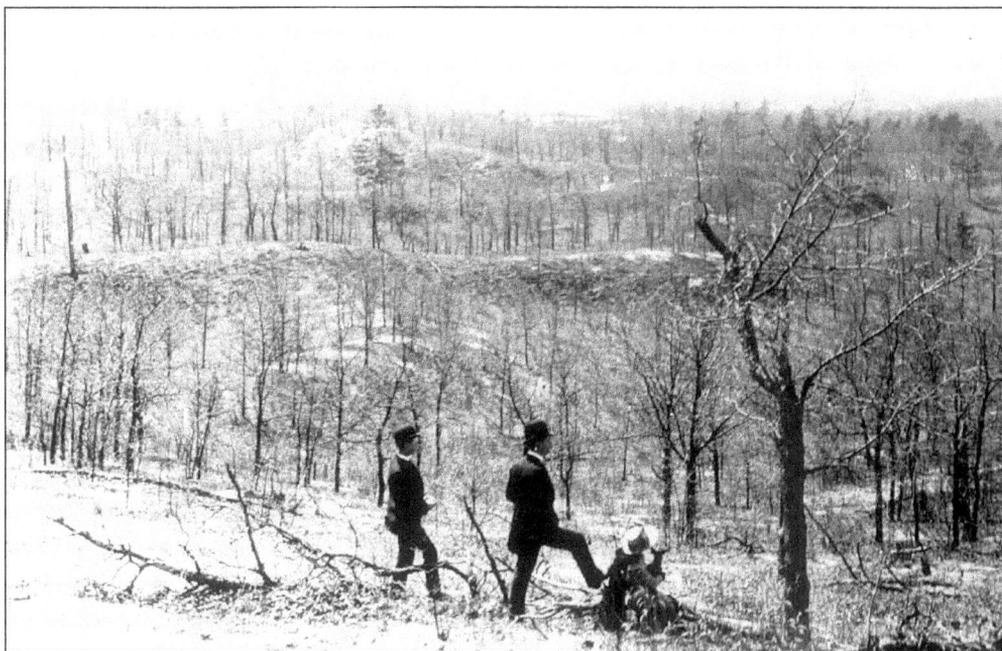

The rolling hills of Duneland presented a beautiful image to the ambitious developers, who envisioned a resort community easily reachable and highly desirable for persons wishing to escape the congested streets of Chicago. (MCPL)

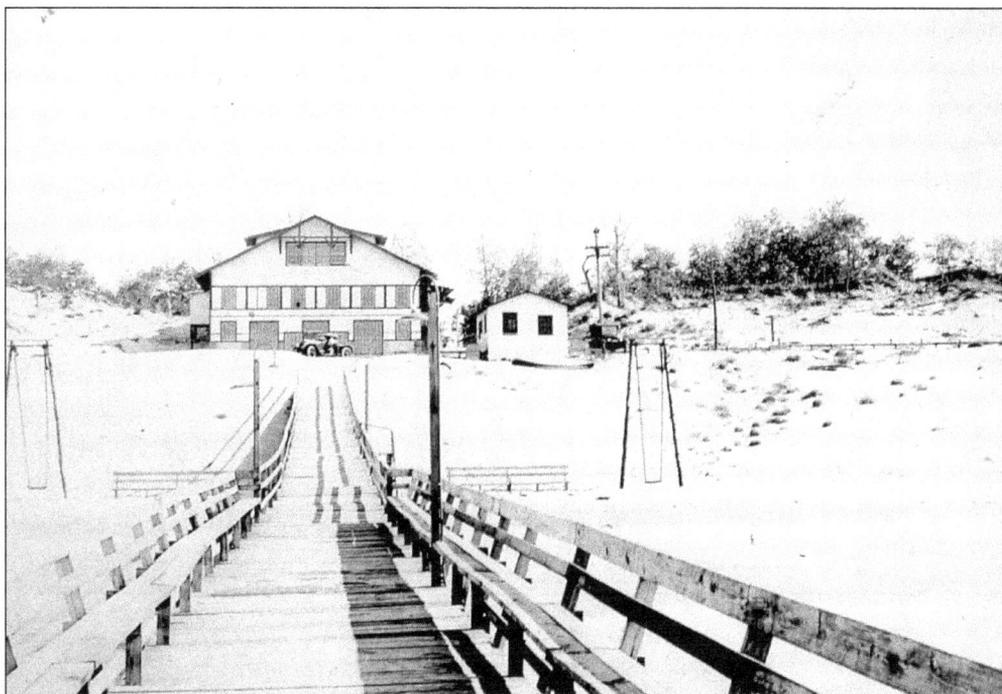

A dance pavilion was one of the first amenities provided for residents of the beach communities —a dance pavilion with a small real estate office to the side and a long pier, with benches, leading onto beautiful Lake Michigan. (MCPL)

CHICAGO

MICHIGAN CENTRAL R.R.

PERE MARQUETTE R.R.

BEECHER

BLUE ISLAND

HOMEWOOD

CHICAGO HEIGHTS

HAMMOND

SOUTH CHICAGO

DYER

WHITING

EAST CHICAGO

LAKE

LOWELL

SHELBY

CROWN POINT

So. GARY

GARY

MILLER

HOBART

HEBRON

WHEELER

DUNE PARK

MICHIGAN

VALPARAISO

CHESTERTON

MICHIGAN CIT

**All Good Roads
Lead to**

Long Beach

America's Finest
Country Home Community
and Playground

56 Miles from Chicago
35 Miles from South Bend
25 Miles from Gary
2 Miles from Michigan City

It is easily reached and easily en-
joyed by every member of the
family, no matter what may be his
inclinations. Come—visit Long
Beach. A revelation and a thou-
sand welcomes await you

WESTVILLE

SOUTH SHORE
ELECTRIC

LAPORTE

NEW BUFFALO

LONG
BEACH

THREE OAKS

GALIEN

LIBERTY

BUCHANAN

ROCHESTER

PLYMOUTH

SOUTH BEND

NILES

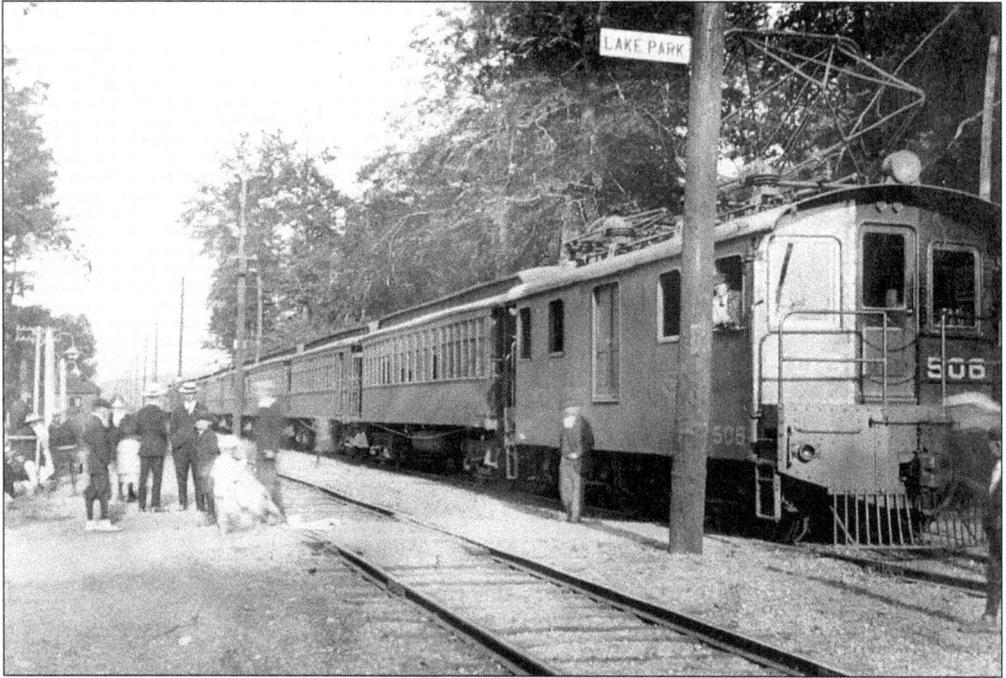

South Shore trains, the electric interurban trains linking Chicago with Michigan City and South Bend, were completed in 1908, providing city dwellers with easy access to Duneland. The train is unloading passengers here at the Lake Park station. (MCPL)

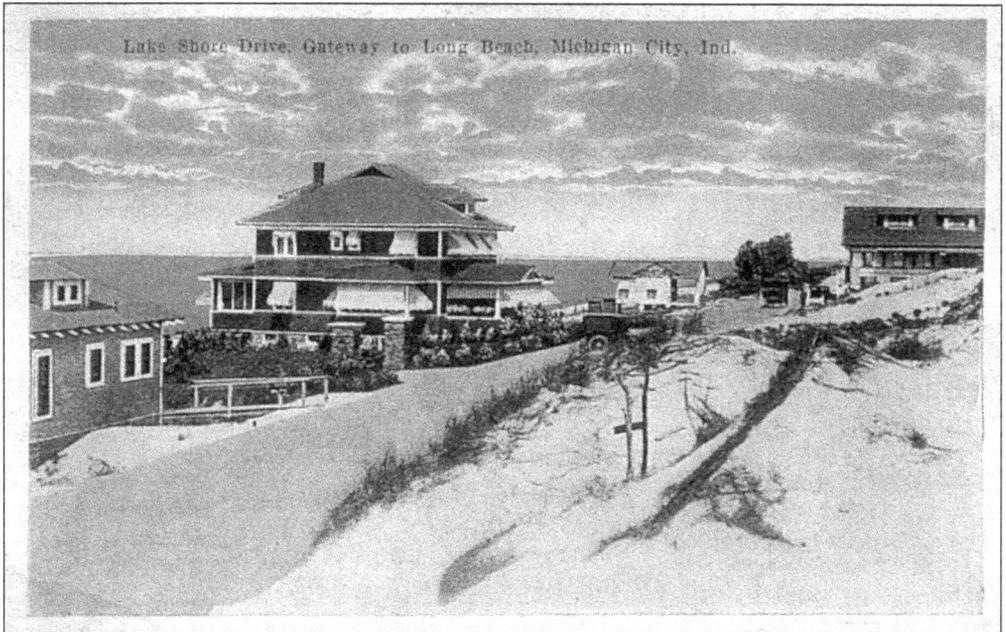

Lake Shore Drive began to attract Chicagoans, notably Cook County, Illinois Assessor Charles Krutckoff, who built the large four-story house pictured at left. It was a real eye-catcher, with a green frame set off by red shingles and striped awnings. A pier was constructed to dock "The Red Head," the first speedboat in Long Beach. (Courtesy of Thate Land Surveying.)

"Overlook," the first cottage in Long Beach, was built in the spring of 1917 for Orrin S. Glidden, on the hillside near Stop 15. It was later sold to J.W. Chandler. The two-story house, with its row of porch windows facing the lake, is still standing. (BKS)

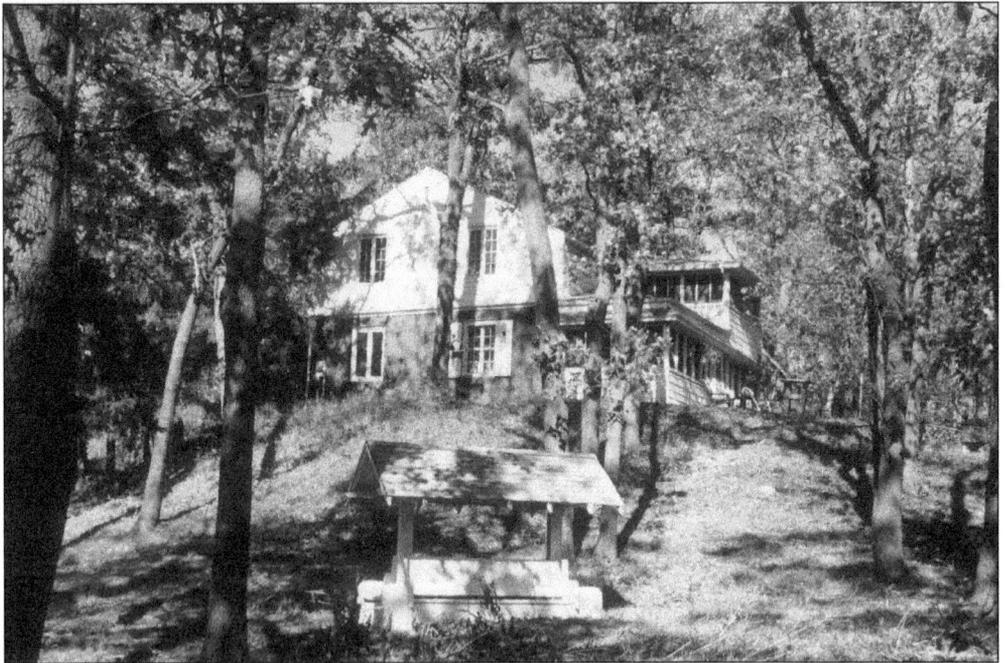

"Four Winds" was built in 1920 by Bertha Bohn, a Chicago environmentalist and Fellow of the American and Royal Geographic Society. Her husband, Henry Bohn, was editor of *Hotel World* and vice-president of the National Dune Park Association. The grounds were to be designed by the renowned landscape architect Jens Jensen. The Bohn house still stands, at the end of Ridgemoor Drive, in the Highland section of Long Beach. (BKS)

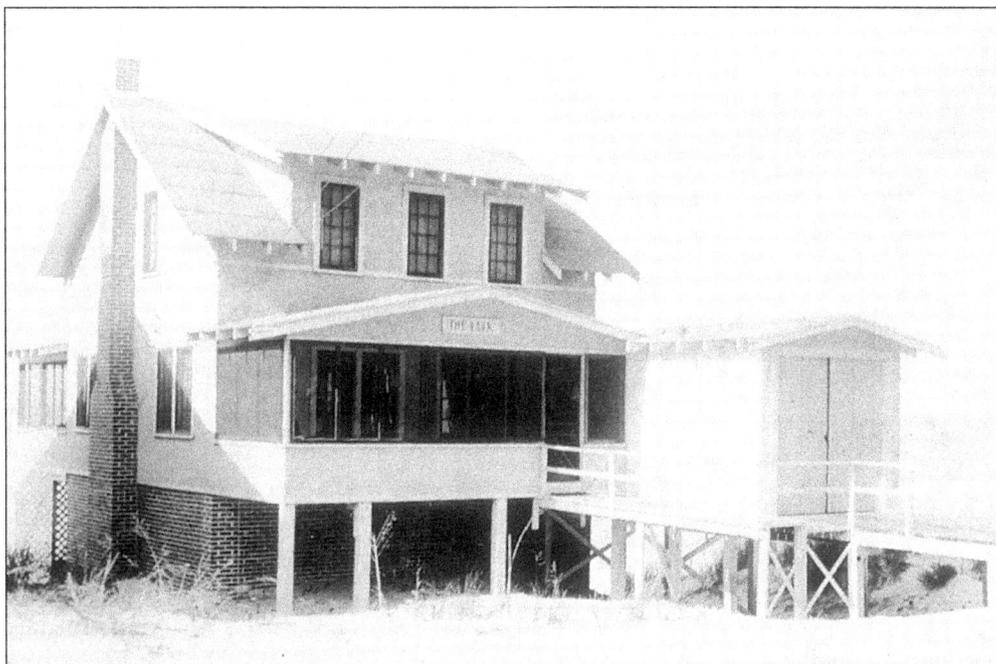

"The Lark" was one of the typical frame cottages built by Long Beach Company. Its open porches, boathouse, and upper-story bedrooms made it an appealing vacation property. It was rented in the summer of 1929 by Dr. and Mrs. Russell Gilmore, of Michigan City, and their two sons. "The Lark" was on the lakeside, west of Blanchard Court. (MCPL)

"Cozy Nook" was the second cottage in Long Beach. It was built for O.G. Hoffman by Frank Glidden, who then built "White Oaks" for his brother and "Red Oak" cottage for himself—all in 1918. Rapid construction of many cottages then began, and Long Beach Company came into the picture in 1919. (Information from *Long Beach Billows*, 1927.)

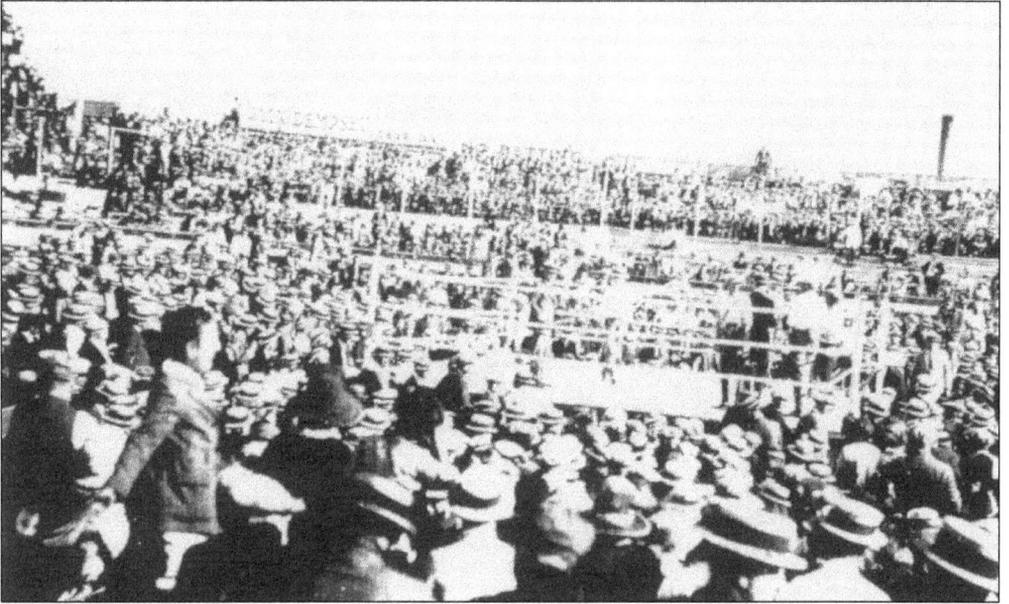

Sky Blue Arena stood on U.S. 12 in Michigan City, on the site later occupied by From's Supplies and Knoll Brothers. A crowd of thousands is pictured here on Labor Day, 1922, for an exhibition by world heavyweight champion Jack Dempsey, with one of his sparring partners. The previously-scheduled Dempsey-Brennan fight had been prohibited, because of illegality, by Indiana Gov. Warren T. McCray. Dempsey spent several summers in Long Beach. (Courtesy of Carter H. Manny Jr.)

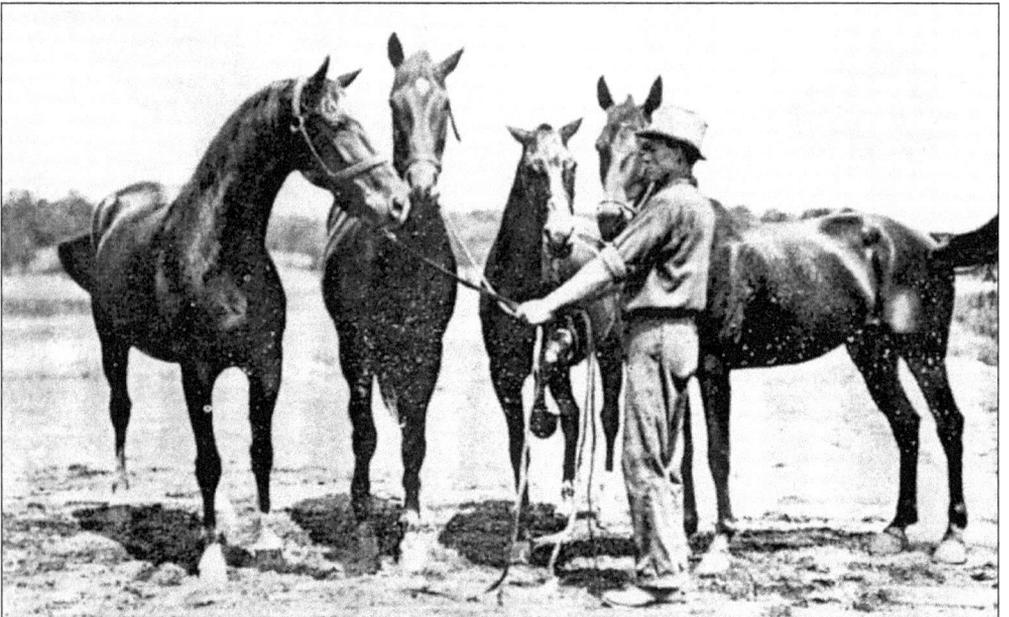

Long Beach Riding Master Bill Beach is pictured at the stables on Oriole Trail with four thoroughbreds—Bob, Star, Lady, and Queen. In the 1920s, the riding trails were "still as primitive as the days when the Potawatomies guided their Indian ponies over these same dirt trails." (*Long Beach Billows*.)

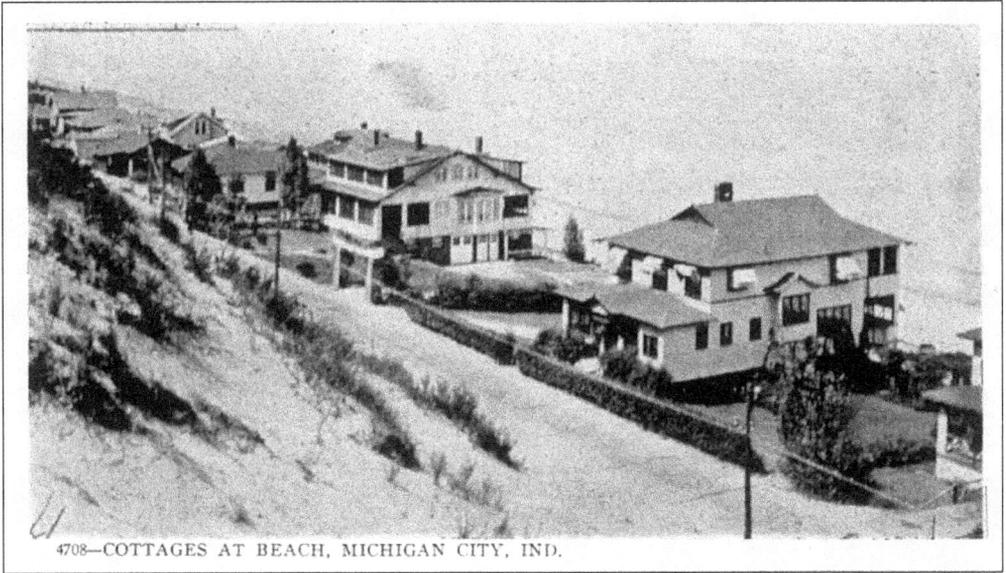

4708—COTTAGES AT BEACH, MICHIGAN CITY, IND.

Along Lake Shore Drive, the cottages in Long Beach grew bigger each summer, as did the families that came to spend their vacation on the Indiana Riviera. (Courtesy of Thate Land Surveying.)

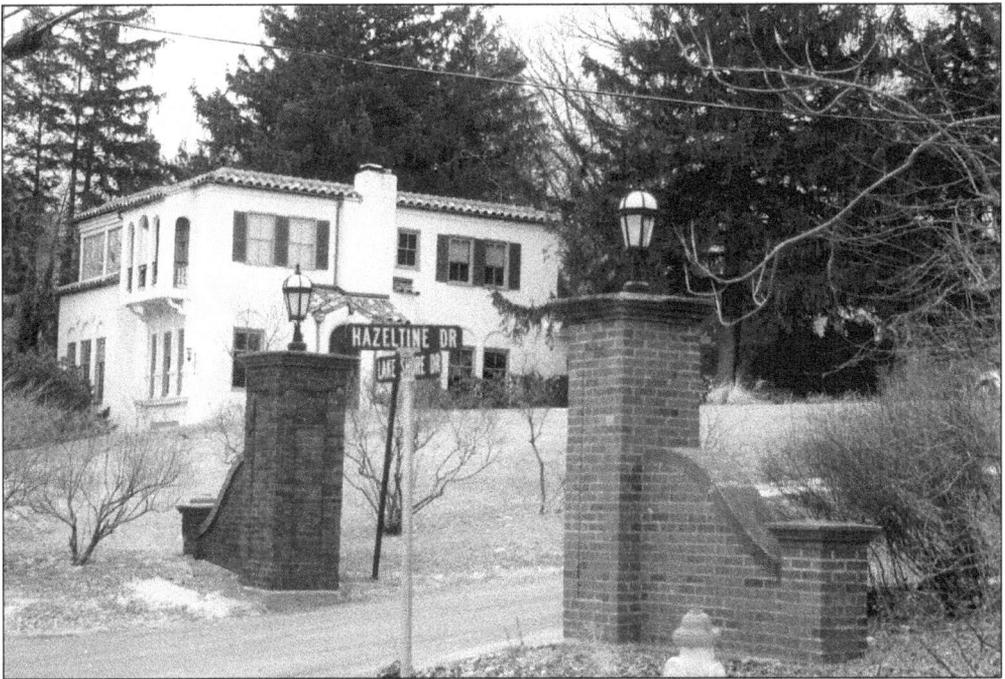

HAZELTINE DR
LAKE SHORE DR

The roads leading inland, off Lake Shore Drive, were all marked with a pair of stylish brick columns and lampposts. This gateway stands at the corner of Lake Shore Drive and Hazeltine, where the white stucco home with red tile roof once belonged to Dr. Little, a Chicagoan. It was called "Little Vista." (BKS.)

Cute kids are pictured on the beach at one of the impressive homes along the lakefront in the 1920s. (Courtesy of Marsha Stonerook.)

Irene McLundie Bernius, shown wading in Lake Michigan with a friend, came from Scotland one summer to visit her aunt and uncle, Blanche and Edward McLundie, in Long Beach. There she met Roy Bernius, whose family was renting a nearby cottage. Irene became Mrs. Bernius and ended up living on Juneway Drive in Long Beach, happily ever after. (Courtesy of Marsha Stonerook.)

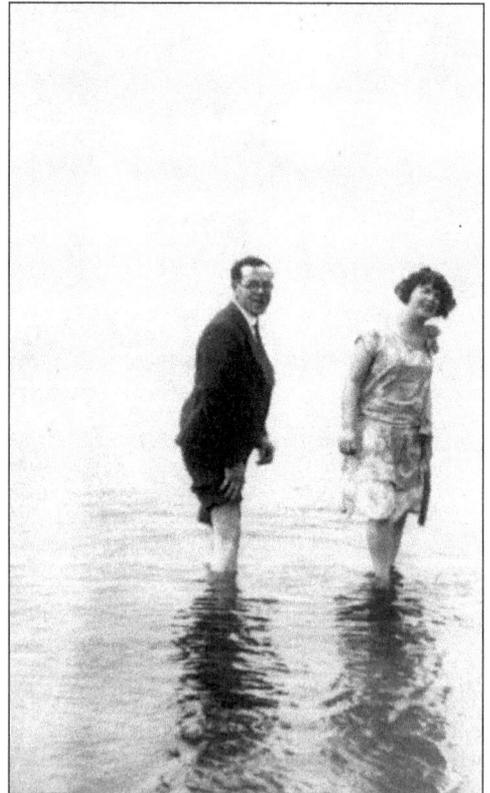

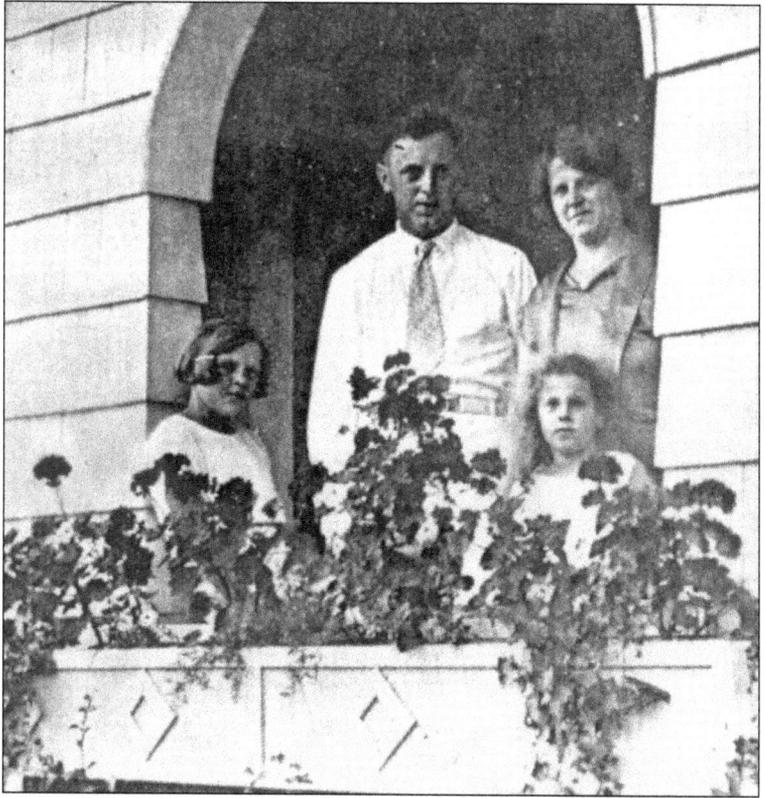

"Woodcrest" was the fulfillment of a dream for the Talman family from Chicago. They are photographed with two daughters, in their picture-perfect cottage on Roslyn Trail—with flowering plants in the window-boxes and a car in the driveway, here in "the land where harmony resides and all discordant elements have been banished." (*Long Beach Billows*.)

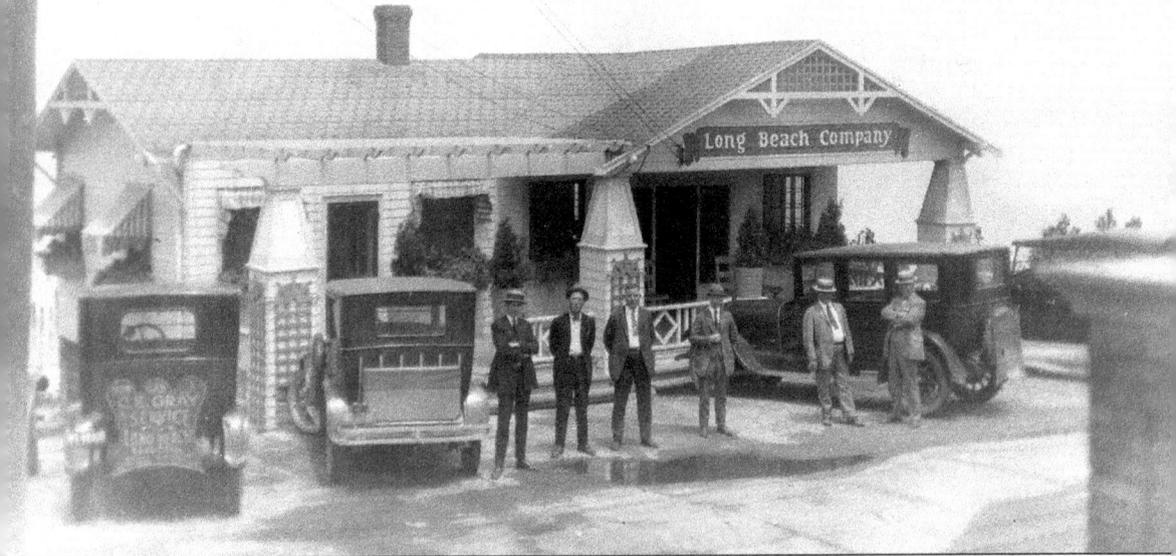

Long Beach Company established its real estate office at Golden Gate, Stop 20 on Lake Shore Drive. Several agents stand ready to conduct tours, and C.E. Gray taxis are available to transport prospects from South Shore trains to Long Beach and its "veritable network of boulevard roadways." The brochure boasted that the winding, curving roads had not been laid out by an engineer who might "callously map a checkerboard plat." Gotto himself had planned the roadways so as "constantly to be discovering new charms, new vistas of great distance, new valleys of green, broad expanse of water. . . ." Gotto also gave many of the streets California-sounding names—Golden Gate, Glendale, Claremont, Loma Portal. Most fanciful of all was the name applied to the last subdivision he created—"Elysium"—a playground of the gods. (Courtesy of Old School Community Center, Long Beach.)

Seven

LONG BEACH
The Reality

WITHIN FIVE YEARS the dream community of Long Beach developed at a phenomenal rate. Orphie W. Gotto was the driving force and the controlling power. In 1919, Long Beach Company was incorporated with Gotto as president and Glidden as secretary, and capital of $250,000 for the purpose of buying and selling real estate; 750 acres were subdivided. In 1920, the plat was recorded for Long Beach Gardens, including an 18-hole golf course, and a major advertising campaign promised "stupendous improvements."

In 1921, the Town of Long Beach was incorporated with three trustees: Harry Carver, Lou Dee, and Orphie Gotto, as president; Mrs. Gotto was town clerk. In that same year, Gotto bought up Glidden's shares. In 1922, the clubhouse opened, as well as the swimming pool, the "Roman Plunge." To celebrate its opening, Olympic star Johny Weismuller was invited to put on a swimming exhibition. Residents of 200 cottages were on hand for the festivities.

On February 19, 1924, Long Beach Country Club was incorporated, with Orphie Gotto as one of twelve board members. On the same day, papers were drawn up for Long Beach Country Club Holding Company, with Orphie Gotto, Belva Gotto, and Clarence Mathias as incorporators. Long Beach Company formed the holding company and then conveyed the golf course property to the holding company. It was a unique arrangement for a unique community, an entire subdivision built around a golf course. When a couple bought a house in Long Beach, they received a share in the holding company that owned the golf course. The holding company leased the property to Long Beach Country Club for 50 years, after which time a new holding company was to be formed, with new requirements.

By this time, many prominent Chicagoans had joined the Michigan City business leaders who originally settled in Long Beach. Lavish parties were held. William F. Barnard, owner of a Chicago printing company and president of Long Beach Country Club, brought out 35 guests in a Michigan Central private railroad car. Long Beach became popular with Chicago politicians, the first being Cook County Assessor Charles Krutckoff, who built a large home on Lake Shore Drive. Chicago mayors were frequent guests of Long Beachers, and Illinois Governors Len Small and Louis E. Emmerson were entertained at the country club.

In 1930, Long Beach had over 400 homes and 63 families in permanent residence. Some of them had given up their Chicago homes after the stock market crash, and were living year-round in their beach homes. A school was founded and a town hall was built—two significant structures for establishing Long Beach as an independent, autonomous community.

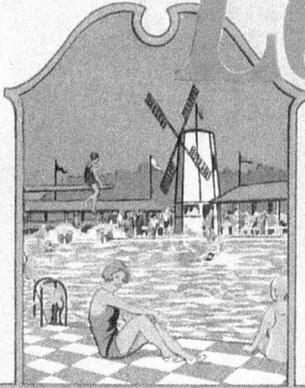

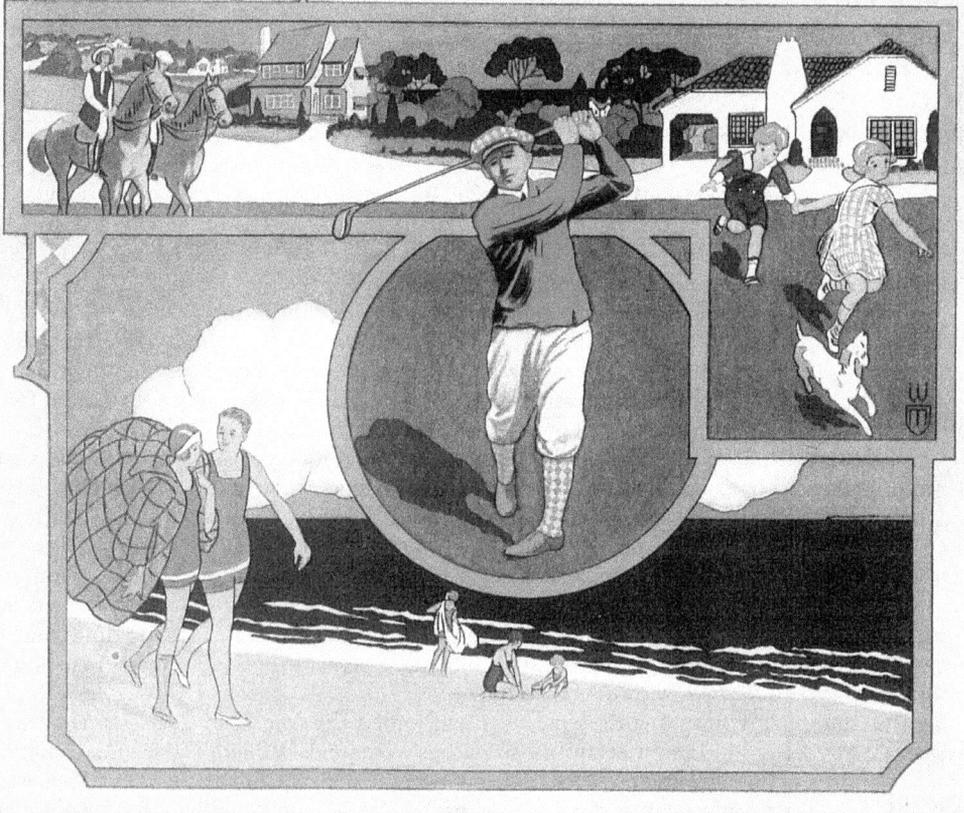

This Long Beach brochure, a handsome booklet printed in the 1920s, depicts the wholesome outdoor activities available to young home-buyers: strolling along the lake, playing in the yard and on the beach, horseback riding, swimming, and sunbathing—all centering on the most fashionable pastime: golf. (Courtesy of Max Barrick.)

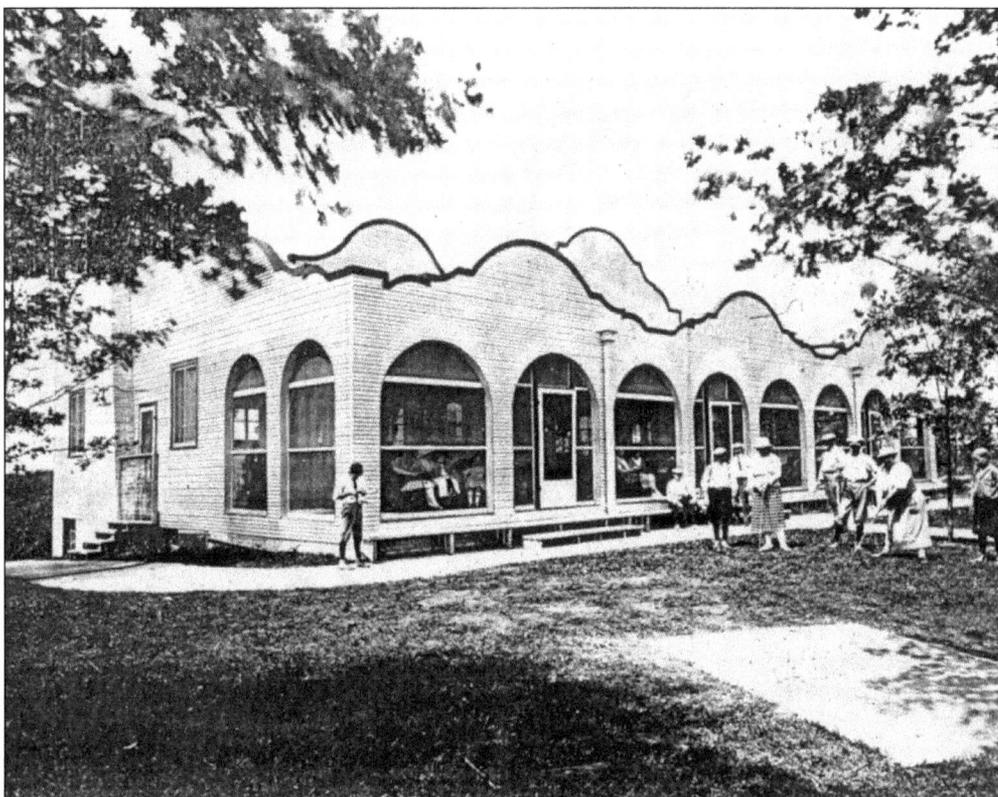

The Nineteenth Hole, a new clubhouse for Long Beach Country Club opened on July 1, 1922. The building stood atop a high dune and was described as "the quaint old Spanish Mission type, its long, graceful curves harmonizing completely with the billowy dunes." First tee was in front of the clubhouse, and number nine was at the foot of the hill. G.L. Spence of Oak Park was president of the club, and the manager was Daniel Bernoske of Michigan City. Dances were held every Saturday night. (*Long Beach Billows.*)

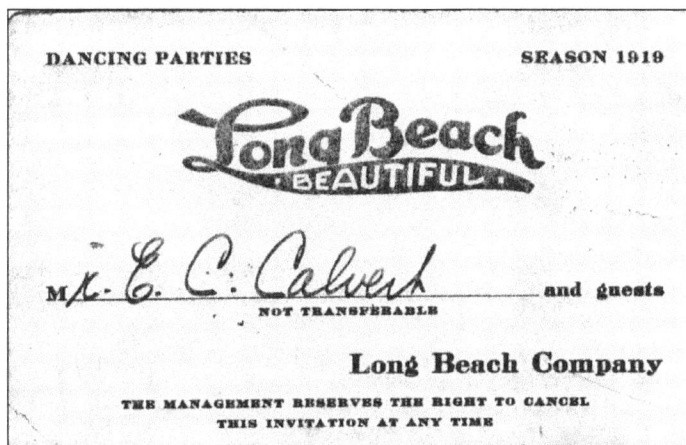

A dance card was issued in 1919 to E.C. Calvert, for the weekly dances that took place at the Pavilion, which preceded the new clubhouse as social center for the community of Long Beach Beautiful. (OLM)

DANCING PARTIES SEASON 1919

Long Beach BEAUTIFUL

M__. *E. C. Calvert*_____ and guests

NOT TRANSFERABLE

Long Beach Company

THE MANAGEMENT RESERVES THE RIGHT TO CANCEL
THIS INVITATION AT ANY TIME

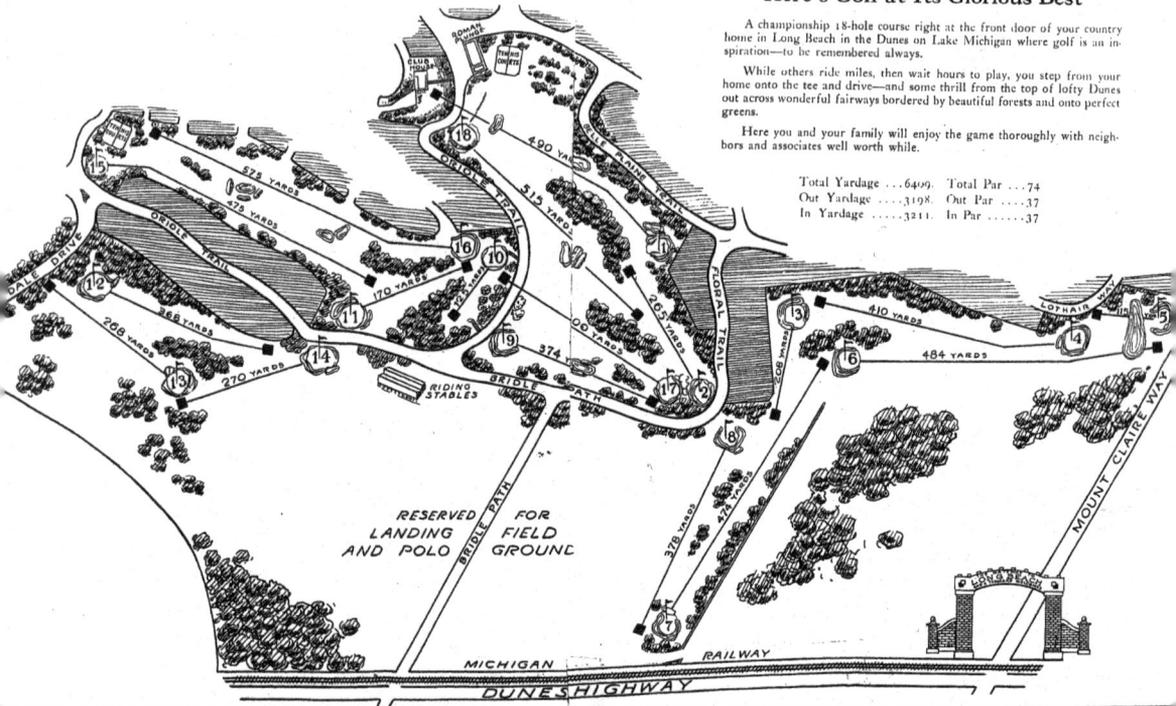

Here's Golf at Its Glorious Best

A championship 18-hole course right at the front door of your country home in Long Beach in the Dunes on Lake Michigan where golf is an inspiration—to be remembered always.

While others ride miles, then wait hours to play, you step from your home onto the tee and drive—and some thrill from the top of lofty Dunes out across wonderful fairways bordered by beautiful forests and onto perfect greens.

Here you and your family will enjoy the game thoroughly with neighbors and associates well worth while.

Total Yardage ...6409. Total Par ...74
Out Yardage3198. Out Par37
In Yardage3211. In Par37

This golf course map shows the configuration of the original 6,409-yard championship course. As the brochure stated, "The Dunes country lends itself admirably to golf course requirements. Many of your tee shots are from dunes 30 to 80 feet above the fairways. It is here at Long Beach that nature in grand unison with man's handiwork has insured variety and interest every foot of the way—and to make you happy at every moment of play." (Courtesy of Michael Brennan.)

INITIATION FEE CERTIFICATE

The Long Beach Country Club

No. 390

This is to certify that as hereinafter provided, and if presented to THE LONG BEACH COUNTRY CLUB within a

period of one year from the date hereof_____will be entitled to receive full credit for an initiation fee, at the present time, equal to an amount of TWO HUNDRED FIFTY DOLLARS ($250.00) in THE LONG BEACH COUNTRY CLUB.

This certificate is issued under and pursuant to the terms and conditions of a certain agreement, dated_____

_____, 1924, by and between the LONG BEACH COUNTRY CLUB HOLDING COMPANY and THE LONG BEACH COUNTRY CLUB. This certificate is not transferable and must be presented to THE LONG BEACH COUNTRY CLUB within a period of one year from the date hereof.

This certificate accompanies an interest in or title to real estate in the Town of Long Beach, Laporte County, Indiana, and shall not be valid unless at the time of presentation, the holder hereof holds and maintains and exhibits his or her interest in said real estate.

This certificate may be held only by persons eligible to membership in THE LONG BEACH COUNTRY CLUB, the membership of which is composed of citizens of the United States, of good and lawful age, of good moral character who shall have an interest in or shall be seized of title to any lot or parcel of land within the limits of the Town of Long Beach.

No person shall be eligible to membership in said corporation who is not a Caucasian Gentile, providing the word "Gentile" as herein used shall be construed in its present, modern, commonly understood meaning. Further qualifications and restrictions to which this certificate is subjected are as provided by the by-laws of said corporation, THE LONG BEACH COUNTRY CLUB.

In Witness Whereof, THE LONG BEACH COUNTRY CLUB has caused this certificate to be signed by its president, secretary and treasurer this_____day of_____19_____.

(SEAL)

By:

Attest:

Secretary

THE LONG BEACH COUNTRY CLUB

President

Treasurer

Initiation certificates were presented by Long Beach Country Club to Caucasian Gentiles who were U.S. citizens "of good moral character" and owners of property in Long Beach. The Town of Long Beach, as well as Michiana Shores and Grand Beach, Michigan, were "restricted communities" in the 1920s and 1930s. (Courtesy of the Town of Long Beach.)

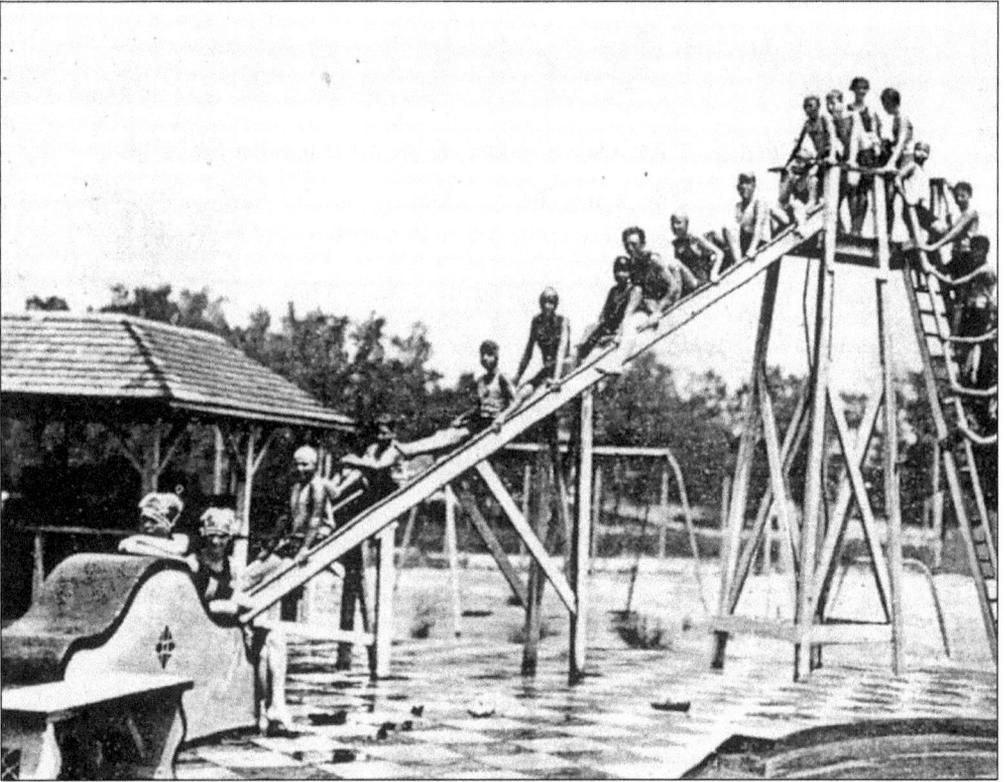

Swimming was the younger generation's favorite sport, as shown by the line-up on the water slide. The pool was exotically named the Roman Plunge. (*Long Beach Billows.*)

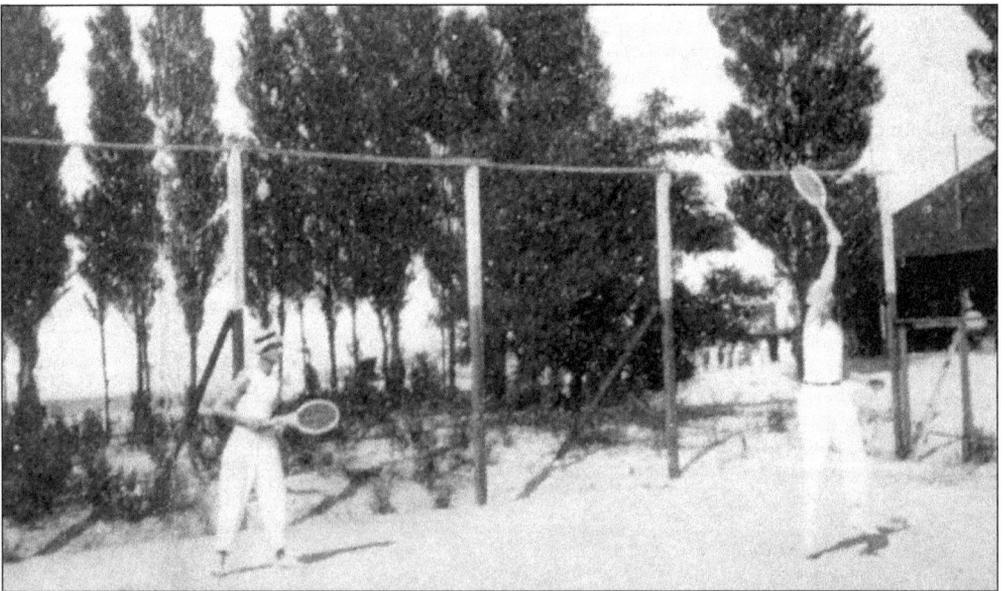

Tennis was another popular pastime, and the Long Beach Company saw to it that tennis courts were provided. Notice the many poplar trees planted by the developers, in an effort to control the shifting sands. (MCPL)

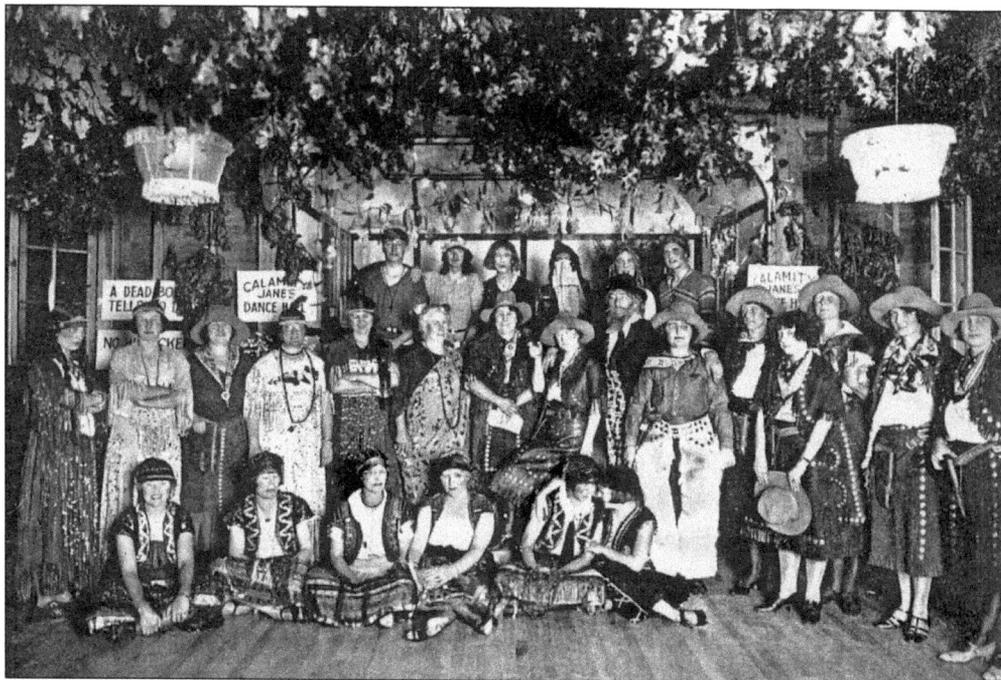

Masquerade balls brought the summer season to a close at Long Beach Country Club. In 1923, the theme was "Calamity Jane" and the Bar X Saloon, as pictured here. On other occasions, club members applied "black face" make-up and had "plantation parties." (*Long Beach Billows.*)

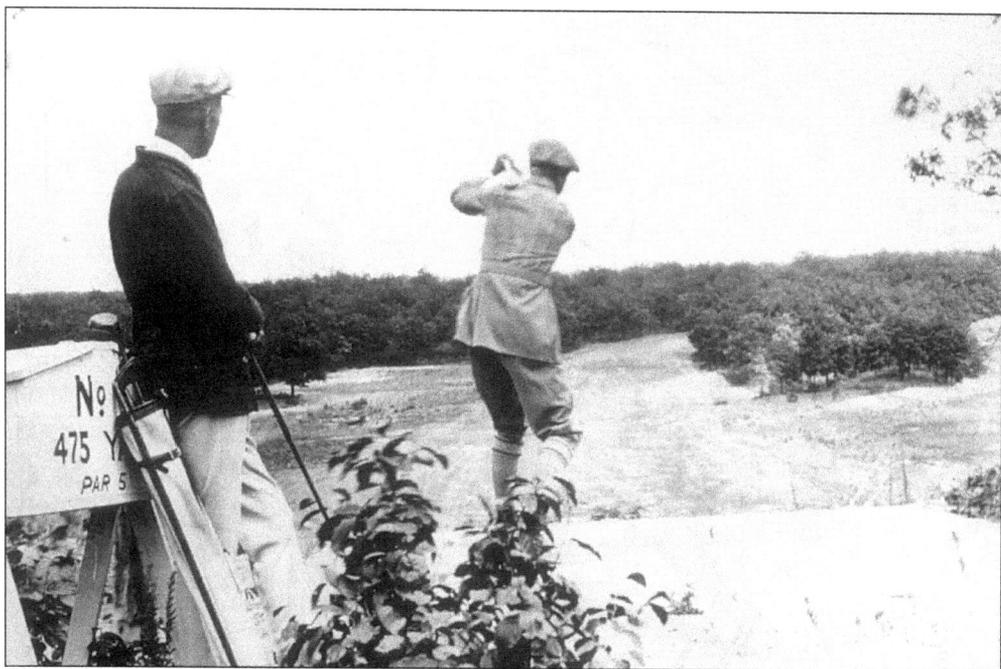

Golfing headed the list of sporting activities. One golfer is observing his partner teeing off at the first hole, both evidently "happy at every moment of play"—just as promised in the brochure. (MCPL)

E.F. "Dutch" Ploner, chairman of the Sports and Pastimes committee at Long Beach Country Club, was master of ceremonies for "The Bletherin" and other special events. Many celebrities played on the golf course during the 1920s and 1930s. (*Long Beach Billows.*)

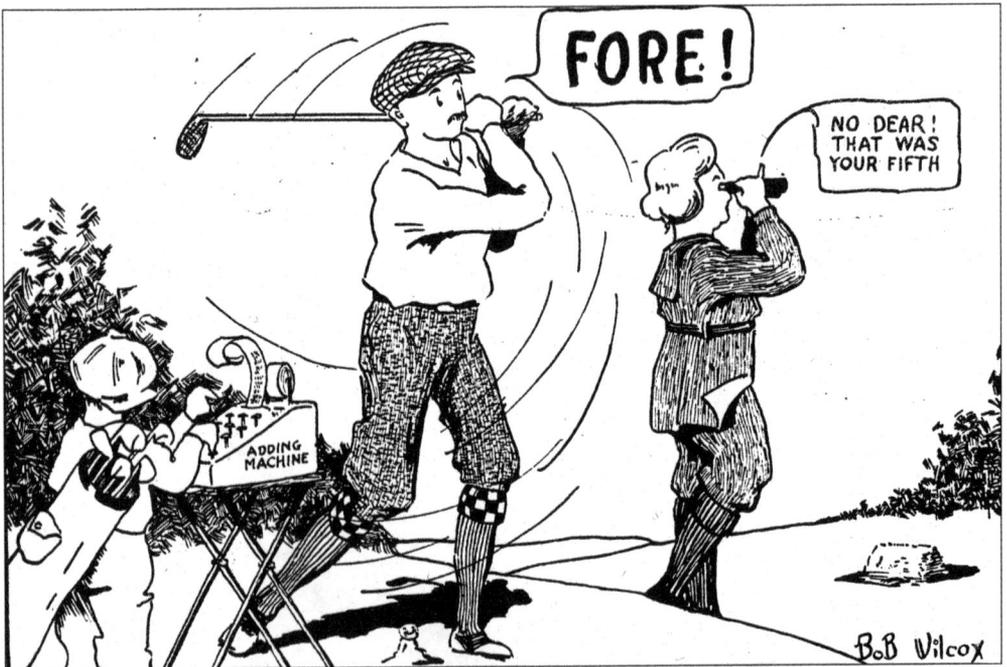

Golf cartoons showed the popularity of the sport in the Michigan City vicinity. Bob Wilcox was a Michigan City cartoonist whose work appeared in local publications. (*Michigan City Evening News.*)

Miss Ruth Kearns of "K" cottage was named the new social hostess of Long Beach Country Club in the summer of 1925. Well-known to listeners of WGN radio, as hostess of the "Skeezix Hour," Miss Kearns handled children's cultural programs, such as coaching plays and short story contests. She also took reservations for adult events and set out the nut cups at bridge parties. (*Long Beach Billows.*)

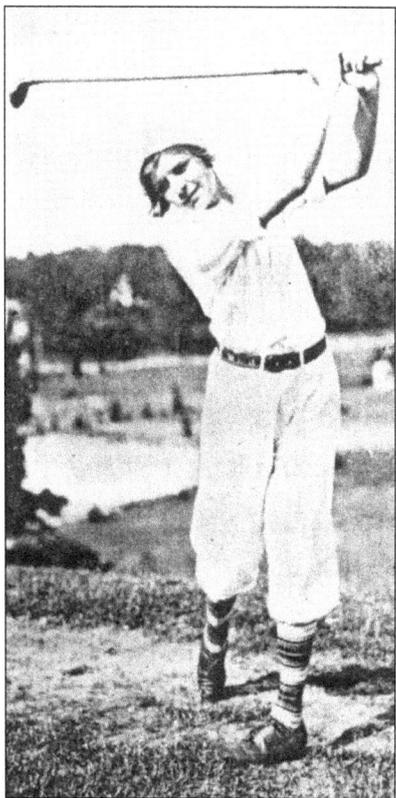

Lady golfers being closely observed in 1925 include Mary Jane Rumpf (far left), women's record-holder for nine holes. Dr. Nola Nance Oliver was termed by Dave, the pro, as "an uncanny putter." Dr. Oliver resided at "Pal-O-Mine" cottage. (*Long Beach Billows.*)

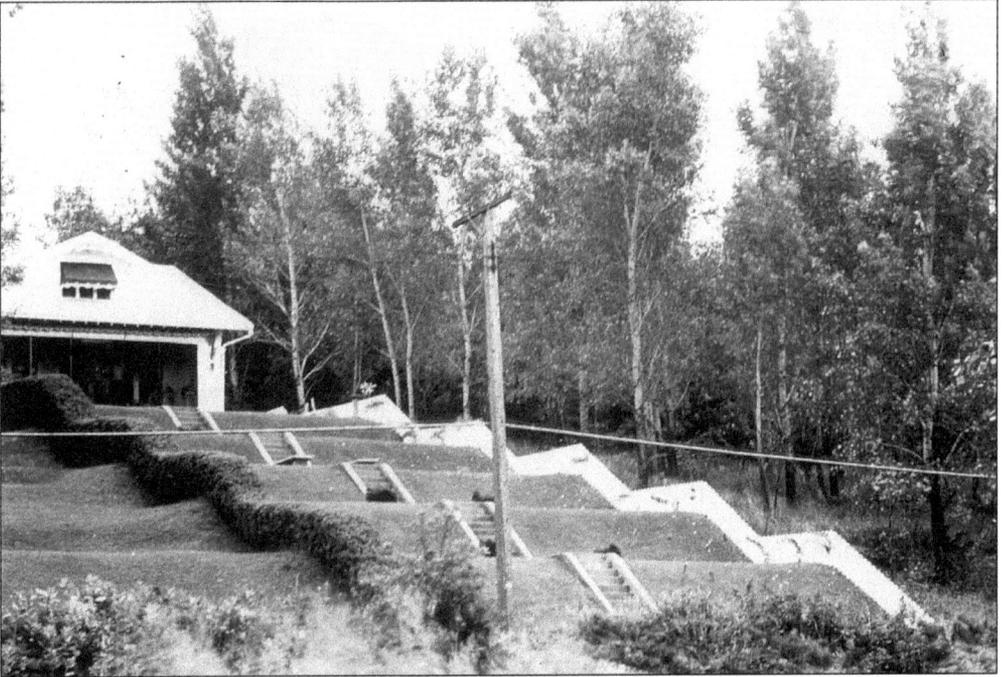

Terraced lawns were one way of taming the sand hills, as Long Beach developed into a landscaped, residential community. (MCPL)

"Stepping Stones" was the name settled on for this home purchased in 1923 by Dr. Harry J. Smejkal of Cicero, Illinois. After buying the cottage on Belle Plaine Trail, Dr. Smejkal held a contest to find an appropriate name. He became a promoter of competitive swimming at the Roman Plunge, and offered several prizes for young athletes. (*Long Beach Billows.*)

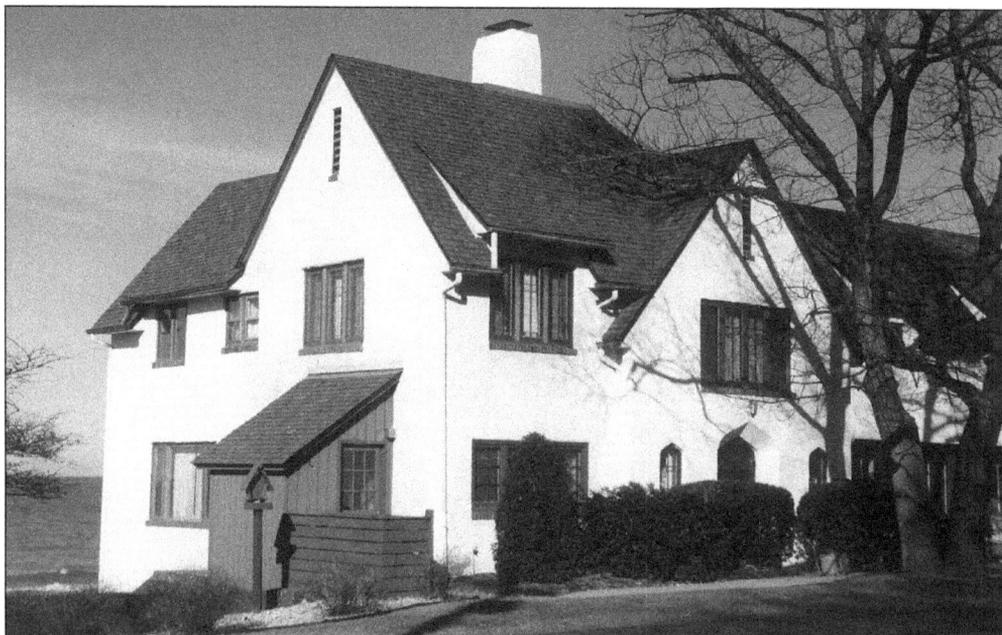

George Truesdell Vail, president of Michigan City Trust & Savings Bank, built this Tudor-style white stucco home on Lake Shore Drive and moved into it in 1922. This decision was an early endorsement of year-round living on the lake. The home was later purchased by attorney William Kenefick and remodeled by John Lloyd Wright, who designed the breezeway and garage addition. (BKS)

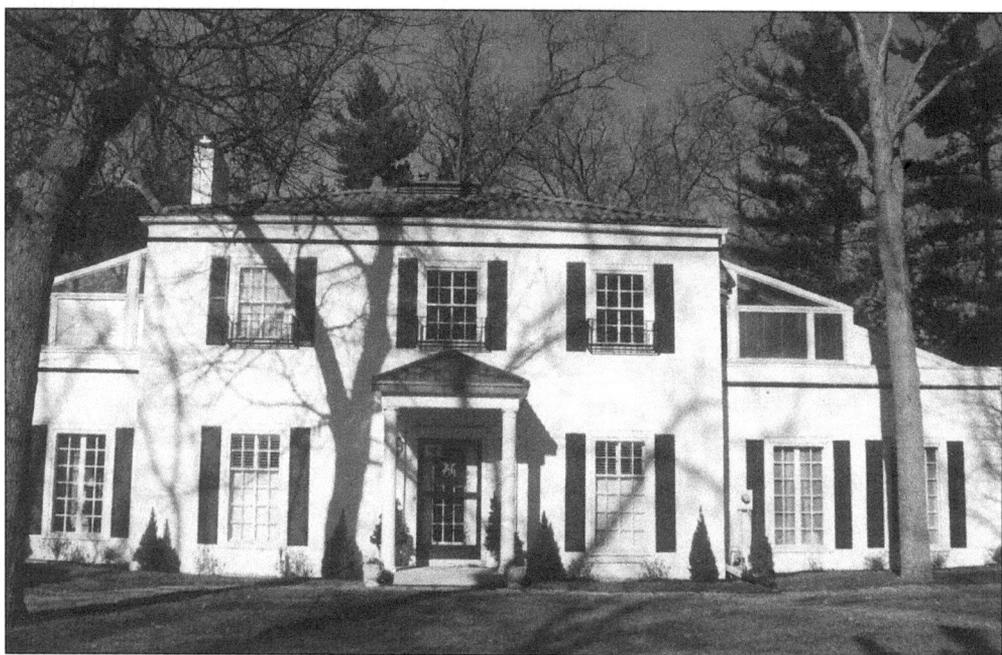

Orphie Gotto, developer of Long Beach, had this home built as his personal residence, at the corner of Oriole Trail and Foxdale. He referred to it as an Italian villa, although the most Italian part of it was the rock garden with waterfall and fountains. (BKS)

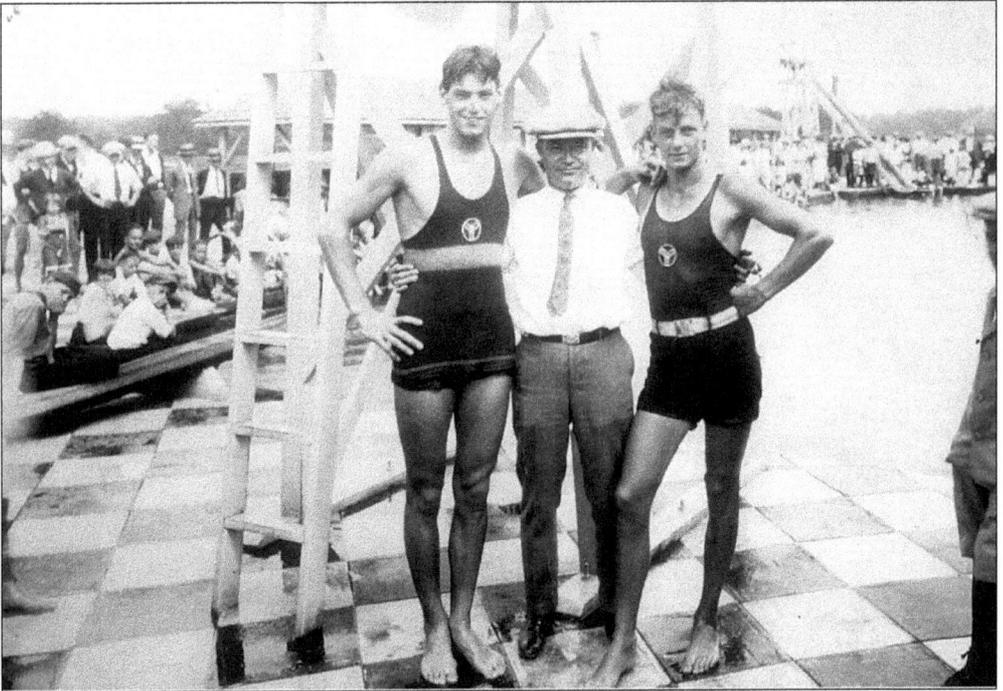

Johny Weismuller (left), the swimming champion who went on to star as Tarzan in the movies, was the guest of Sparrow Purdy at Long Beach Country Club. At the time of his first appearance in Long Beach, the 18-year-old Weismuller held 28 world records. He and his brother Pete (right), an accomplished diver, gave several exhibitions in Long Beach during the 1920s. (*Long Beach Billows.*)

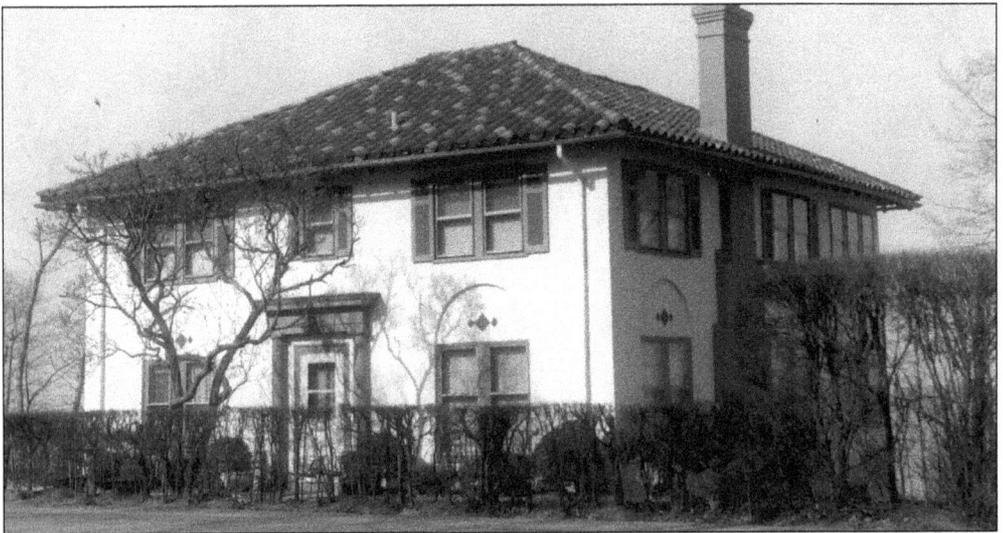

Sparrow Purdy lived in this Mediterranean-style house on the lake, which is still standing at Stop 22 in Long Beach. The white stucco house had interior walls of ivory, with plum carpeting; and the soft green trim around the windows was carried inside as the accent color in a jade green/coral kitchen and jade green/orchid bedroom. In the hallway stood "a clever phone booth with a decorative wrought iron grille." (*The Beacher.*)

Swim Trophies were presented to Purdy Championship winners of 1927 (left to right) Bob Blocksom, Munroe Van Gunten, Mary Ellen Hogan, and Dorothy Hogan. The event was sponsored by Sparrow Purdy and was held at the Roman Plunge annually, on the last weekend of August. (*Long Beach Billows.*)

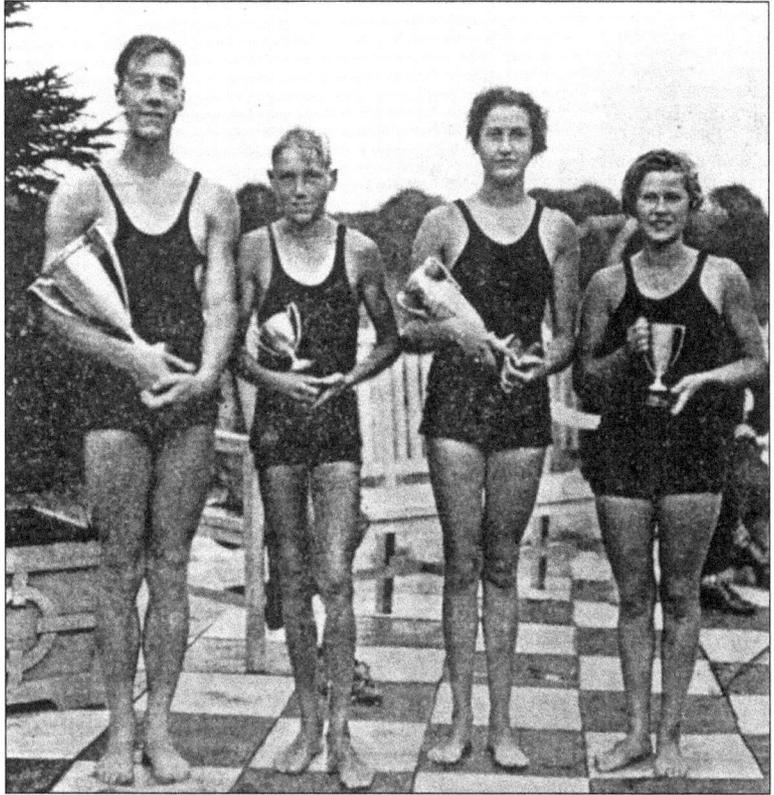

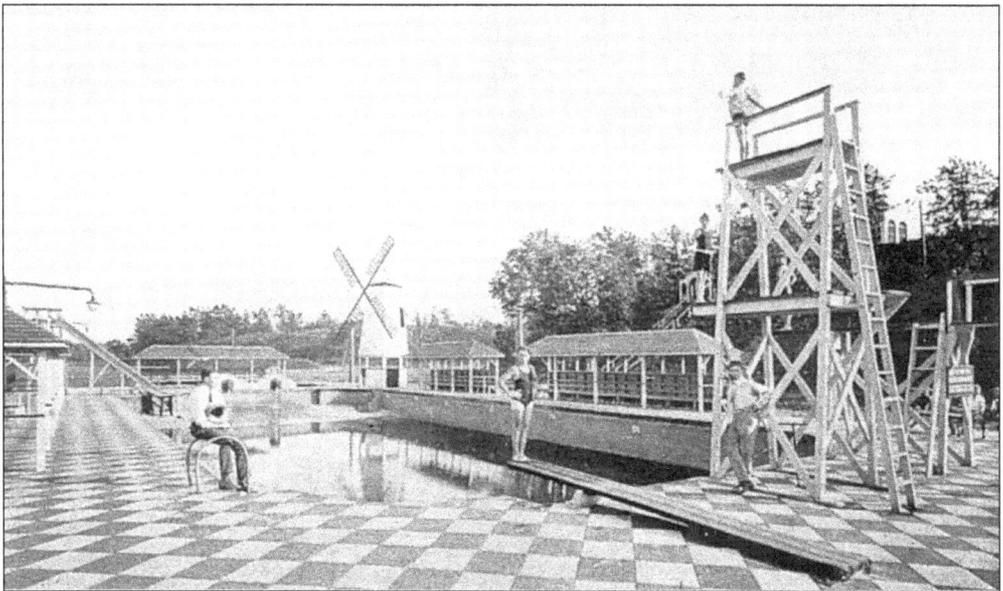

The Roman Plunge, smartly tiled in black and white tiles, had high and low diving boards and a water slide. It measured 40 by 100 feet and was 8 feet deep at the diving end. To show its international flavor, the showers were situated in a Dutch windmill. (*Long Beach Billows.*)

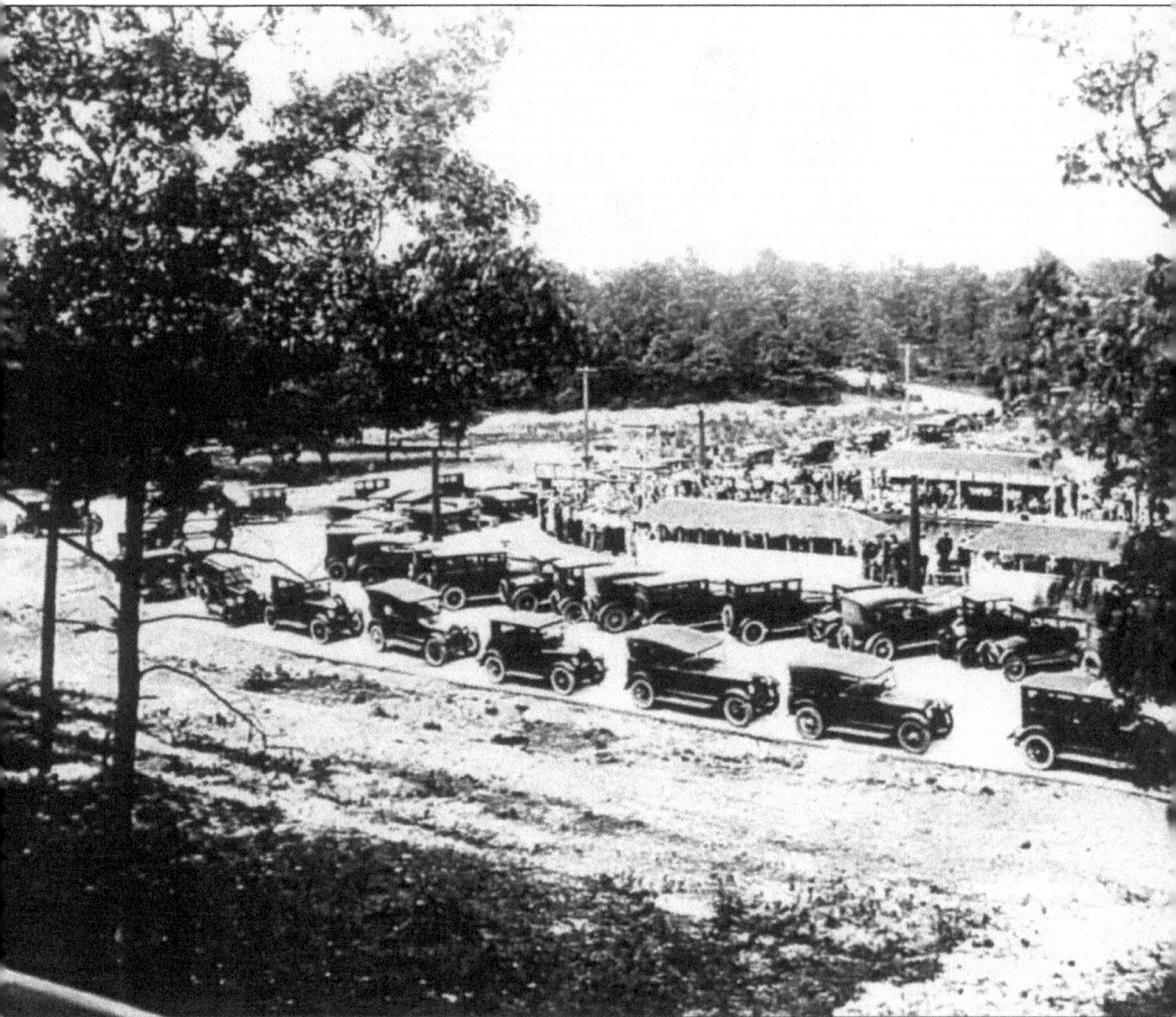

The parking lot was filled to capacity on the Sunday afternoon in August, 1922, when Johny Weismuller performed at the Roman Plunge. Once Henry Ford made motor cars available for $365, they sold like hotcakes, and Michigan City became a favored destination point. Well-advertised exhibitions at the Sky Blue Arena and the Roman Plunge drew huge crowds. Chicagoans came in droves—business executives, sports columnists, aldermen, prominent politicians—and this popularity continued for years. A favorite anecdote was that Dan Ryan, chairman of the Cook County Board of Commissioners in the 1950s, planned the present system of expressways so as to reduce his travel time for getting out to Long Beach. Dan Ryan and his family rented for 15 years at Stop 25 and pioneered the July 4th fireworks display in Long Beach. (*Long Beach Billows*.)

Orphie W. Gotto was one of the founders of Long Beach. In 1919, he and his wife formed Long Beach Company, along with Orrin and Olive Glidden. Gotto ran the feed store business at Ninth and Spring Streets in Michigan City, established by his father in 1893. The Gottos lived at 418 Eighth Street until their move to Long Beach in 1921. (Portrait in Long Beach Town Hall.)

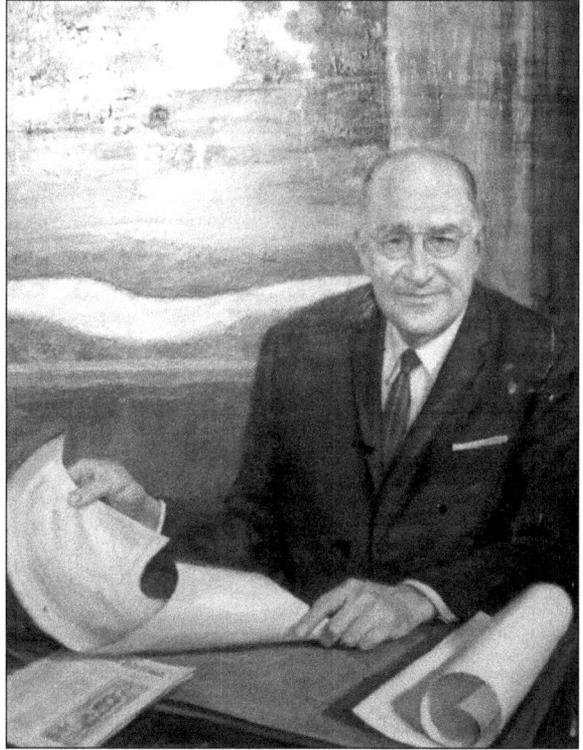

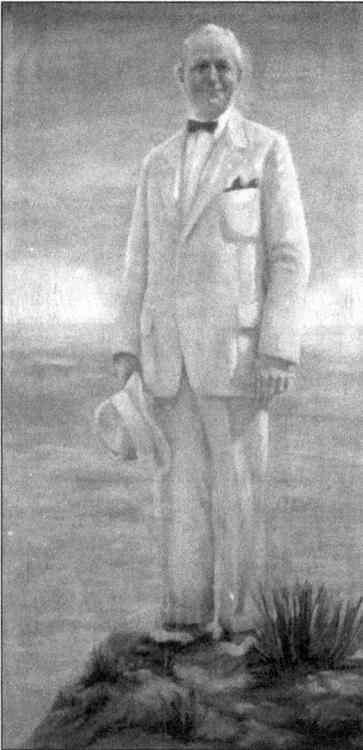

Clarence Mathias (1891–1963) became Orphie Gotto's partner in Long Beach Company in 1923. He lived on Oriole Trail, in a cottage called "Naeta," and served on the original Long Beach School Board. He sold Long Beach Realty to Phyllis Waters, its present owner. (Portrait in Long Beach Town Hall.)

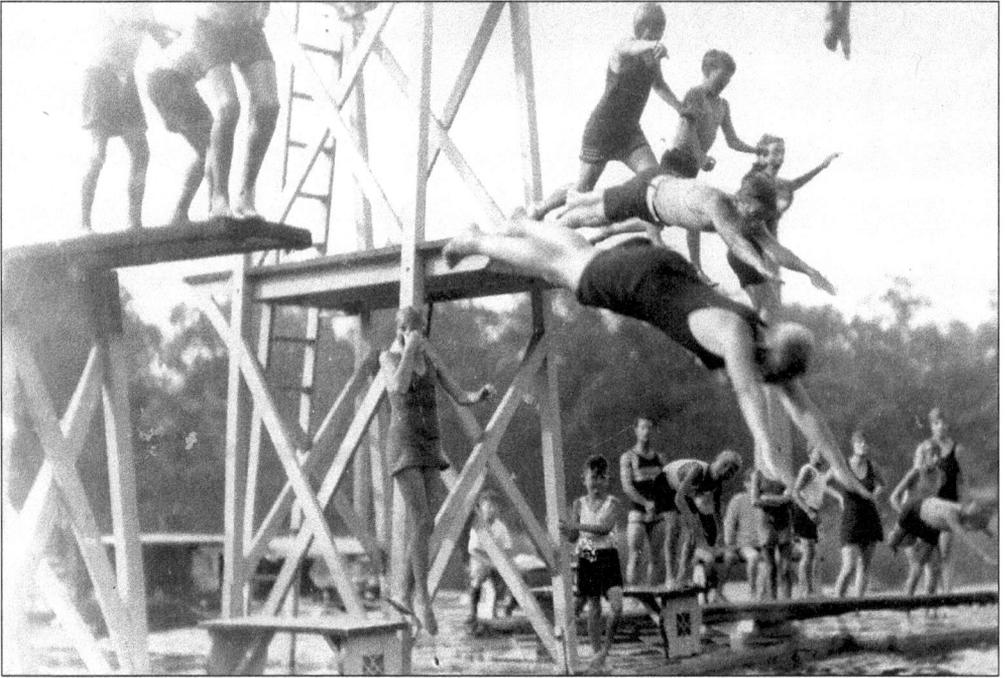

High dives, low dives, hold your nose, jump in, feet first—there's something for everyone at the Roman Plunge. Fish clubs were formed, so that swimmers could advance from Minnows to Perch, Salmon, Whales, and finally, in 1929, Sharks. (Courtesy of the Old School Community Center, Long Beach.)

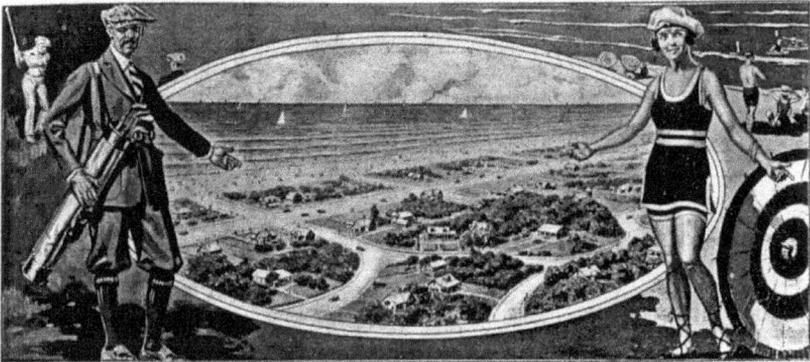

ol. 1 LONG BEACH, INDIANA, SATURDAY, JULY 8, 1922 No.

The *Long Beach Billows*, the first publication to serve the beach communities, was founded in the summer of 1922 by Harry Miles Jr., and continued publishing into the 1930s. Its logo featured a golfer (male) and bathing beauty (female), gesturing toward the winding roads and landscaped cottages that fronted on a broad, sandy beach, with sailboats on the lake as far as the eye could see. (*Long Beach Billows*.)

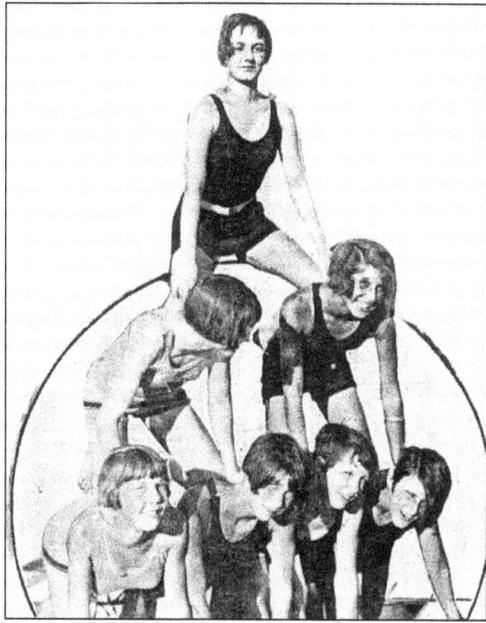

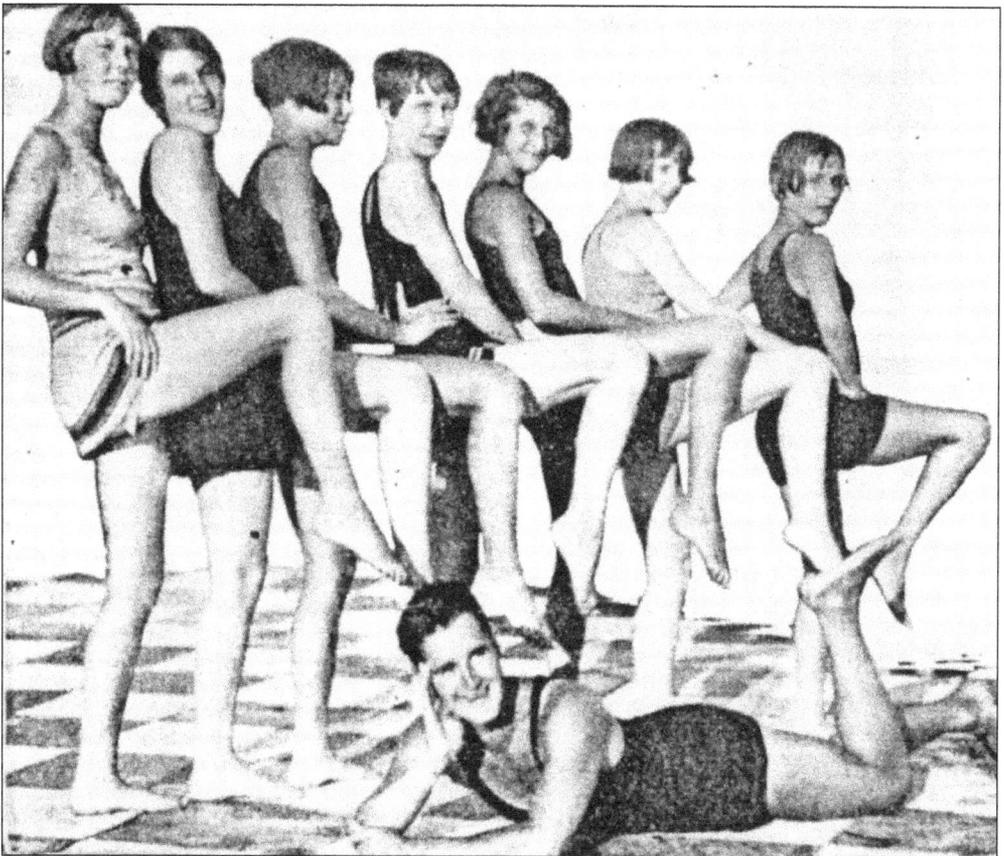

A pyramid and chorus line were among the poses staged by teenage girls at the Roman Plunge, for the benefit of at least one hairy-chested spectator. (*Long Beach Billows*.)

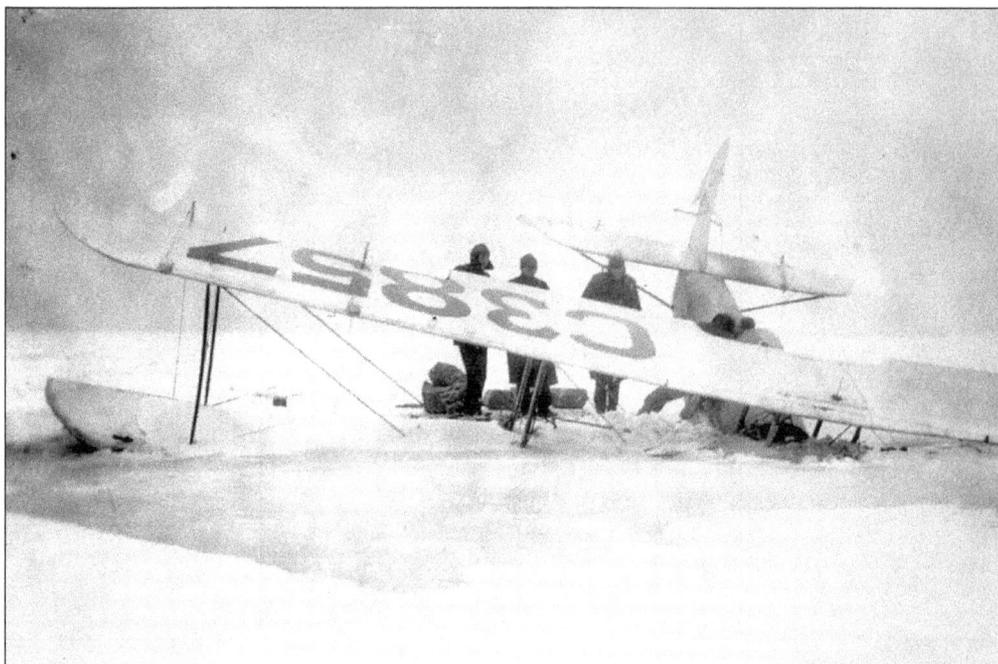

A small plane, reputedly carrying bootleggers, has a hard landing on the sandy shores of Long Beach in the mid-1920s. (MCPL)

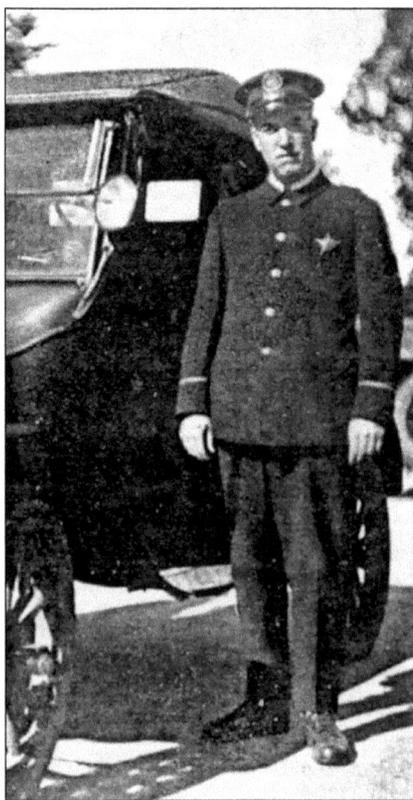

Jiggers! The only policeman in Long Beach in 1925, Officer Ephriam Reid had his hands full—enforcing the 18 mile per hour speed limit and "no parking" rules on Lake Shore Drive, plus directing "lost" delivery trucks and breaking up intruders' beach parties. "This beach is private and no outsiders are allowed," he explained. Thanks to Officer Reid's efforts, there had never been an automobile accident on the beach roads, and the community was regarded as safe and sound. (*Long Beach Billows*.)

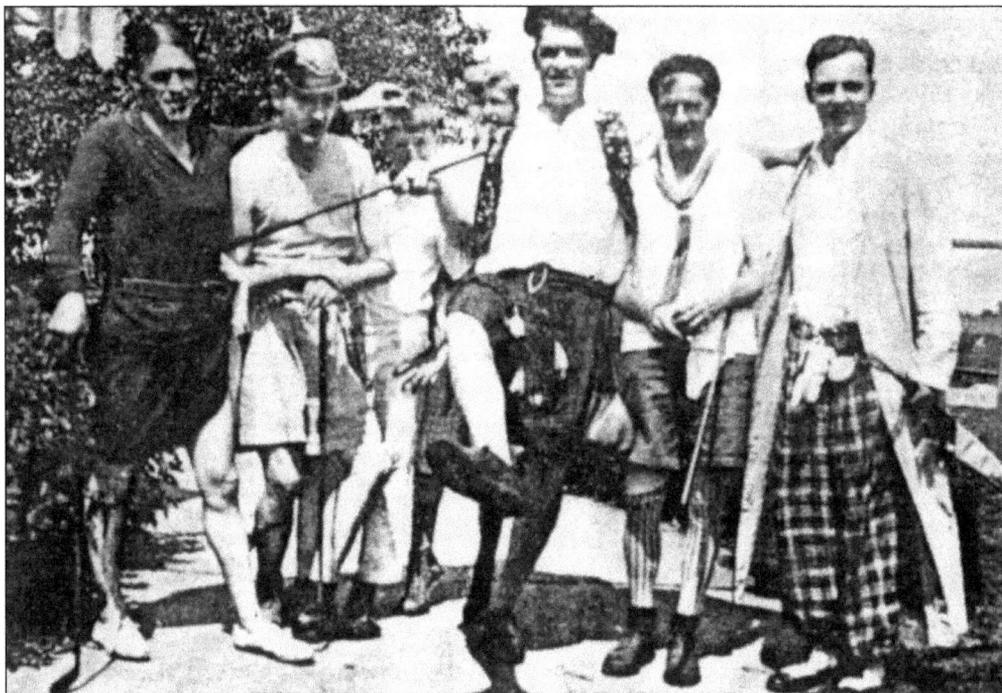

"The Bletherin" was a strictly stag affair, supposedly of Scottish origin, when men could spend the day "bletherin' all over the golf course." There may have been gambling and other undercover activities, but the wives mostly seemed to approve and in fact helped get the costumes together, for an event which became more outrageous each year. (*Long Beach Billows*.)

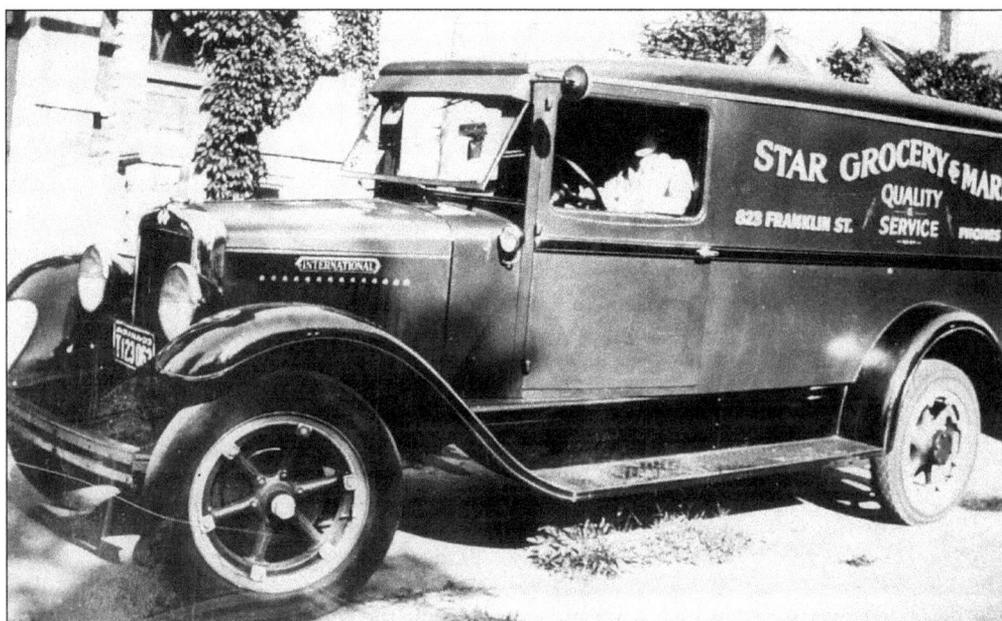

Groceries were delivered daily to Long Beach, by Star Grocery & Market, which operated in the 1920s on Franklin Street in Michigan City. Proprietors were Meyer & Schwartzkopf. (MCPL)

Four generations of beach-goers summered together in 1925 at Fond Days cottage on Somerset Drive. Pictured (left to right) are Mrs. Richard Berndt, her daughter Mrs. R.B. Blodgett, Great-Grandma Mrs. E. Andrews, and the youngster Jeanne Blodgett. (*Long Beach Billows*)

Cottages were overturned by high wind and waves, during the winter snowstorms of 1929–1930. Pictured here, between stops 25 and 26 in Long Beach, were the victims of storm damage, (left to right) Gustavson, Bullards, and Periwinkle. (OLM)

106

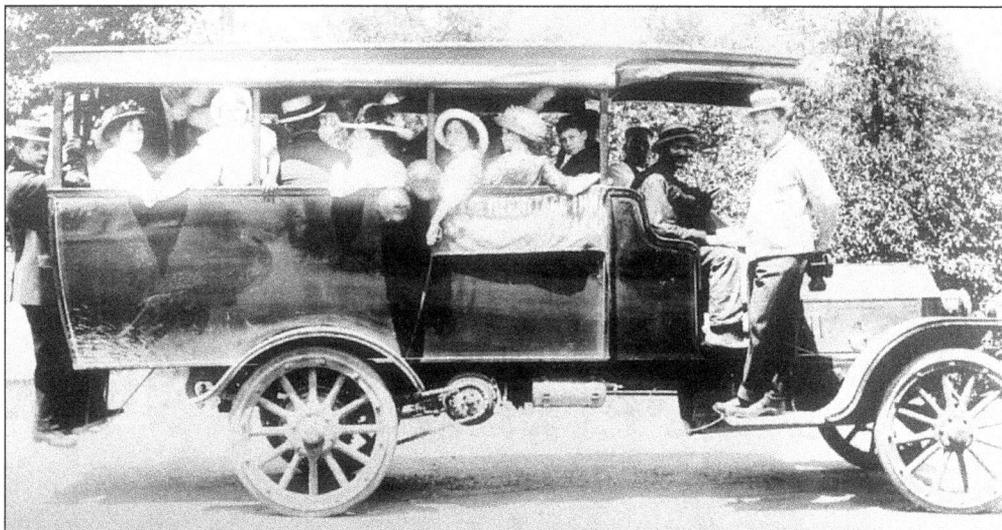

The bus that transported passengers to the beach communities was an open-air conveyance that had a surprisingly long-term effect. Many years after bus service was discontinued, and even up to the present day, locations in Long Beach are commonly identified as "Stop 15" or "Stop 20," for the bus stops of the bus that used to run along Lake Shore Drive. (MCPL)

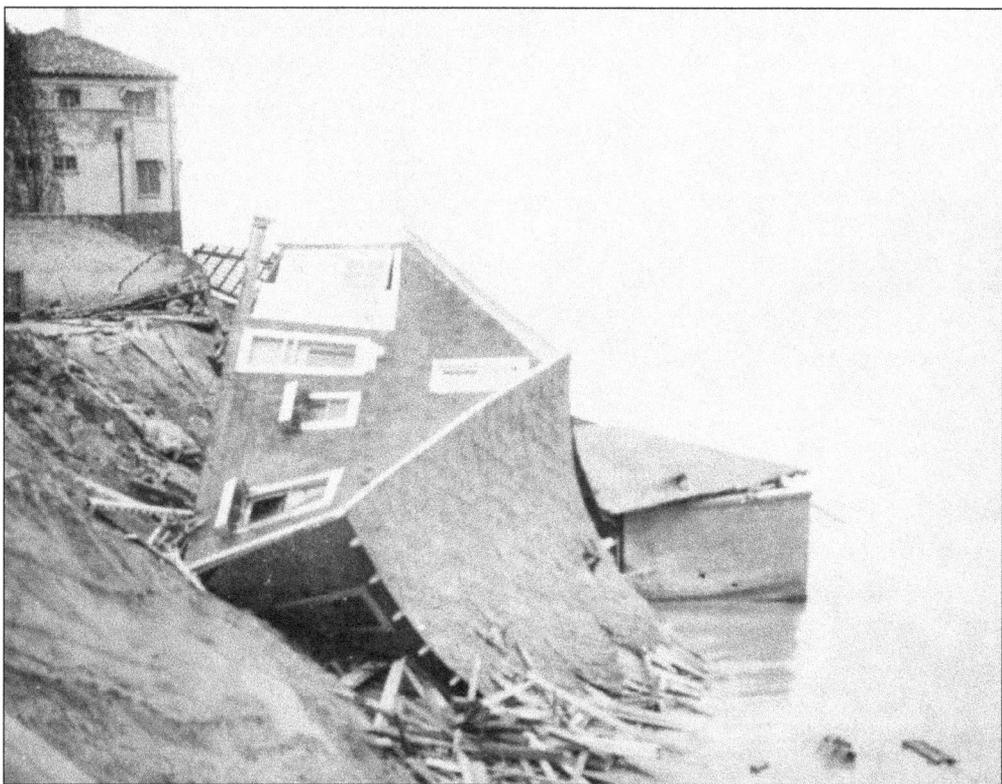

The heavy thunderstorms of 1929–1930 demolished 15 lakeside cottages, and damaged many others. Among the survivors was "the Sparrows," the white stucco home of S.E. Purdy shown in the background. (OLM)

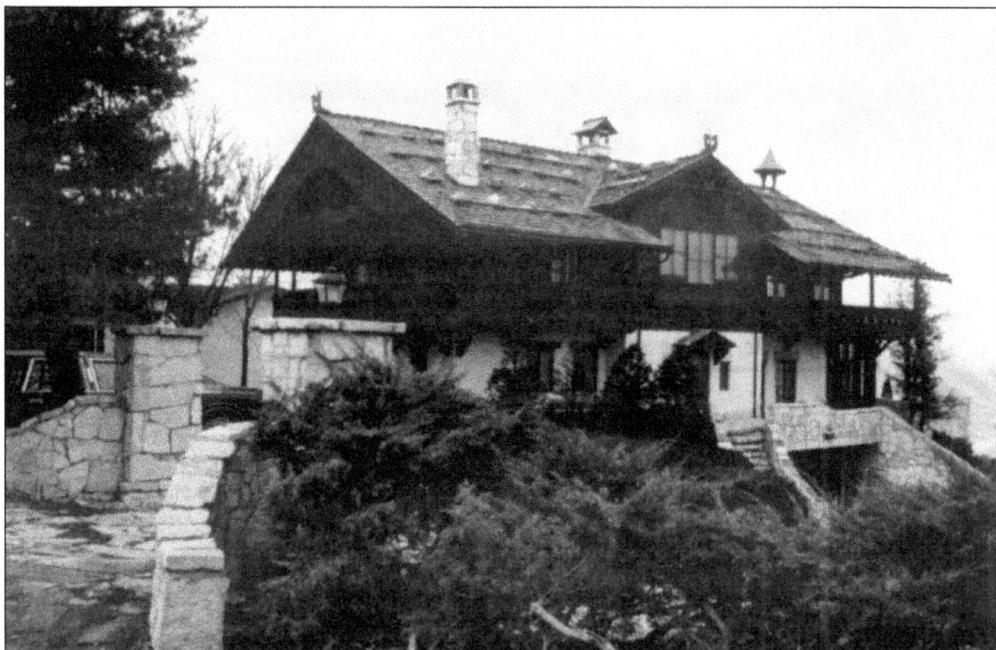

"The Swiss Chalet" was completed in 1929 for Charles E. Arnt, president of Citizens Bank in Michigan City. Chicago architect Karl Vitzhum incorporated many Alpine features in the design. Broad eaves shelter the balconies and huge boulders on the roof serve as protection during severe storms. (*The Beacher*.)

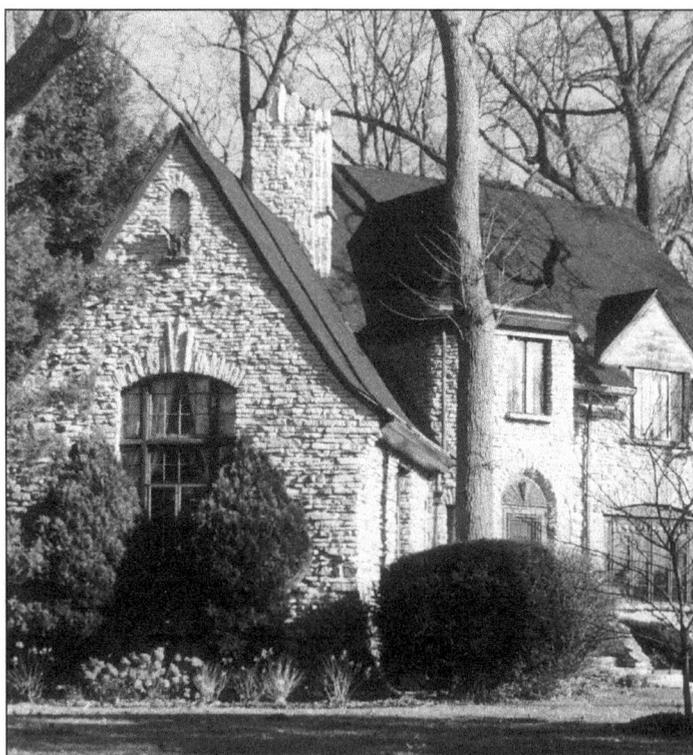

"Castle Abri" was designed for Philip T. Sprague in a French Normandy style. Sprague, who was president of the Hays Corp., had seven carloads of fieldstone shipped from the family farm near Lockport, Illinois. The home was designed by local architect Samuel Boonstra and completed in 1931. (Courtesy of June Hapke.)

Dr. William M. Scholl, one of the most famous Long Beach residents, is shown here boarding a plane for Frankfurt, Germany, where he was constructing a new plant. Dr. Scholl had been born on a dairy farm near LaPorte, one of 13 children, and went on to found an empire of foot care products. Never married, he left the business to his nephews. (MCPL)

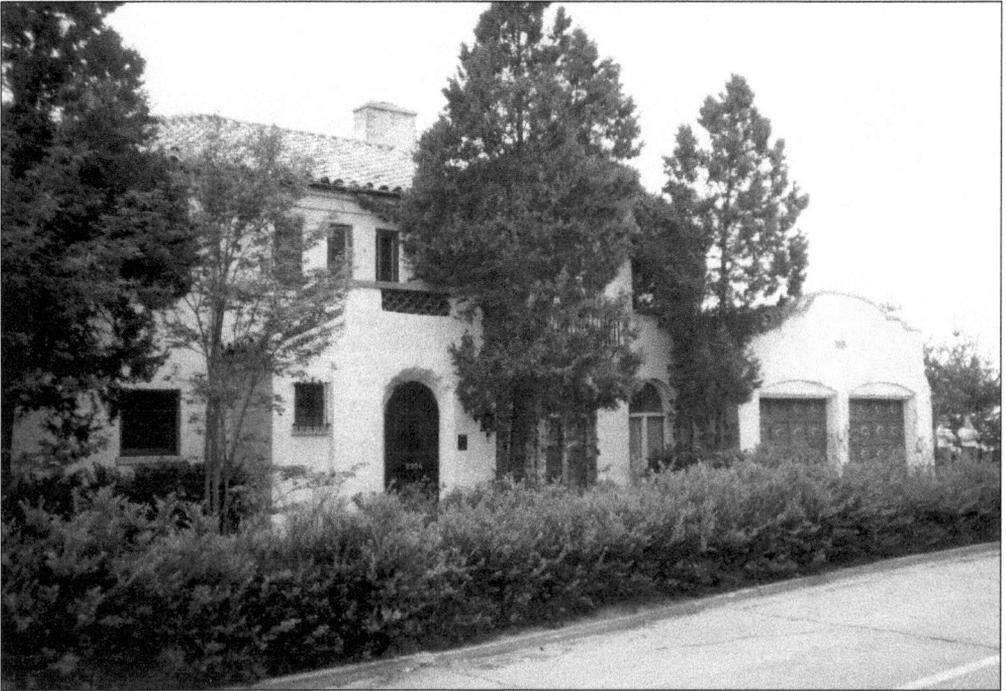

"Casa Del Lago" was Dr. Scholl's Spanish-style "Home on the Lake," still standing at Stop 24. He also maintained a home in Palm Springs, California. At its peak, the Dr. Scholl industry had 10 manufacturing plants and 423 retail stores in 57 countries. In Michigan City, he started the Arno Adhesive-Tape plant. Dr. Scholl, a marketing genius, died in 1966 at the age of 83. (Courtesy of Ted and Kim Reese.)

John Lloyd Wright, son of famed architect Frank Lloyd Wright, moved to Long Beach in 1923, and introduced modernist architecture to a community accustomed to revivalist styles. Wright said he had chosen to live in Long Beach, appreciating its opportunities for "comfort, healthy recreation" and because its "wind-blown landscape was a source of inspiration to me." (*Long Beach Billows.*)

Long Beach School, designed by Wright in 1927, was a one-story structure of sand-colored stucco. According to his principles of "organic architecture," the building was to blend harmoniously into its environment. The growing number of permanent residents had started holding classes at Bob White Cottage. Sixteen students were in the first class. The building today serves as the town community center. (BKS)

"Studio Court" was the home where John Lloyd Wright and his wife Hazel raised their two children, Elizabeth and Jack. It was a tall, shingled structure set high on a sand dune, to take advantage of lake breezes and the view of surrounding woods. A driveway passed through the lower-level archway, leading to Wright's studio at the back. (BKS)

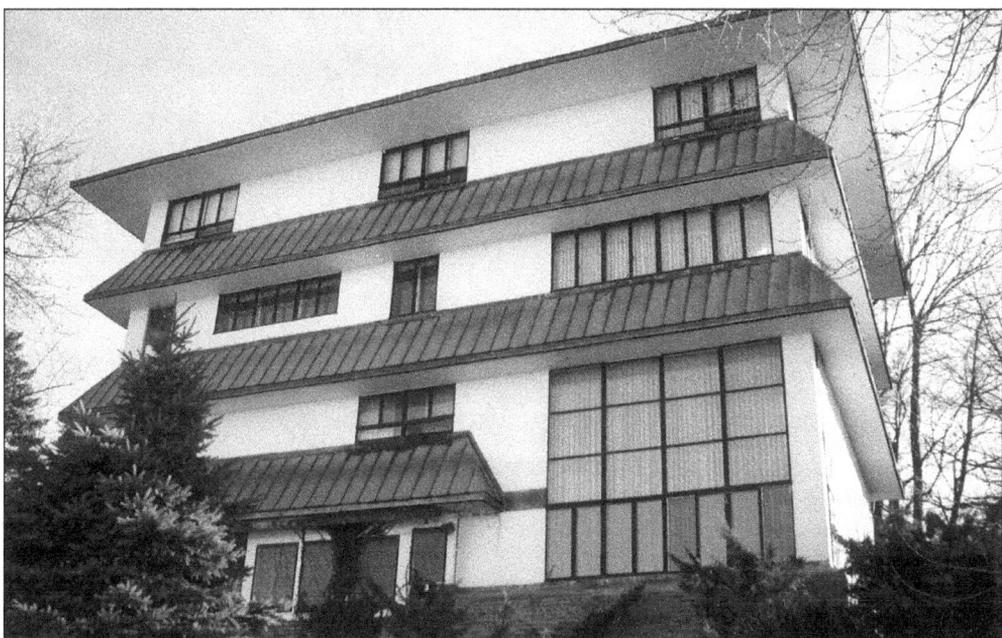

"Pagoda House," so named for its tiers of slanted copper roofing, is the most spectacular of Wright's designs in Long Beach. The four-story house was erected on 30-foot-long steel I-beams, to resist the heavy winds off Lake Michigan. It was built in 1933 for John Burnham, a Michigan City glove manufacturer. (BKS)

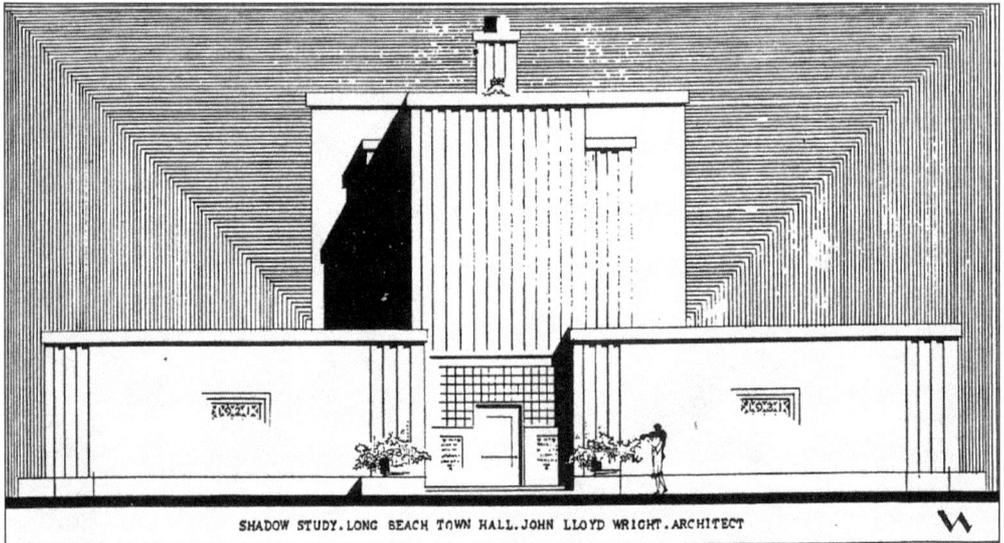

SHADOW STUDY. LONG BEACH TOWN HALL. JOHN LLOYD WRIGHT. ARCHITECT

Long Beach Town Hall, a Wright design, was dedicated on July 4, 1931, ten years after the town was incorporated. Its bold geometric design and simplified facade showed the influence of Viennese and Dutch architecture, which Wright had observed on a 1929 trip to Europe. The building was hailed as "a fine example of modern architecture." (*Long Beach Billows.*)

"Shangri-La" was the home designed by Wright for Frances Gordon Welsh, in 1938. The seven-level structure was built of stone and wood shingles, and angled into its naturalistic, duneland setting. Wright fell in love with his client. They were married and in 1945 moved to California, thus bringing to a close the architect's 22-year career in Long Beach. All the buildings he designed in the beach communities are still standing. (Courtesy of Liv Markle.)

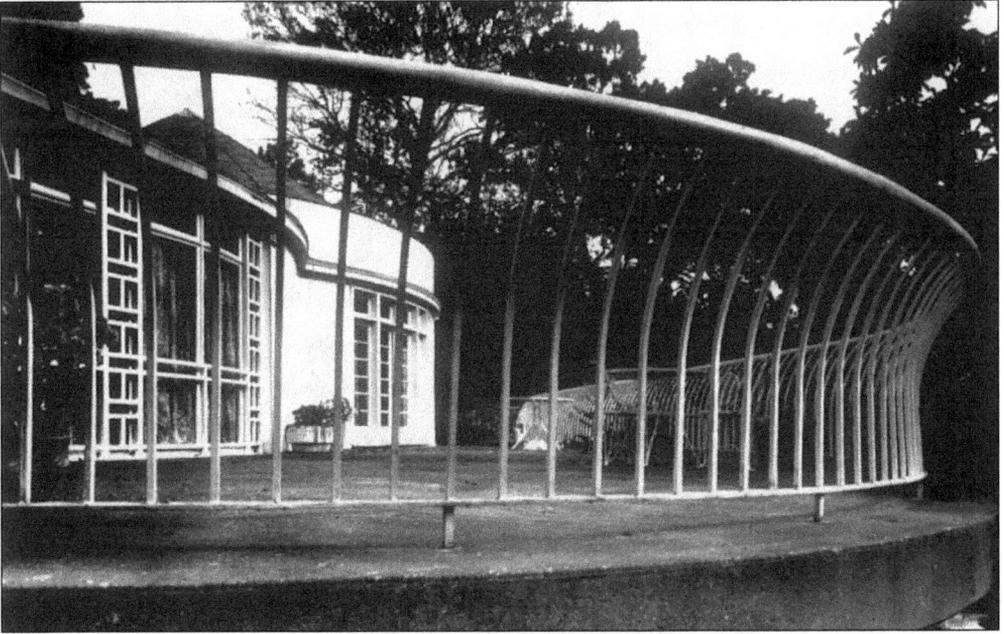

"Nancette" was the home of Nancy DeLucia, wife of Paul "The Waiter" Ricca, an affiliate of Jimmy Hoffa. Ricca went to prison on tax evasion charges, because he couldn't explain where he got enough money to build the house. In the late 1950s, the house was transferred to the Teamsters Union, as a training facility. Ricca also built a house "shaped like a gun" for his sister, Mrs. James Nuzzo, on Northmoor Trail. The Nuzzo home was later owned by Notre Dame Coach Frank Leahy. (Courtesy of Karen Luksich.)

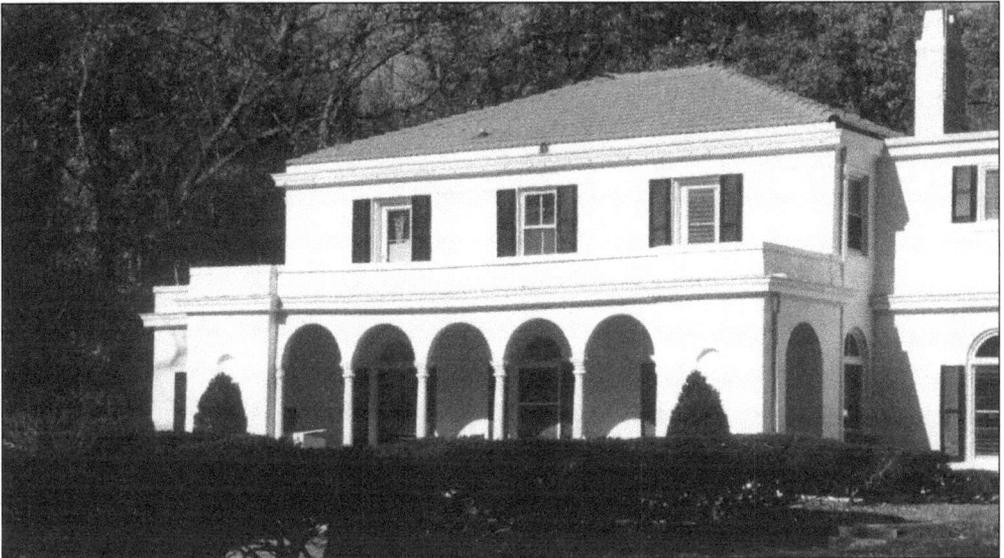

"The Patio" was owned by Mrs. J.P. Howlett, who hosted charity benefits in 1931, such as a bridge luncheon for 160 ladies, with Msgr. Abraham of Sacred Heart (Syrian) Church as guest-of-honor. Meanwhile, her son George Howlett was making headline news as reputedly setting up a "booze syndicate" for Al Capone in Michigan City. The scandal died down a few months later, when Capone was sent to prison for tax evasion. (BKS)

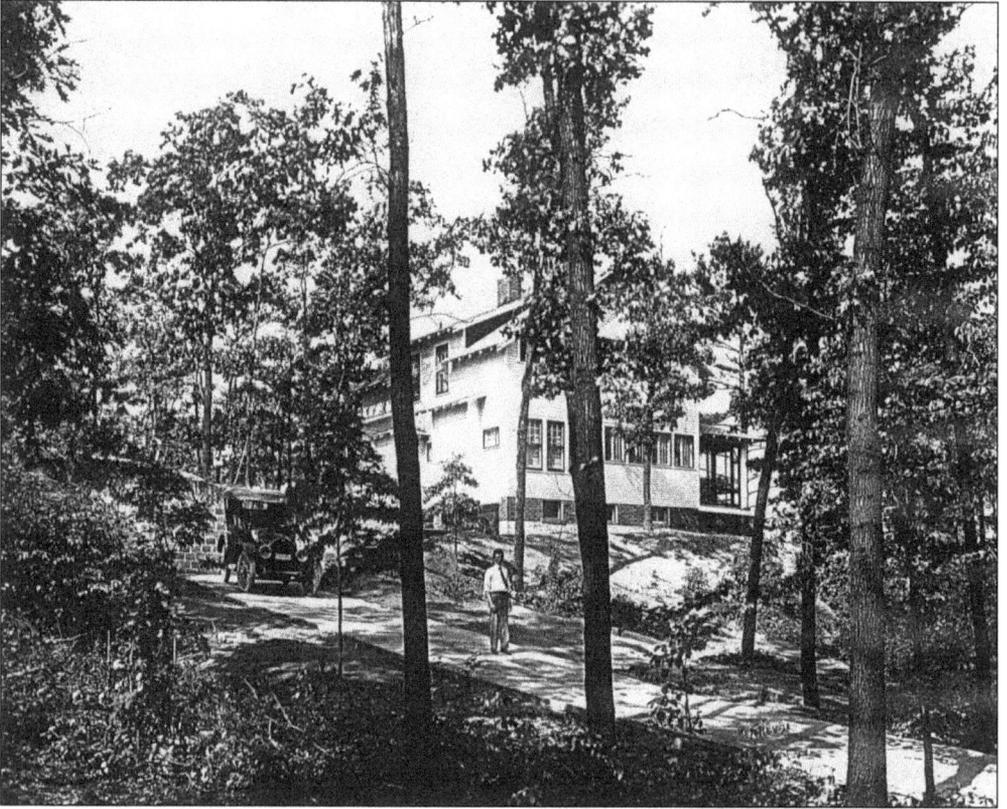

"Sweet Brier" was the name chosen for his home by Theron Miller, pictured here in his Duneland Beach driveway. In 1925, Theron brought his bride, Elizabeth Ford, to the home he had built the previous year; the couple had two sons, Theron Jr. and Hoit. (Courtesy of Dorothy Miller.)

Eight

DUNELAND BEACH AND MICHIANA SHORES

IN 1920, as Indiana's beach communities were off to a flying start, Prohibition was enacted nationwide. Michigan City's three breweries and 77 saloons had to close down. Their previous customers were spending leisure time somewhere else, presumably on golf courses, tennis courts, and bathing beaches, pursuing healthful and legal activities. In the meantime, five sand mining companies had sprouted up and threatened to change the looks of the public playgrounds. Clearly, the interests of industry and recreation were at odds. Environmentalism was a revolutionary concept, coming out of Chicago.

Into this fray appeared Theron F. Miller, a Michigan City lawyer with ideas of his own about preserving the environment. Miller bought up the 60 acres east of Long Beach which earlier speculators O.S. Glidden and E.E. Heise had sold to Lake Sand Company of Cook County, Illinois, and its president Martin Hausler. On June 19, 1920, Miller announced that "within a few days Duneland Beach will be placed upon the market." His advertisement called attention to "its wonderful beauty... the broad sandy beach...the wooded knolls and ridges...the magnificent view. . . . In the development of land such as this the result to be sought after is the preservation of the natural beauty."

One of his stipulations was that no homes should be built on the beach side of Lake Shore Drive. In his last will and testament, Miller deeded the beach, parks, and roads to the Duneland Beach Association.

Only a small corner was left on this stretch of Indiana lakefront and on Feb. 28, 1921, it was incorporated into Michiana Shore Estates. Today six lakefront cottages are on the Indiana side, but the development continues, uninterrupted, into Michiana, Michigan. Further inland, where the Michigan Central Railroad (now Amtrak) tracks were laid, the little town of Corymbo had existed. During the 1860s and 1870s, Corymbo had a train depot and sawmill, and was inhabited by railroad employees and woodchoppers. Much of the land was owned by the Burgwald family of LaPorte County, who sold it in 1920 to Glidden and Gotto, the developers of Long Beach.

The present town of Michiana Shores was originally part of a 589-acre development, two-thirds of which was in the state of Michigan. Long Beach Company sold most of the land in 1926 to Alex Lonnquist, a Chicagoan, whose company was over-extended and foreclosed on in 1932. Gotto and his new partner, Clarence Mathias, decided to turn Michiana Shores into a log cabin town. Their first log cabins sold for $1400, plus $395 for the land. They went up along Hiawatha Trail, which became known as "school teacher row" for the many Chicago teachers who vacationed there. In 1947, the town of Michiana Shores was incorporated.

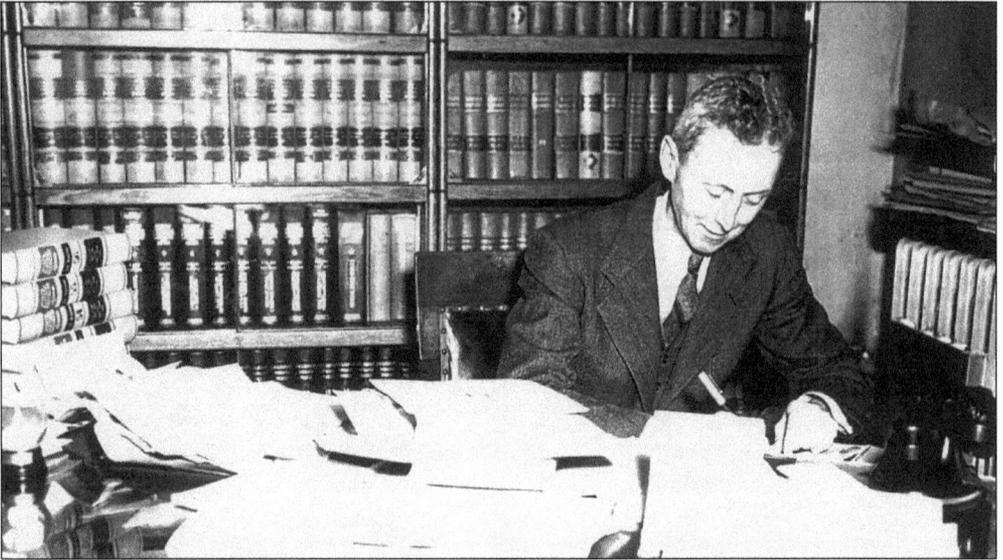

Theron Miller (1879–1955), a University of Michigan Law School graduate, had notarized the 1914 sale of land to Lake Sand Company, and subsequently made plans to preserve the natural beauty of Duneland Beach. He was a Michigan City native whose parents had moved to town when his father, Samuel Miller, became the city's first superintendent of schools. (Courtesy of Dorothy Miller.)

Advance Lot Sale of Duneland Beach Addition,

Preliminary to big Opening Sale of 1921 Season.

HERE IS WHAT YOU HAVE BEEN WAITING FOR

The chance to buy one or more of those high class most desirable Lake Michigan Beach Lots, 60 feet or more wide, on unusually easy terms and without interest or taxes to pay for first two years from date of purchase.

IN THE NEW BEAUTIFUL

Duneland Beach Addition

Duneland Beach advertisements featured the wooded lots as well as the beaches. Theron Miller, an early environmentalist, planned the residential community to take advantage of its natural setting. To assure quality homes, he imposed a 1,500-square-foot minimum size limitation. He personally guaranteed the loans. (MCPL)

Here's What a Home
In Picturesque Duneland Beach
Can Give You

In this garden spot so accessible, people marvel at and enjoy stronger, healthier sunshine; invigorating breezes off blue waters make life better among these verdant duneland hills.

The rugged and natural terrain is one grand geological phenomenon; magnificent, stable dunes tower over Lake Michigan. The waterfronts of the world are justly envious of Duneland's rare beauty in such a combination of natural surroundings.

For the active pursuits—a hike or trail in and about the sandy knolls and a climb up a giant dune is rewarded by an entrancing panorama. Then, sloping to the wide beach, marvelous bathing awaits, particularly fine for children because of the gentle decline. Always within easy reach are riding, golf, and other sports. Winter diversions include skiing and tobogganing.

Near Duneland Beach is the Indiana Dunes State Park; Michigan City is a few minutes away, with its many schools and churches. Many stores maintain delivery to Duneland Beach residents.

With modern conveniences, accessibility, plus health and pleasure opportunities Duneland Beach passes every requirement of an ideal residential community.

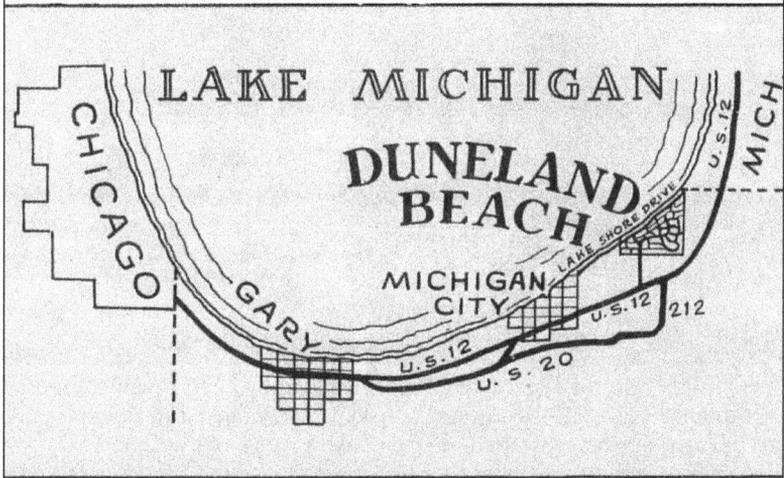

Here's what a home in Duneland can give you—the advertising brochure emphasized the beauty of the home sites and the outdoor activities. (Courtesy of Dorothy Miller.)

117

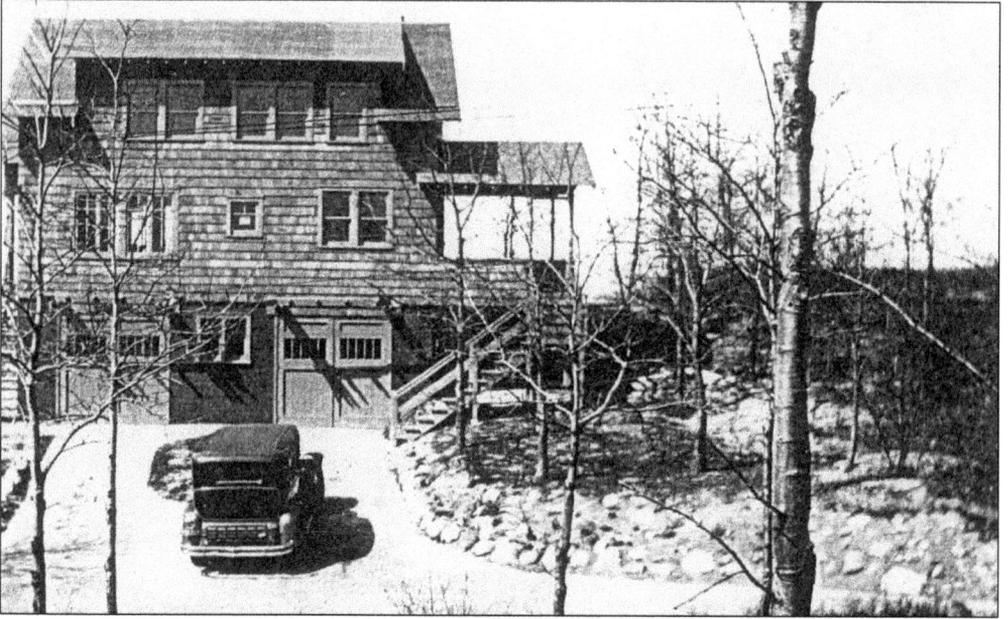

A shingled house on Manitou Trail uses natural materials to blend with the setting. "Manitou" and "Iroquois" were some of the streets named after Native Americans. Menauquet was one of the 62 Potawatomi chieftains who had signed their X-marks to the 1826 treaty granting land to the government for Michigan Road. (Courtesy of Dorothy Miller.)

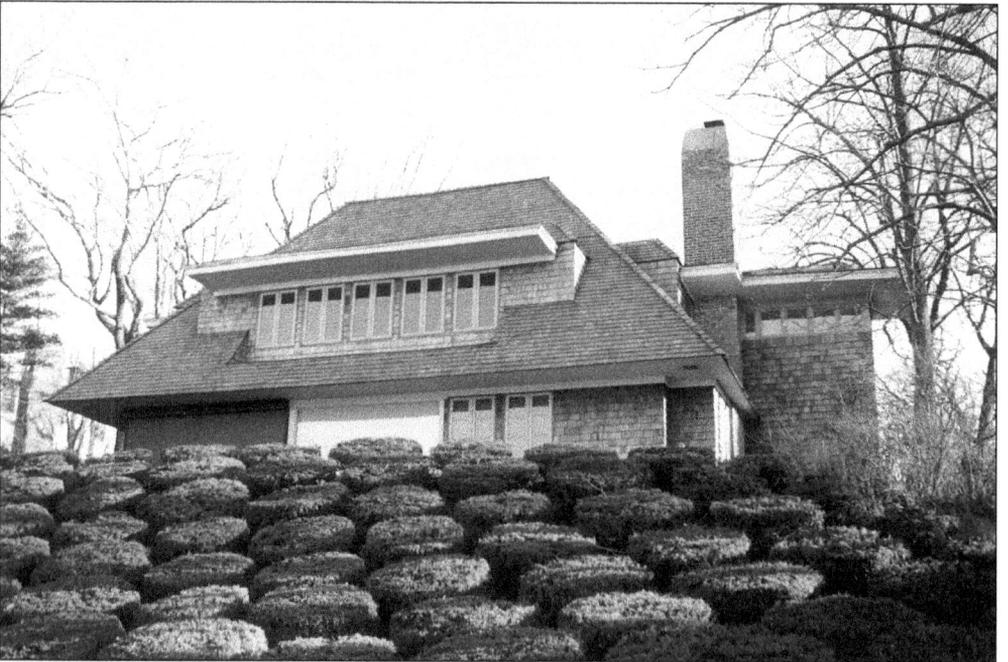

"Early Birds" was the last Indiana home designed by Long Beach architect John Lloyd Wright. It was built for Adele and George Jaworowski, who conducted an early-morning Polish radio program in Chicago. The home, still standing on Lake Shore Drive at Stop 35 in Duneland, was completed by Elizabeth Wright Ingraham after her father moved to California. (BKS)

Scenes from Duneland Beach depicted a safe, sunny community where substantial homes were nestled into woodland settings. Theron Miller engaged Chicago realtors to sell the home sites. (Courtesy of Dorothy Miller.)

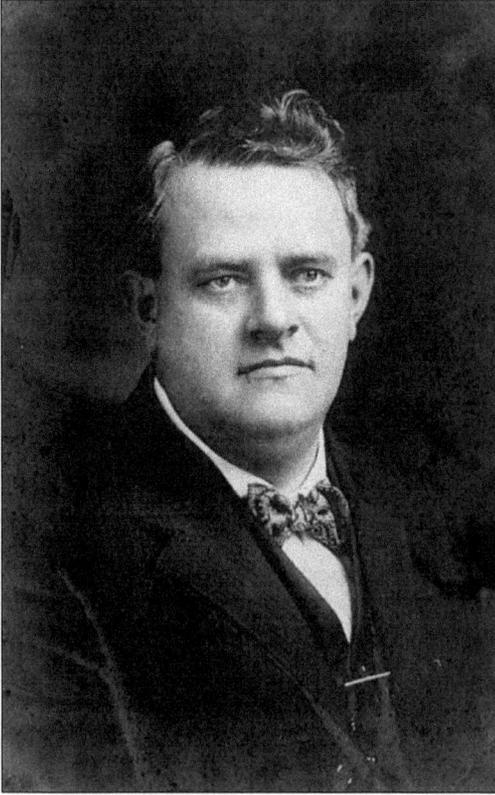

Orrin S. Glidden (1874–1933) had purchased 60 acres of land fronting on Lake Michigan, as early as 1909. He had moved to the area from Lakeside, Michigan with his wife Olive Turner Glidden, who was the postmistress in Lakeside. Orrin invested heavily in real estate in Door County, Wisconsin and north of St. Joseph, Michigan, as well as Indiana. He settled in Duneland Beach but died in 1933, at the age of 59, having lost most of his property during the Great Depression. (Courtesy of Jackie Glidden.)

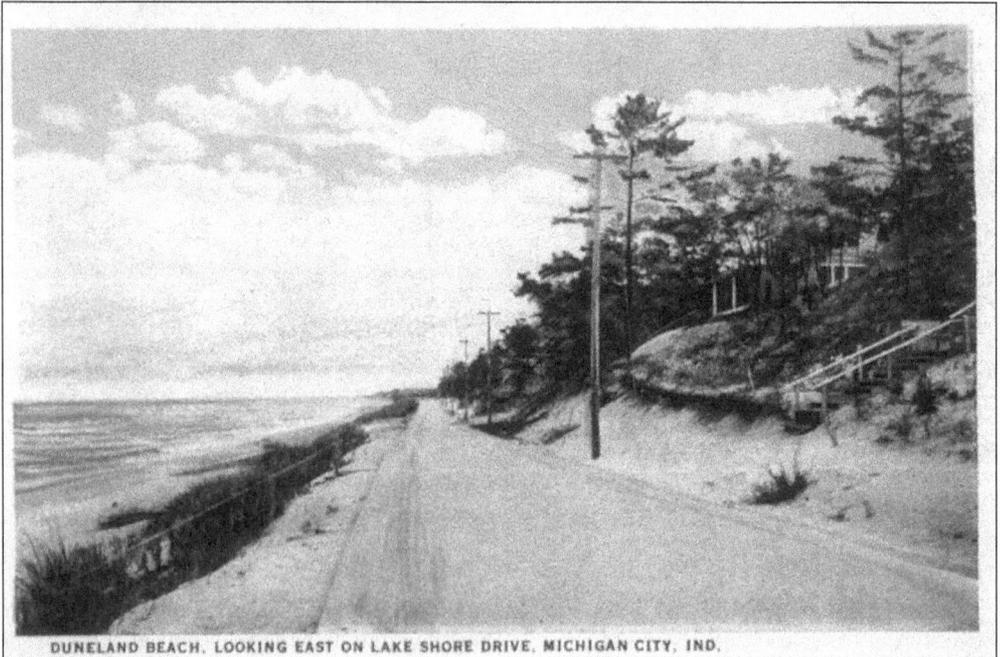

DUNELAND BEACH, LOOKING EAST ON LAKE SHORE DRIVE, MICHIGAN CITY, IND.

Duneland Beach, looking east on Lake Shore Drive, shows houses on the hill but no structures on the lake side except for steps leading down to the beach. (MCPL)

The Chester Glidden House, a colonial-style home built for Orrin Glidden's son, is located on Lake Shore Drive, at Stop 34. Several family members still live in the vicinity. (BKS)

Elsie Glidden Mathias lived in this Duneland Beach house after her marriage to Harold Mathias, whose brother had gone into the real estate business with Orphie Gotto. Their daughter Sue later married Fred Miller, whose family had a meat market in Michigan City. Notice "Sweet Brier" on the hill. (BKS)

Indian hunting techniques were staged in Michiana Shores many years after the land was settled by Europeans and their descendants. (MCPL)

Indian culture has continued to the present day in the state of Michigan, where a number of Native Americans were allowed to remain, because they had been converted to Christianity. (MCPL)

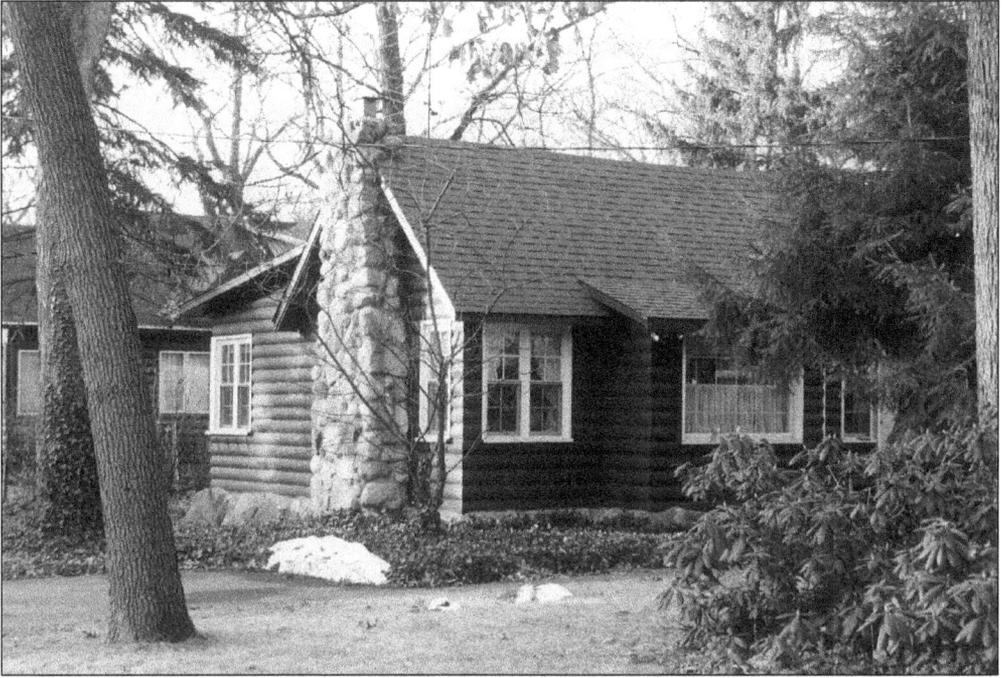

Log Cabins brought a distinctive, woodsy flavor to the Michiana Shores community developed by Orphie Gotto and Clarence Mathias. Although modern homes have been added into the mix, the town still retains its log cabin appeal. (BKS)

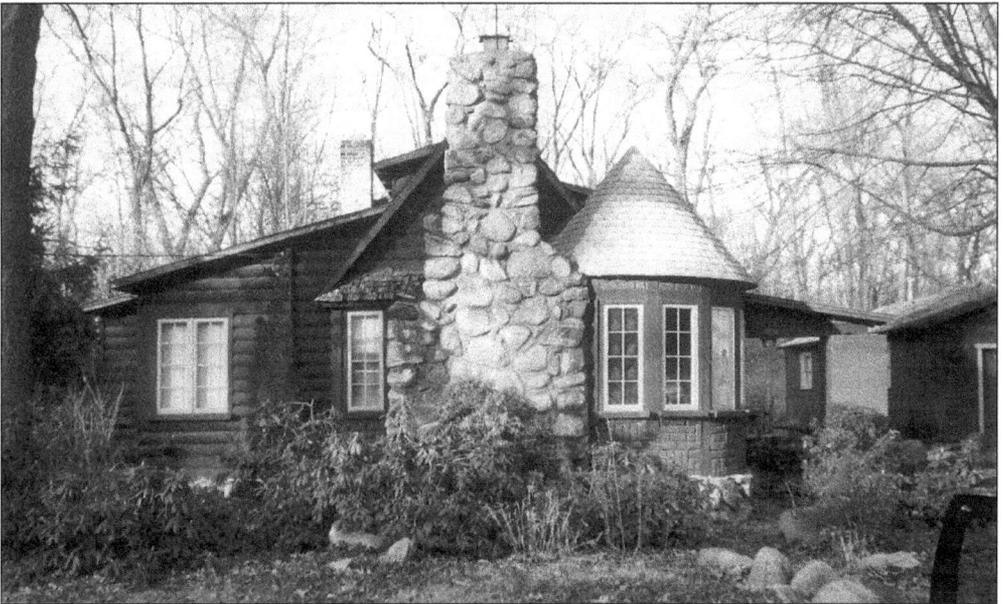

Hiawatha Trail, Pokagon, Mohawk, and Cherokee are among the Indian names bestowed upon the streets in Michiana Shores, where this cabin is located. The most prevalent Indian name, however, remains Pottawattomie (note the spelling variation), adopted by a country club and residential community east of Michigan City. According to local legend, Pottawattomie Park is where the Indian councils were held. (BKS)

Karl Warren

The Michiana Shores Theatre Colony brought a new level of sophistication to the beach communities. Organized in 1939 by John McMahill, a Broadway actor/director, the group constructed a modern theatre building in 1940. This drawing was done by Karl Warren, an artist who lived in Michiana Shores and commuted daily to his advertising job in Chicago. In 1942, the facility was sold to Norman and Letitia Barnum, who ran an acting school in Chicago and operated the theatre until 1950, when Don Bolen rented and produced a season of plays. That summer, he became acquainted with Ruth Holden and Tyler and Nora MacAlvay, and they organized the Dunes Arts Foundation to purchase the 360-seat theatre, lodge, and 13 other cabins. In 1957, an additional 26 acres of land were purchased. Theatrical performances were staged, with Eric Nordholm as director and set designer, and Sally Montgomery as choreographer. Nora MacAlvay, author of two children's books and three plays, founded the DAF Children's Theatre in 1948. (Courtesy of Dani Lane.)

Nora Tully MacAlvay, drama instructor and founder of the Children's Theatre, is honored here at a birthday party. A native of England, Nora graduated from the University of Chicago and moved to Michigan City after her marriage to Tyler MacAlvay. They were both leading forces in the Dunes Arts Foundation. Pictured at left is friend Jerry Montgomery. (Courtesy of Dani Lane.)

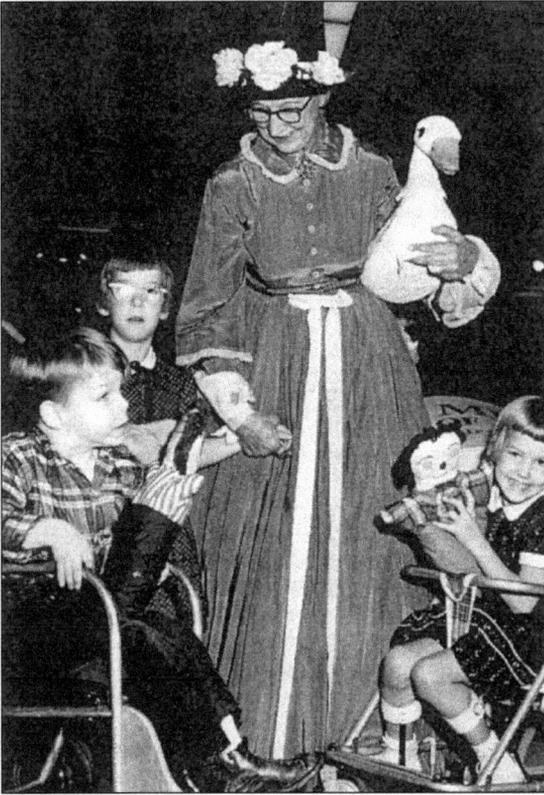

Cecelia Komarek, a resident of Michiana Shores and costume designer for the DAF Children's Theatre, portrayed Mother Goose at book fairs held annually at the Museum of Science and Industry. Her daughter, Grace Saunders, was also deeply involved with the Dunes Arts Foundation. (Courtesy of Dani Lane.)

The Signal Tree, towering above other trees, was reportedly used by Indians to send signals. It stood in Michiana Shores on the Indiana/Michigan border, as indicated in a sign posted by surveyors in 1847. Eighty years later, it stood witness to a handshake between Orphie Gotto (right) of Long Beach Company and Mr. Tobin of the Lonnquist Company. (MCPL)

A DRIVE PATH AND BRIDGE TO GOLFMORE HOTEL.

Marquerite photo

Golf courses had become an integral part of beach communities by the 1930s, and imposing edifices were built to attract golfers. In 1922, the Golfmore Hotel (above) was constructed in Grand Beach, Michigan, about ten miles east of Long Beach, Indiana. The grounds were laid out by Phil Hesse and included a 9-hole golf course, opened in 1911 and expanded to 18 holes in 1913. (Courtesy of Grand Beach clubhouse.)

The Beverly Shores clubhouse (below), golf course, and residential development went up about ten miles west of the Michigan City beach communities, in the early 1930s. Frederick Bartlett, the developer, was evidently influenced by the success of similar resort areas in Long Beach and in Florida, but his plans got off to a slow start because of the 1929 stock market crash. (MCPL)

CLUB HOUSE AT BEVERLY SHORES, MICHIGAN CITY, IND.—21

BIBLIOGRAPHY

The Beacher, February 21, 1985, April 25, 1985, and other issues

Beyer, Maggie, "Long Beach, The Town: Celebrating 75 Years This Year," *The Beacher*, Vol. 12, No. 24, June 20, 1996

Brennan, George, *The Wonders of the Dunes*, Indianapolis, 1923

Duneland Beach Abstract of Title, LaPorte County Abstract Company, 1836–1921

Dunes Arts Foundation and the Dunes Summer Theatre: A History, Dunes Arts Foundation 50th Anniversary Publication, 2001

Kubik, Matt, "A Little Sheridan Beach History," from *Sheridan Beach Homeowners Association Newsletter*, June, 2001

Long Beach Billows, 1922–1932

Long Beach Plat Book, Wheeler Abstract Company, 1836–1921

Manny, Carter Hugh, *Reminiscences of a Small-Town Curmudgeon: My Hometown*, unpublished manuscript, 1969

Michigan City Evening News, Feb. 22–June 22, 1919, and other issues

Millick, Steve, "History of Michiana Shores," unpublished manuscript, n.d.

Morrow, Jim, *Beverly Shores: A Suburban Dunes Resort*, Arcadia Publishing Co., 2001

Munger, Elizabeth, *Michigan City's First Hundred Years*, c. 1969

Nicewarner, Gladys, *Michigan City, Indiana: The Life of a Town*, 1980

Oglesbee, Rollo B. and Albert Hale, *History of Michigan City Indiana*, 1908

Simons, Richard S., "A Way of Living," *Indianapolis Star*, February 9, 1964

Wilson, George R., *Early Indiana: Trails and Surveys*, Historical Society Publications, Vol. 6, No. 3, Indianapolis, 1919

www.ingramcontent.com/pod-product-compliance
Lightning Source LLC
Chambersburg PA
CBHW050654150426
42813CB00055B/2026